HISTORIC PHOTOS OF
SAN FRANCISCO
IN THE 50s, 60s, AND 70s

TEXT AND CAPTIONS BY REBECCA SCHALL

TURNER
PUBLISHING COMPANY

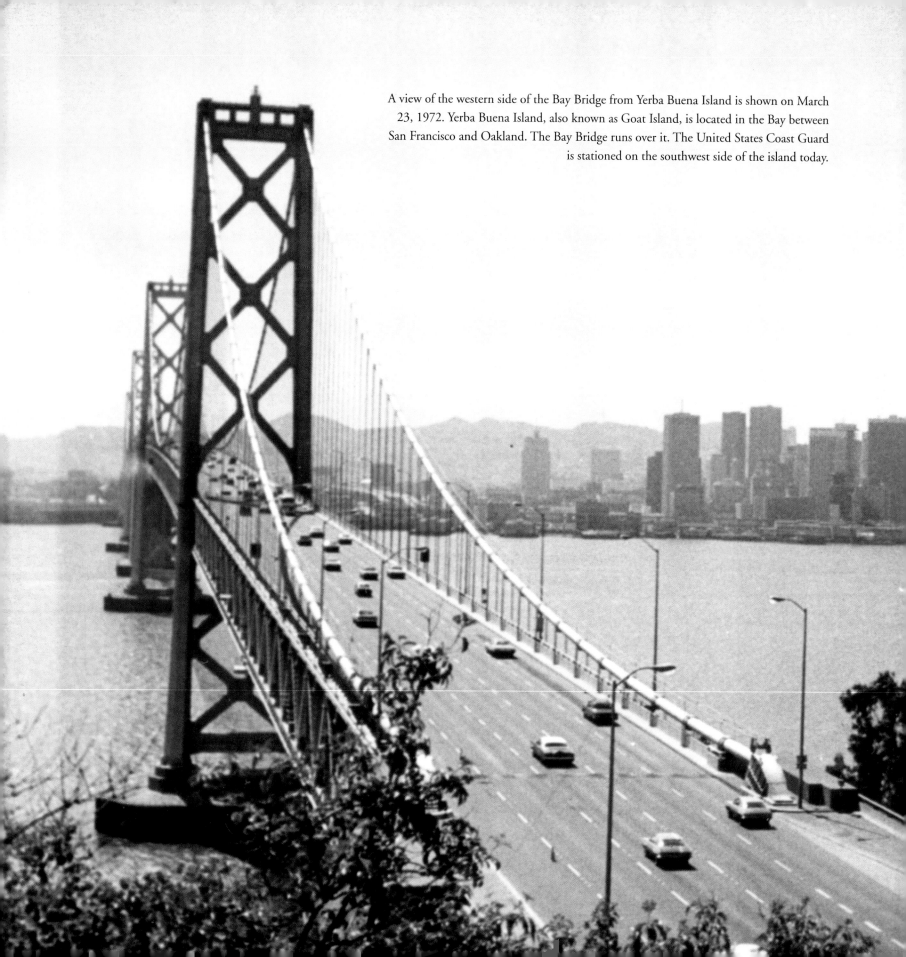

A view of the western side of the Bay Bridge from Yerba Buena Island is shown on March 23, 1972. Yerba Buena Island, also known as Goat Island, is located in the Bay between San Francisco and Oakland. The Bay Bridge runs over it. The United States Coast Guard is stationed on the southwest side of the island today.

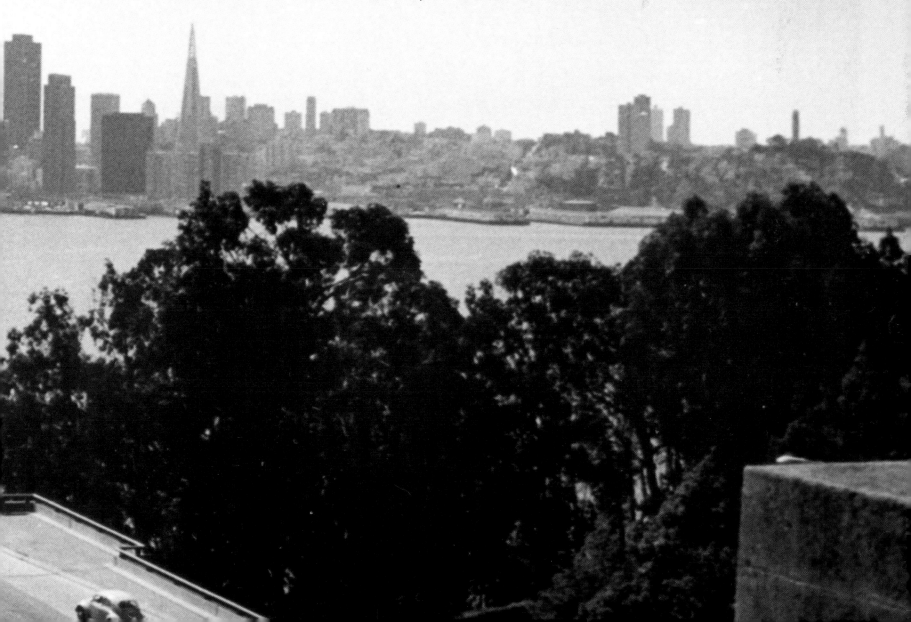

HISTORIC PHOTOS OF
SAN FRANCISCO
IN THE 50s, 60s, AND 70s

Turner Publishing Company
200 4th Avenue North • Suite 950
Nashville, Tennessee 37219
(615) 255-2665

www.turnerpublishing.com

Historic Photos of San Francisco in the 50s, 60s, and 70s

Library of Congress Control Number: 2010926731

ISBN-13: 978-1-59652-597-9

Printed in China

10 11 12 13 14 15 16 17—0 9 8 7 6 5 4 3 2 1

CONTENTS

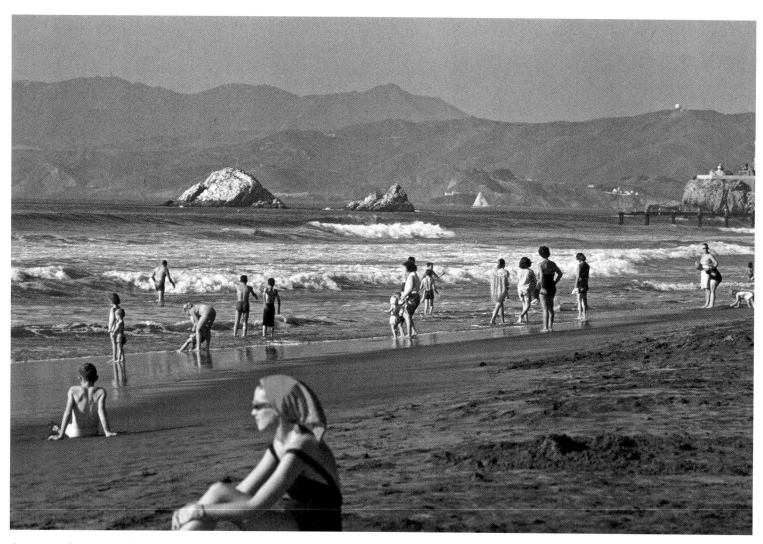

Ocean Beach is pictured on October 14, 1961. San Franciscans recognize that the fall is the nicest and warmest time of the year in the city and take full advantage of the Indian Summer days, knowing full well that each could be the last one before the rainy season begins.

ACKNOWLEDGMENTS

For San Franciscans and San Francisco aficionados everywhere.

Thank you to my family—Fran Schall, Gerry Schall, Teddy Schall, Pedie Schall, and my grandma, Bess Berger, for your unequivocal benevolence, collaboration, support, and humor. Special thanks to Marc Levin, Christina Moretta, photo curator and librarian at the San Francisco History Center at the San Francisco Public Library, and Bradley D. Cook, Curator of Photographs at the University Archives and Record Center of Indiana University, and to all the beats, hippies, and counterculture revolutionaries that flourished during San Francisco's Renaissance and contributed immeasurably to the national significance and cultural legacy of the city.

PREFACE

San Francisco is one of the world's great cities, known worldwide for its diversity, natural beauty, quality of life, culture, and cuisine. San Francisco, a beacon of the country, has always been an avant-garde, bohemian, extravagant, and intellectual city, which has historically drawn anyone slightly out of step with mainstream America and wanting to try out new styles of living. Much of what happens to the country usually starts in California, more often, in San Francisco, the cultural, social, and political powerhouse of the state.

The city has come a long way since its humble beginnings as a rough-and-tumble frontier town, and recovered tremendously from the ashes of the 1906 Earthquake and fires that nearly destroyed it. It took center stage during World War II as a major port of supplies and embarkation to the Pacific Theatre. San Francisco was the hub of activity for the major counterculture movements of the 1950s through the 1970s, becoming a center for the emergence of the Beat movement in the 1950s in San Francisco's North Beach, the hippie movement in the 1960s in the Haight-Ashbury District, and of the continuing civil rights and gay rights movements in the Castro in the 1970s. Although San Francisco's Presidio acted as a vital military base and figured prominently in American wars from the late nineteenth through the mid-twentieth century, San Francisco became a fervently antiwar city by the 1950s, 1960s, and 1970s. The social ferment of the 1960s forever changed how young people felt about themselves, and they migrated to San Francisco by the tens of thousands out of a sense of adventure, idealism, and unlimited possibilities.

The music of the 1960s and 1970s, such as the Rolling Stones, Janis Joplin, the Doors, and the British invasion of the Beatles, invited resistance to the established order and alerted people to other ways of living. They rejected all that their parents' generation had valued. Groups were forged in this era of identity politics; gay rights, women's rights, Black Power, Red Power, and civil rights in general. This activism carried into the next decade, when women fought for equality and gays fought for acceptance and protection under the law in society.

When photography emerged in France in the nineteenth century, it allowed people to capture the modern world and

document its history in unprecedented ways. The power of photographs is that they are less subjective than text in their treatment of the past. Although the photographer can make decisions regarding subject matter and how to capture and present it, photographs do not allow the same opportunity for incorporation of opinion and bias as text does. For this reason, photographs offer an original and untainted perspective that allow the viewer to observe, experience, and interpret for themselves. Thousands of historic photos of San Francisco reside in archives, and while those photographs are of great interest to many, they are not always easily accessible.

This book is the result of countless hours of reviewing thousands of photos in the San Francisco Public Library Archives, as well as extensive historical research. I greatly appreciate the generous assistance of my family and others listed in the acknowledgments of this work, without whom this book could not have been possible.

The goal in publishing this work is to provide broader access to extraordinary photographs that will inspire, educate, and preserve with proper respect and reverence the story of San Francisco during these turbulent and formative decades. The photographs selected have been reproduced in their original black-and-white format to provide depth to the images. With the exception of touching up imperfections caused by the damage of time, no other alterations have been made.

This book is divided into three chapters, representing San Francisco in the 1950s, 1960s, and 1970s, respectively. In each section, *Historic Photos of San Francisco in the 50s, 60s, and 70s* attempts to capture various aspects of daily life in the city and provide a broad perspective of the historical significance of these divisive and decisive decades, illustrated by the selection of photographs, which feature important people, places, events, architecture, commerce, transportation, and scenes of everyday life. I encourage readers to reflect on this paramount time as they gain a new appreciation for the momentous history, unique character, and cultural and social influence of San Francisco in the latter half of the twentieth century.

—*Rebecca Schall*

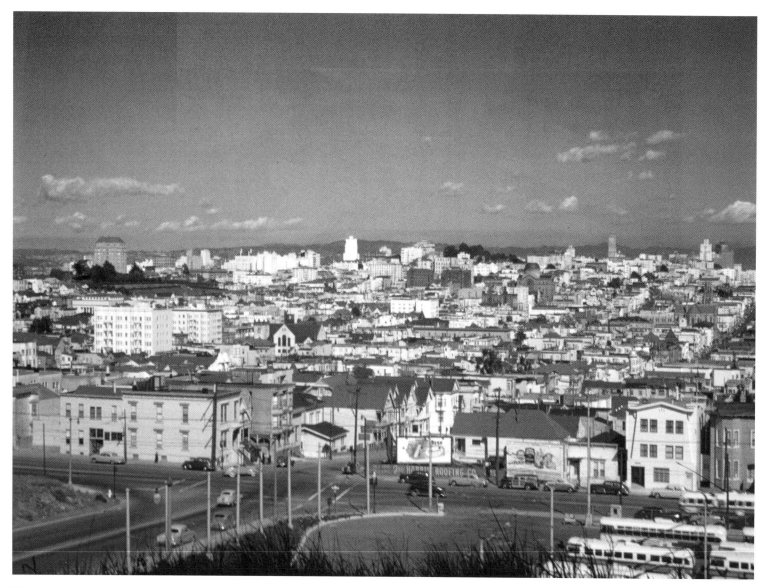

This 1950s photograph, taken from the heights of Lupin and Laurel above the intersection of Bush Street and Presidio Avenue, provides a panorama of San Francisco. Apartments at this intersection provide some of the best views in San Francisco today. In the foreground is a large streetcar yard of San Francisco Municipal Railway, and today the site houses half of San Francisco's electric trolley buses.

THE 1950S:

THE SAN FRANCISCO RENAISSANCE, POST-WAR PROSPERITY, NUCLEAR ANXIETY, AND THE BEAT GENERATION

With the end of World War II and the jubilation of allied victory, tens of thousands of soldiers returned home to the Bay Area. These returning veterans, the "Greatest Generation," had, within 15 years, experienced two of the most serious challenges in the history of the country—the Great Depression and World War II, a global conflict fought over the entire planet in which 50 million people perished.

The United States emerged from the war as the richest and most powerful country in the world. People were tired of the economic deprivation and the dislocation of war of the previous years and wanted to return to a secure life and share in the fruits of victory. The excitement and pride of defeating Nazi Germany and Imperial Japan were somewhat tempered by the evolution of the Cold War with the Soviet Union almost immediately after the end of World War II, particularly after the development of nuclear weapons by Russia. As an interesting local footnote to history, the war with Japan officially ended with the signing of the San Francisco Peace Treaty in 1951.

The fifties saw the most dramatic improvements in the economy in three decades, resulting in a period of relative economic prosperity for many, and a return to a consumer-based society similar to that of the 1920s. Returning soldiers went to college for the first time with the help of the G.I. Bill. The overall feeling of peace and prosperity was personalized by President Dwight D. Eisenhower, a father-like political figure.

Postwar San Francisco witnessed unprecedented population explosions in the 1950s. With the new boom in the economy, returning soldiers were eager to start families, prompting a nationwide baby boom. African-Americans came to the Bay Area by the tens of thousands to work in shipyards and factories during World War II and stayed after the war as well. The gay population also rose in San Francisco during and after World War II when almost 10,000 homosexuals were dishonorably discharged from the military, many of whom were processed through San Francisco and decided to remain. San Francisco underwent another significant demographic change during this time with new influxes of immigrants from Latin America and Asia, and a shifting of the Caucasian population to the suburbs. The huge postwar population increase prompted cookie-cutter subdivisions and the rapid building and expansion of the Sunset District and Visitation Valley.

The 1950s in the Bay Area was also a time of freeway construction, urban renewal, and the reshaping of local neighborhoods. To accommodate the expanding towns and populations, Caltrans started a progressive and aggressive freeway project in the Bay Area to the outcry of many San Franciscans, who were infuriated at the proposals to have freeways go through neighborhoods and displace large urban populations. The end of the decade saw a freeway revolt as people tried to prevent the carving up of neighborhoods by concrete expressways and ramps. To minimize this, Caltrans' solution was to quickly build double-decker freeways, ultimately proving to be eyesores and seismically dangerous, as the 1989 Loma Prieta Earthquake would prove. In 1959, the San Francisco Board of Supervisors voted to stop anymore freeway construction in the city, and the city has maintained a strong anti-freeway stance since.

San Francisco, always a center for counterculture movements, gave birth to the Beat movement in the fifties. The Beatniks used poetry and prose, art, and film to express their disaffection with American consumer culture and the ethos of conformity in the nuclear age. Leaders of the Beat movement, such as Jack Kerouac, William Burroughs, Lawrence Ferlinghetti, and Gary Snyder, published their literature in City Lights Bookstore in North Beach, which had become the locus of the movement. This new movement, which promoted social cynicism, free expression, and waking up the American psyche, was marginalized by the mainstream. In 1957, after City Lights published Allen Ginsberg's poem "Howl," Ginsberg and City Lights owner Lawrence Felinghetti were charged with obscenity violations. However, ultimately a groundbreaking verdict acquitted them, saying that "Howl" was in fact protected by the First Amendment and was not obscene, but rather socially significant. The Beat movement foreshadowed even greater social protest to come in the following decades.

The public was fascinated and anxious as Senator McCarthy spread paranoia about Communists in government. Loyalty Oaths started across the Bay in Berkeley, and those who refused were fired. Americans also became captive audiences for advertisers to sell products and propagate ideas of the American ideal. People were encouraged to all look the same and buy the same things, and women were presented primarily as homemakers. In other local media, in 1954 locals sat transfixed as movie goddess Marilyn Monroe married baseball star Joe DiMaggio (who grew up in San Francisco) at San Francisco's City Hall.

In the 1950s, San Francisco, like the rest of the nation, was fully involved in the Cold War against the Soviet Union, and paranoia and an apocalyptic mentality infiltrated people's daily lives, leading to such futile activities as nuclear drills in Bay Area schools. During the Korean War in the early fifties, the Presidio once again came into action as military headquarters, and Letterman Hospital prepared to take care of those injured in the war. The San Francisco Presidio, at that point the new headquarters for the eminent 6th U.S. Army, functioned as the center of operations for Nike missile defense, which were positioned all over the Golden Gate. In 1959, Nikita Khrushchev, Premier of the Soviet Union, caused a media circus when he visited the City by the Bay during a two-week tour of the United States. The smiling Premier seemed friendly and genuine, surprising to many Americans who had been expecting a sinister and malicious Cold War nemesis. Greater change would follow in the coming decades, and San Francisco would be at the forefront of upcoming social revolutions, catalyzing dramatic changes in the nation.

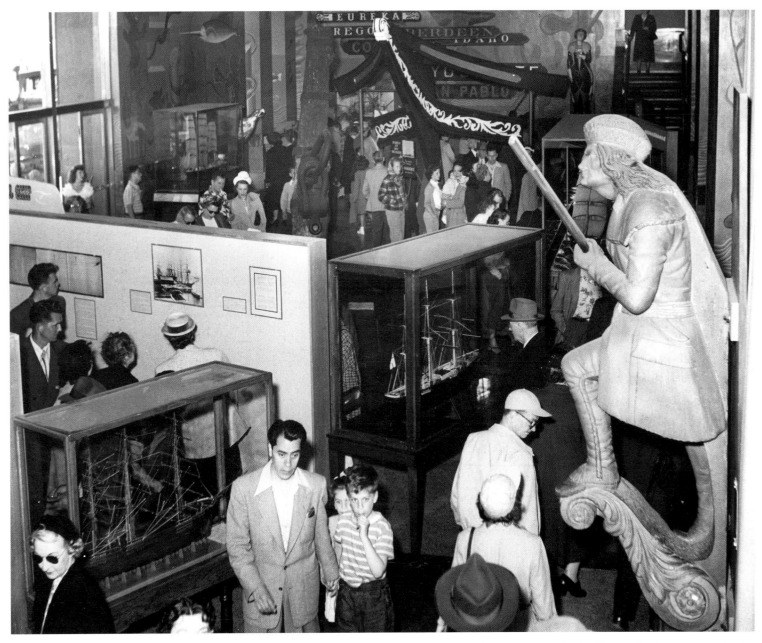

The San Francisco Maritime Museum at Aquatic Park opened in 1951 in what was originally a bathhouse, built in 1939 under the Works Progress Administration (WPA). After spending most of the 1940s being occupied by World War II troops, the Streamline Moderne building, which resembled an ocean liner, converted to house a variety of maritime-related artifacts and exhibits. Visitors in the rear of this 1951 photograph pass under the resurrected bows of the old San Francisco schooner *Commerce*, built in 1900 in Alameda. In the foreground, museum visitors pass under the only clipper ship on the West Coast with a figurehead of Davy Crockett.

Commuters cross from the Southern Pacific Depot at 3rd and Townsend to catch the new #30 Stockton trolley bus on January 20, 1951, its first day of service. This Muni bus line, today one of the busiest in San Francisco, replaced the F Stockton streetcar, one of many streetcar lines to be superseded by electric and diesel buses during the 1950s. Years later, the F Market historic streetcar line resumed use of the F name, although the two lines did not have any part of their route in common. The 1914 Southern Pacific Depot was replaced in 1975 by a new train station at 4th and Townsend, and the former location is currently the site of retail stores and a high-rise apartment complex.

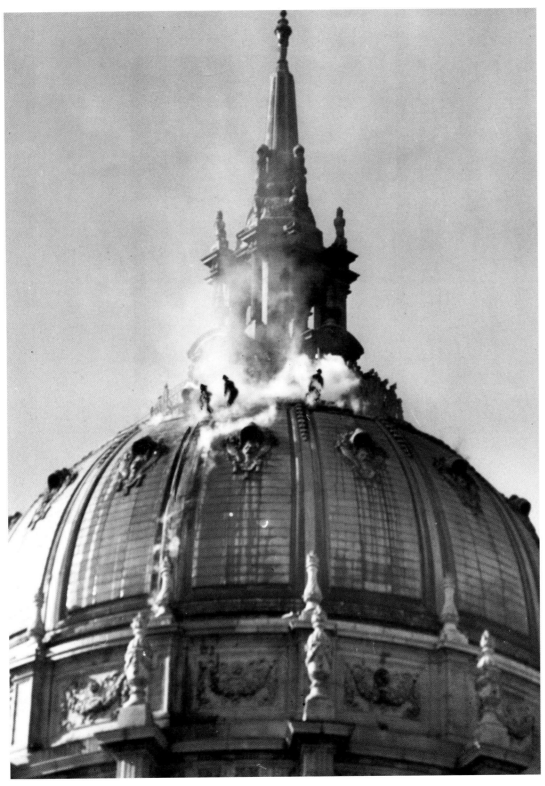

Pictured here on February 16, 1951, firefighters worked in dense smoke to battle a fire atop City Hall's dome. More than 50 firemen were needed to extinguish the flames. San Francisco's previous City Hall, located at the corner of Larkin and Grove where the San Francisco Public Library Main Branch now stands, had been left in ruins after the Great Earthquake and fires of 1906. San Francisco's new Beaux-Arts City Hall opened in the Civic Center in 1915 in time for the Panama-Pacific Exposition, as a part of the nationwide Progressive Reform movement that focused on beautifying inner cities as a way to achieve civic virtue and social harmony. Its 307.5-foot-high dome, modeled after Les Invalides in Paris, is the fifth largest in the world, over a foot taller than the U.S. Capitol in Washington, D.C. The 500,000-square-foot stately monument takes up two city blocks.

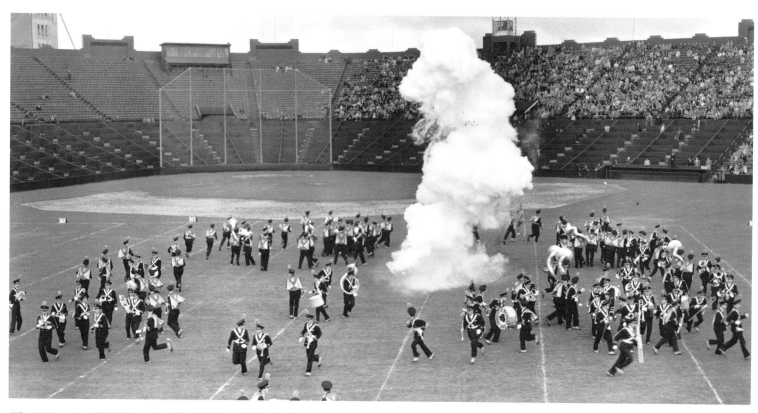

The University of Michigan band is playing at Seals Stadium on January 2, 1952. After a downtown parade, the 150-piece band, hailed at the time as the best in the nation, performed before 2,500 enthusiastic fans. Seals Stadium was built in 1931 at 16th and Bryant streets for the city's two minor league baseball teams, the Seals and the San Francisco Missions. The Seals became the stadium's sole occupant in 1938 and played until the New York Giants moved to San Francisco in 1958. The Giants played in Seals Stadium for two seasons before moving to Candlestick Park in 1960. After Seals Stadium was demolished in 1959, the location was converted to a mall and then a car dealership. Currently, the site houses a shopping center. The memory of San Francisco's longtime minor league baseball team lives on in Lou Seal, the official mascot of the San Francisco Giants, as well as a commemorative statue along the waterfront outside AT&T Park.

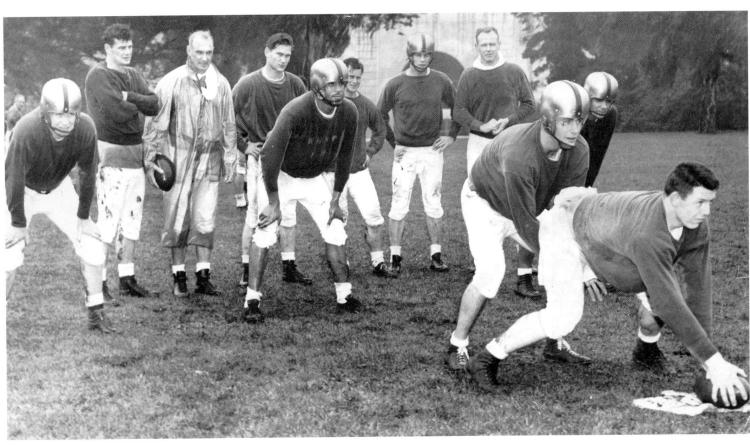

College football all-stars from the West team practice at Kezar Stadium prior to the East-West Shrine Game in 1951. Included in the photograph are future NFL Hall of Famers Frank Gifford (rear crowd, second from right), Ollie Matson (fullback in middle), and Ed Brown (quarterback, behind the center). Matson and Brown were part of the undefeated 1951 University of San Francisco Dons, considered one of the best in college football history. The team, however, did not play in a post-season college football bowl because the bowls in the South asked the team not to bring its two black players (including Matson), and the Dons refused. The team was disbanded after the 1951 season due to the high cost of maintaining the program. The annual East-West Shrine Game is a college football all-star game played since 1925 as a fundraiser for the Shriners Hospitals for Children. The game was played at Kezar Stadium and other Bay Area locations until 2005, when it moved to various locations in the country.

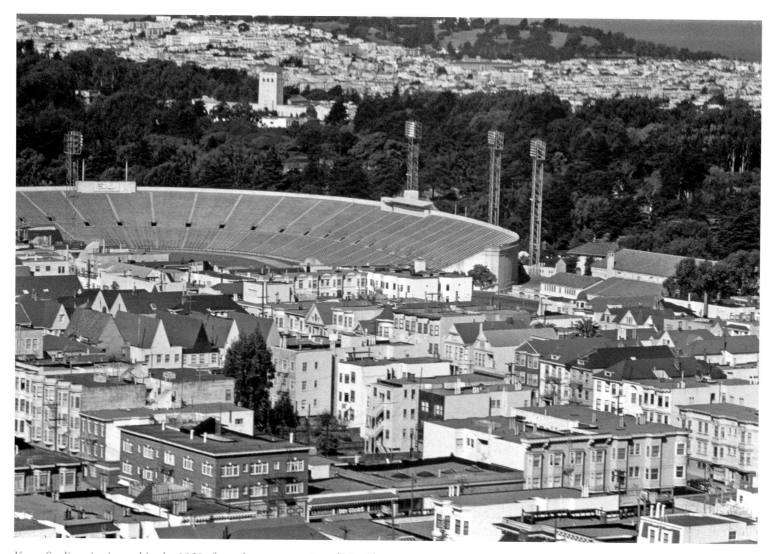

Kezar Stadium is pictured in the 1950s from the vantage point of Mt. Olympus. Kezar Stadium, in the southeast end of Golden Gate Park, was the former longtime home to the San Francisco 49ers and in 1960, for the first season of the Oakland Raiders. In the seventies, the stadium became a concert venue for legendary musicians such as Led Zeppelin, Joan Baez, the Grateful Dead, Carlos Santana, and Neil Young. Kezar Stadium was featured in the 1971 crime movie *Dirty Harry*, starring Clint Eastwood. The original stadium was demolished in 1989, and Kezar was rebuilt with a much smaller seating capacity. Today, the stadium is used for high-school sports, public recreation, and minor league professional franchise events.

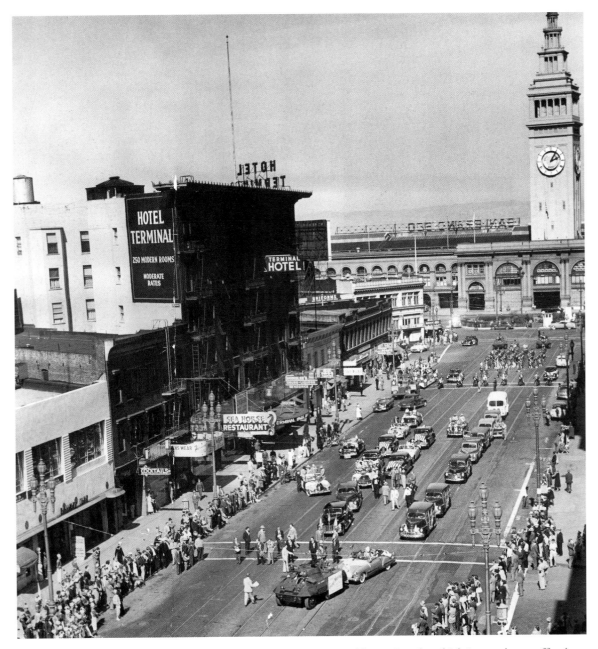

On March 17, 1951, 60,000 spectators cheer during the St. Patrick's Day Parade, which jammed up traffic along Market Street all the way to San Francisco's City Hall. One of many cultural celebrations in the city, the annual St. Patrick's Day Parade in San Francisco, which typically includes more than 5,000 participants from all over the country, is the largest one west of the Rocky Mountains and has always been popular because of the large Irish-American population in San Francisco. The Ferry Building can be seen along the waterfront at the end of Market Street in the background.

Maiden Lane is pictured here on March 30, 1951, during its Spring Festival. For many years, the Maiden Lane Merchants Association held an annual "Spring Comes to Maiden Lane" celebration. Maiden Lane, the two-block pedestrian street between Stockton and Kearny, has a sordid history, yet one would never know by looking at the posh high-end boutiques and outdoor cafes that line the street today. Known as Morton Street in the nineteenth century, this thoroughfare was saturated with more legal brothels than any other place in San Francisco and averaged one murder every week. Destroyed in the 1906 Earthquake, the street was renamed Maiden Lane in recognition of its unsavory past.

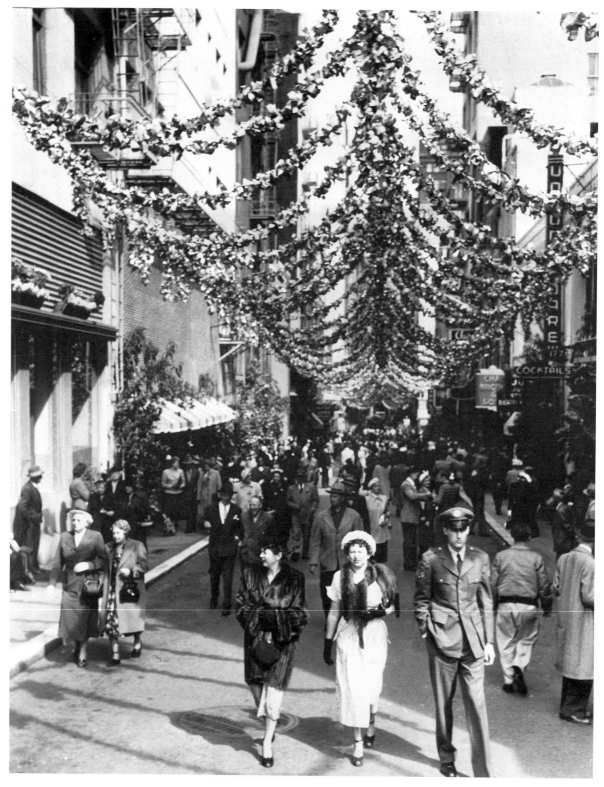

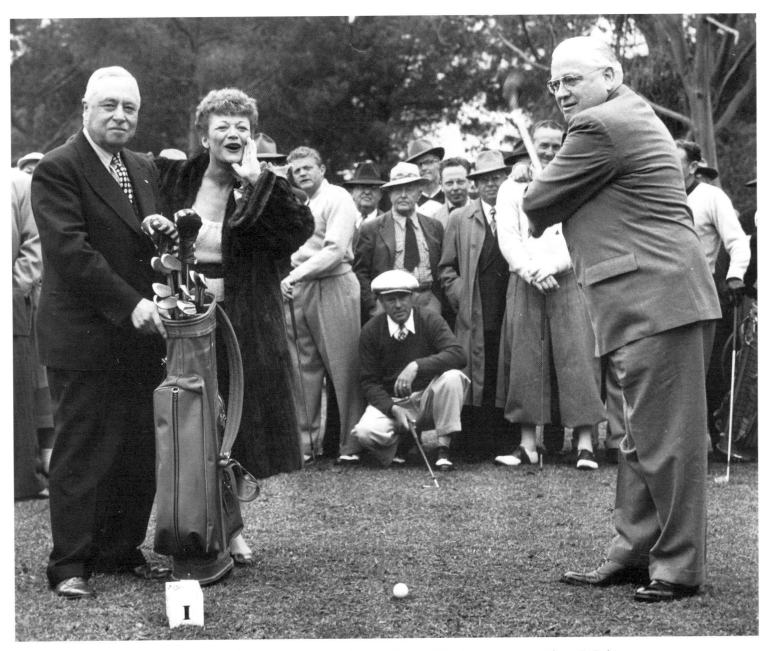

Louis Sutter, president of the Recreation Park Commission; singer Beatrice Kay; and San Francisco mayor Elmer E. Robinson are pictured on April 4, 1951, at the opening of a new nine-hole golf course off the main drive in Golden Gate Park. As the mayor took a swing, Louis Sutter acted as a caddy. The mayor missed the ball, and the singer yelled "fore" anyway. Today, the beginner-friendly Golden Gate Park Golf Course continues to be a favorite of locals.

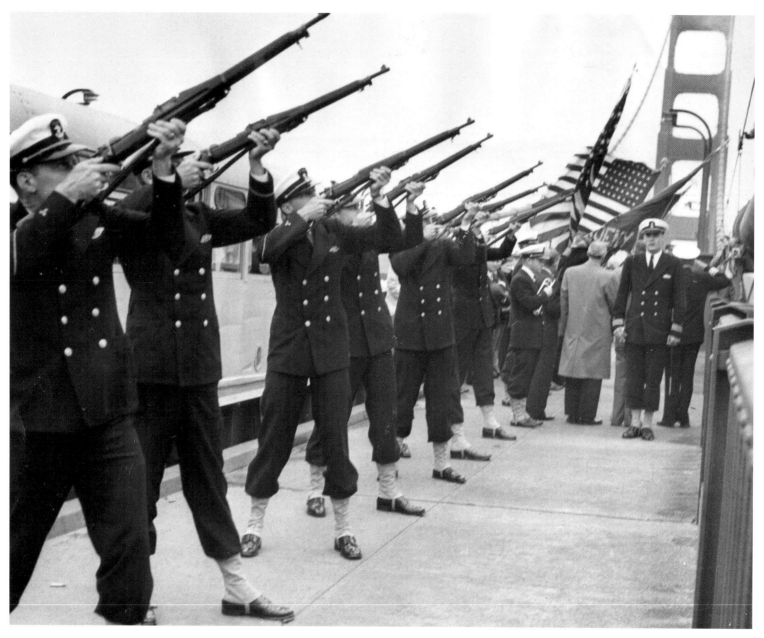

During a gun salute in a memorial ceremony honoring merchant marines, an honor rifle squad of cadets from the California Maritime Academy in Vallejo is pictured on May 22, 1951. They are standing on the Golden Gate Bridge center span as a wreath is cast into the Pacific Ocean during World Trade Week.

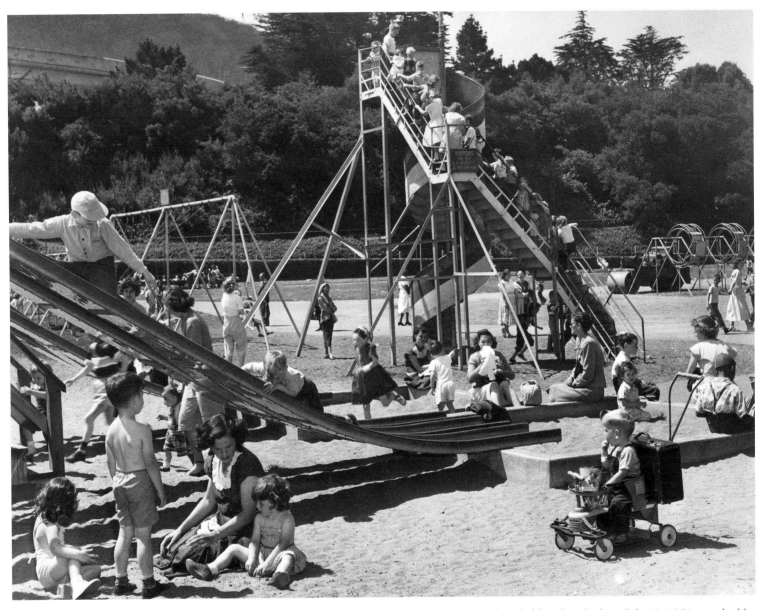

Dozens of youngsters play on the slides and swings at Children's Playground in Golden Gate Park on July 18, 1951, watched by their mothers. Opened as the nation's first public playground for children in 1887, the expansive grounds at one time featured such attractions as a bear pit and elephant rides, in addition to the slides, play structures, and carousel that have been longtime favorites. The playground was extensively renovated in 2007 and reopened as the Koret Children's Quarter.

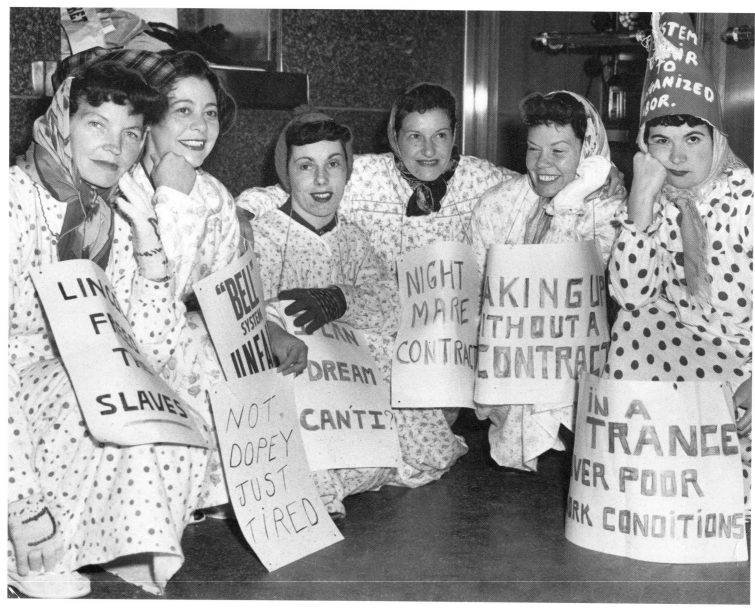

Striking employees dressed in nightgowns are shown on the picket line at the Pacific Telephone and Telegraph Company's 25th and Mission streets telephone exchange on July 24, 1951. The ladies came to picket at 6:30 A.M. dressed in pajamas and wearing signs saying "I can dream, can't I?" Written on the back of the photo was, "In case you're worried, they've got street clothes under the nightgowns." This office, along with the P.T.T. offices in Oakland and many other locales in Northern California, had been picketed for almost a week. Eight hundred workers, members of the C.I.O. Communications Workers of America, walked off their jobs at the Bush Street and Grant Avenue exchanges to protest what union officials charged was a lockout of plant employees who observed the picket lines.

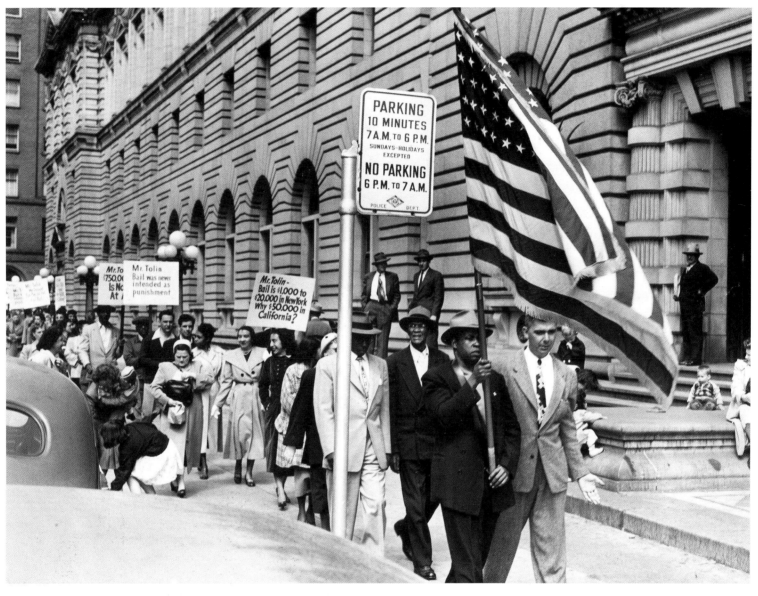

Picketers on September 21, 1951, around the U.S. Post Office Building at 7th and Mission streets, protest the bail policy of assistant U.S. attorney Ernest A. Tolin for 12 westerners accused of being Communist Party leaders. The picketers were part of the California Emergency Defense Committee, but other marchers identified themselves as affiliates of the "Communist In-line Civil Rights Congress." During the Cold War, many feared that Communism would spread in America—fears confirmed with trials of Americans who had shared secrets with the Soviets. In 1947, Truman ordered four million government employees to take loyalty oaths and get checked out. The movie industry began to be targeted, with people's names appearing on unofficial lists of suspected Communists. Republican senator Joseph McCarthy crusaded against supposed Communists in the U.S. government, resulting in thousands of ruined lives, careers, and reputations. McCarthyism now refers to irrational charges against innocent citizens.

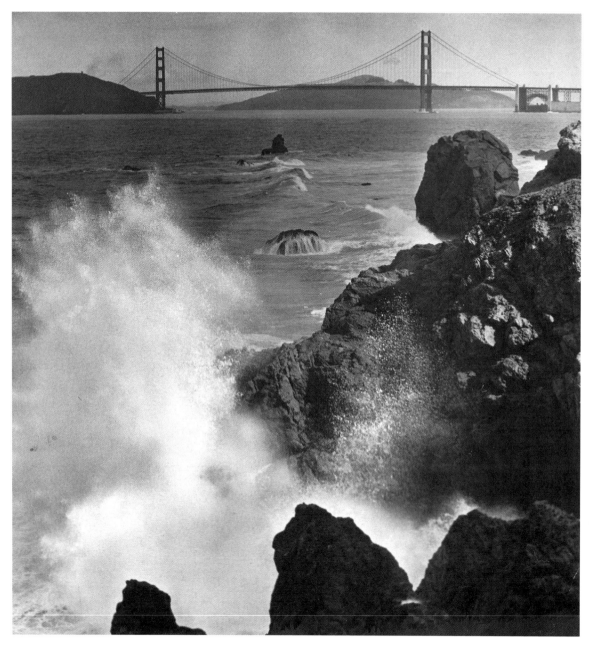

Spumes of surf crash against Dead Man's Rock at Land's End on December 5, 1951. Following a series of bad winter storms earlier that year, the normally calmer Pacific waters turned violent. The Golden Gate Bridge, damaged by an earlier storm and temporarily closed, stands out in the background. The rock was so named because of the numerous fishermen who had fallen to their deaths on the surf some 30 feet below.

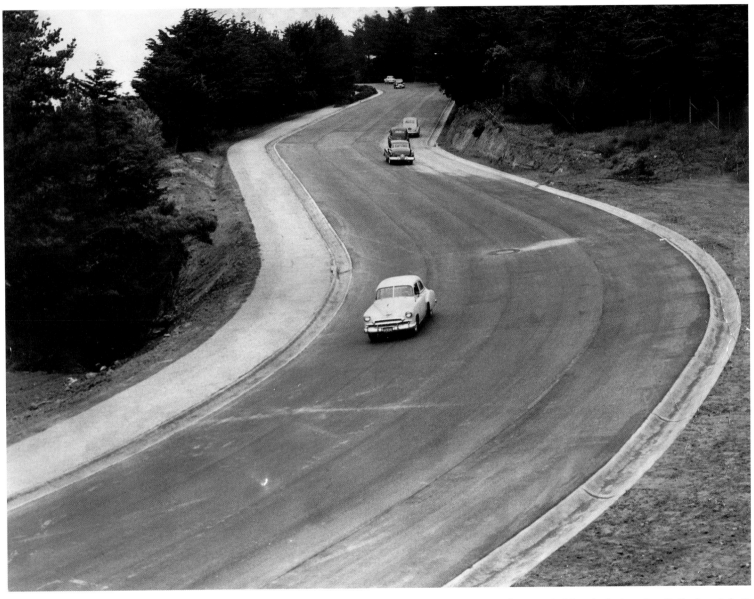

A car meanders along El Camino del Mar's scenic drive from the Legion of Honor in Lincoln Park to Land's End on July 2, 1951. Recently re-opened following a series of severe winter storms, the road was prone to mudslides, and in 1951, it had been closed for seven of its 33 years. Nature finally got its way in 1957, when a 5.3 magnitude earthquake in Daly City and further landslides finally brought down the road for good. Today, only hikers can traverse the closed portion of El Camino del Mar between the Palace of the Legion of Honor and the *USS San Francisco* Memorial.

A man is pictured in 1950 leaning against a fence on El Camino del Mar near the San Francisco Veterans Administration Medical Center. This hospital, in operation since 1934, continues to meet the medical needs of men and women who have served our country.

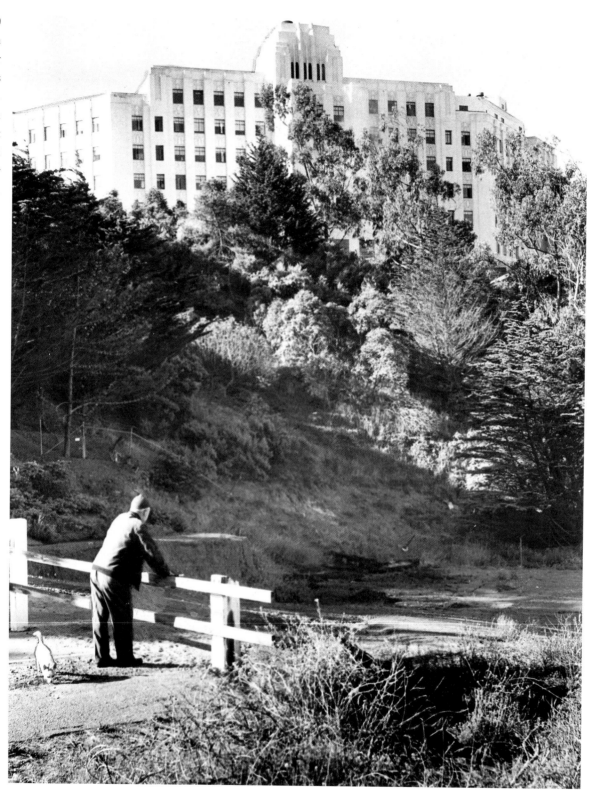

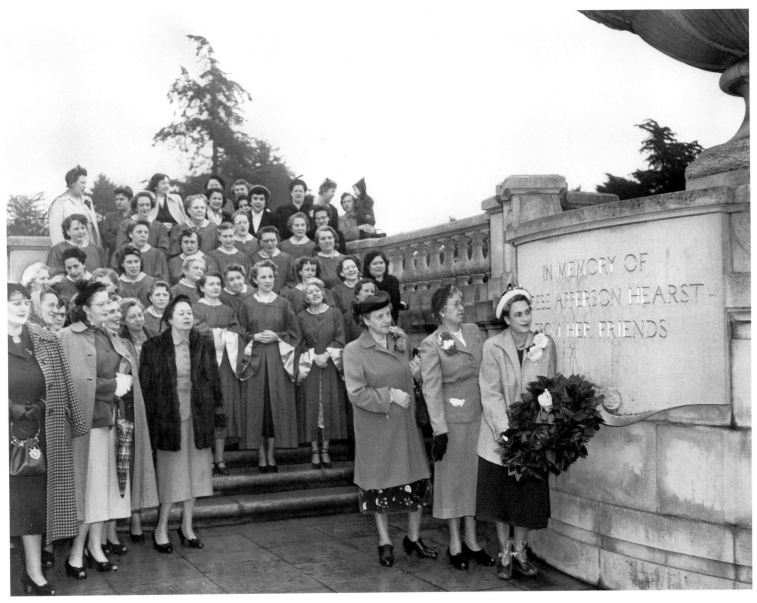

On February 16, 1952, a ceremony is held in Golden Gate Park near a monument honoring Apperson Hearst to commemorate the 55th anniversary of the founding of the National Congress of Parents and Teachers by Phoebe Apperson Hearst and Alice McLellan Birney. Holding a wreath that was laid at Hearst Memorial Fountain is Mrs. E. M. Hood, President, S.F. District, Parents-Teachers. With her are Mrs. George M. Hearst (left), a past president who was a ceremony speaker, and Mrs. George W. Chambers, chairperson of the day.

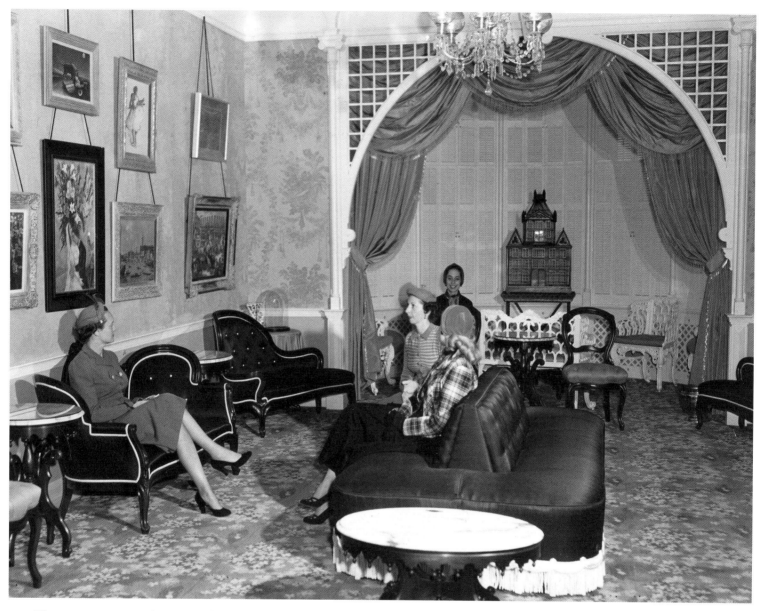

The postwar economic boom transformed the country. America was economically self-confident for the first time since the 1920s as the country rapidly turned into a consumer society. For the first time, more Americans were doing more white-collar than blue-collar work, but they also were living in the shadow of the Cold War. It was patriotic to be contributing to the American capitalistic dream. Important in this consumer society was easy access to goods and services. Shopping centers and malls began to spring up across the country and in San Francisco, closer to where people lived rather than downtown. When the Stoneson brothers opened the complex in 1952 along 19th Avenue by the shores of Lake Merced, it was the fourth largest shopping center in the country. Many San Franciscans remember the big "E" of the shopping center's anchor store, the Emporium department store, which could be seen along 19th Avenue. The grandiose women's lounge at the Emporium at Stonestown, which was recognized as the "plushest in town," is pictured here in July 1952. The Emporium was acquired by Macy's in the 1990s.

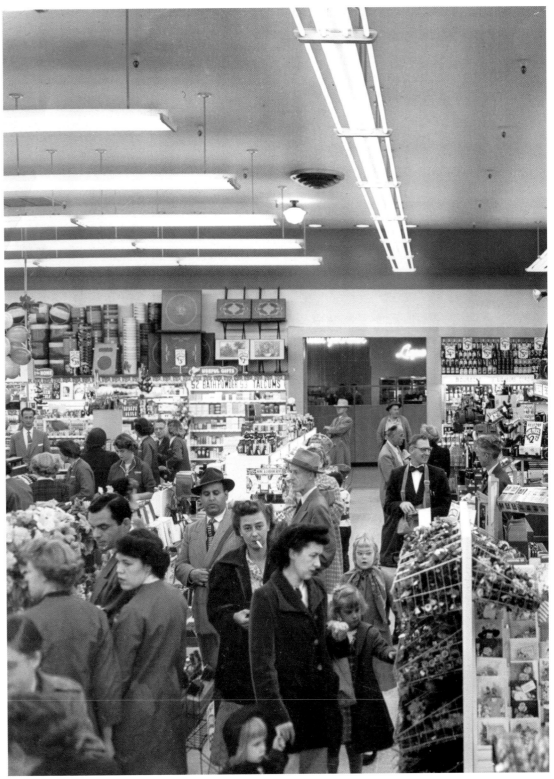

Another early and very popular business at the Stonestown shopping center was Walgreens Drugstore. The interior of that Walgreens outlet is pictured here at on November 21, 1952. Walgreens, which started in 1901 in Dixon, Illinois, as a neighborhood pharmacy, has proliferated and is now one of America's largest drugstore chains, with one seemingly located every few blocks in San Francisco.

In the 1950s, many women in San Francisco were housewives, and their daily activities centered on their families and their homes. In this photograph, a woman purchases her family's dinner from Bob Wong at Wong's Meat Market on September 15, 1954.

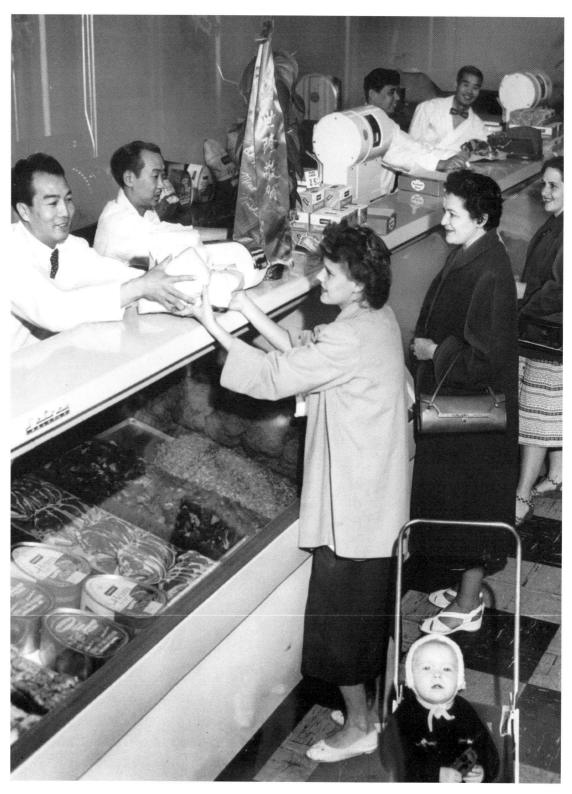

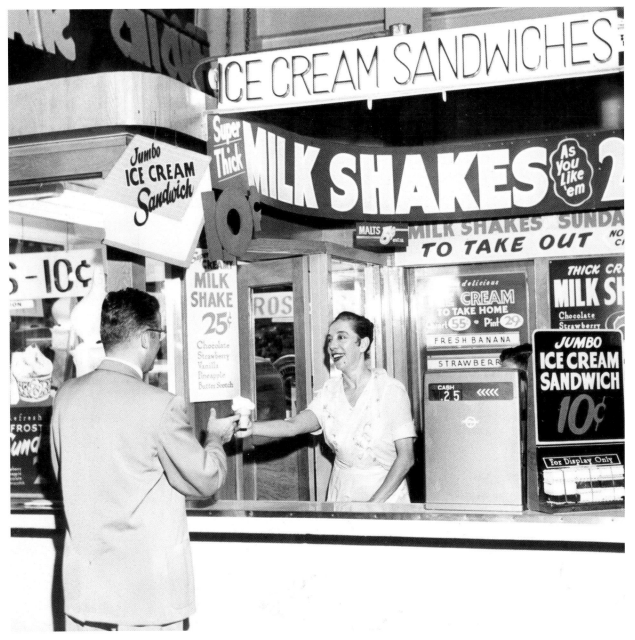

A customer waits for his order at the ice-cream counter at the Crystal Palace Market in the fifties. Opened in 1923 at 9th and Market, the market had numerous stalls where individual merchants sold fruits and vegetables, meats, cheese, drugs, jewelry, and tobacco, and offered many consumer services.

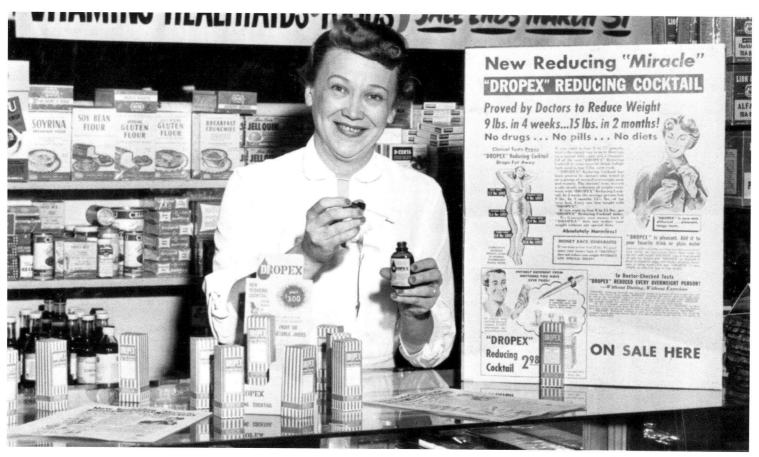

A woman stands behind a counter at the Crystal Palace Market selling some sort of slimming concoction. One of the most popular of the independent merchants at Crystal Palace Market for many years, known as the Snake Man, used garter snakes to attract a large crowd around his stall where he sold a special soap said to cure acne and other skin irritations.

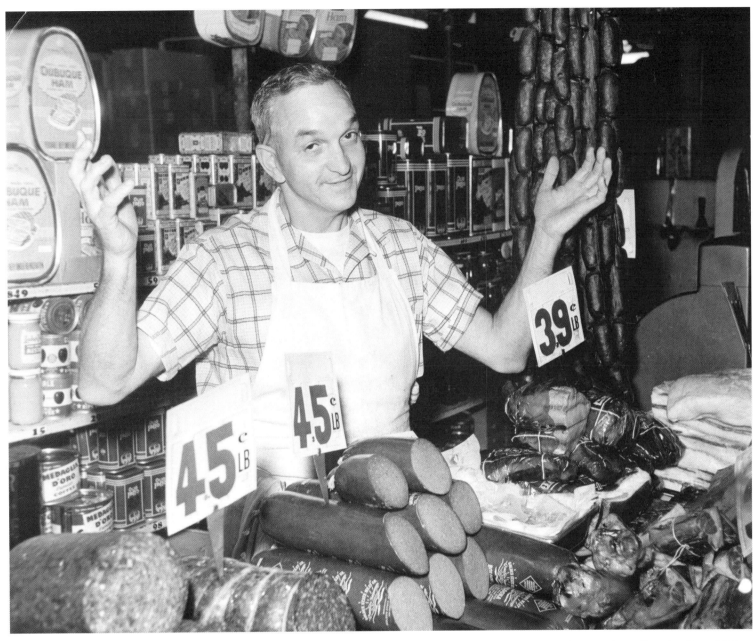

Andre La Forgia stands behind a meat counter at the Crystal Palace Market. Another popular stall in the Crystal Palace Market was operated by the Anchor Brewing Company, which sold the locally brewed steam beer that is still popular today.

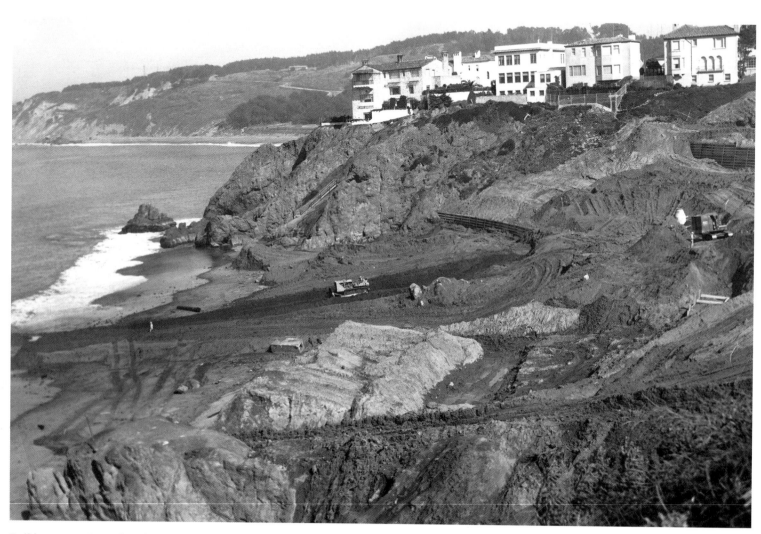

Bulldozers are pictured in the early fifties plowing the sand at James D. Phelan Memorial Beach State Park, more commonly known as China Beach, at the end of Sea Cliff. The beach was being dolled up as it was intended to be the city's official ocean swimming spot.

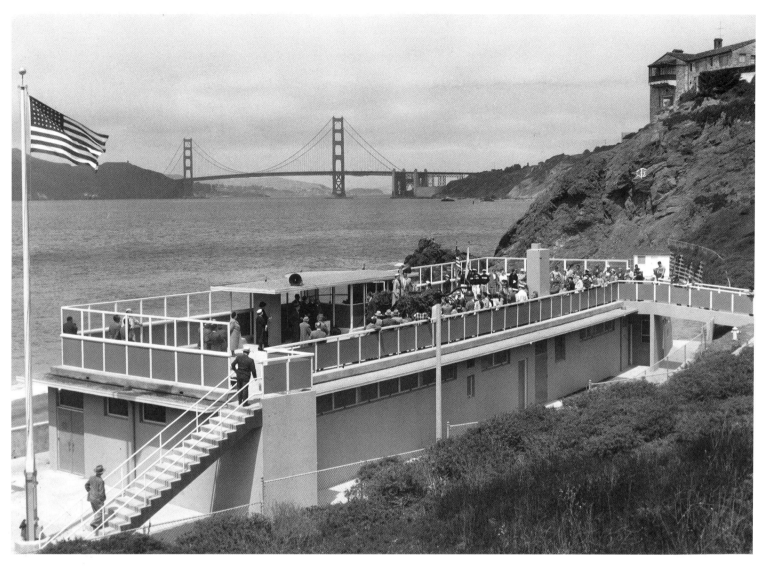

The new beach house at China Beach is dedicated in August 1954 by Supervisor James Leo Halley. The $140,000 beach house, very expensive for the time, contained a lobby, check room, first-aid station, shower rooms and lockers for men and women, lifeguard room, refreshment concession, and rooftop observation area. Although the beach house is run-down today, sunbathers still bask on the rooftop observation deck on warm days, and many people stroll along the beach to enjoy the spectacular views of the Golden Gate Bridge, Marin County, and the Pacific Ocean.

Nancy Menhennet and three friends are pictured standing atop a cliff at Land's End on April 25, 1955, watching the Coast Guard search for her missing brother and his friend. Each year, the U.S. Coast Guard is called upon to rescue people who have climbed out on the rocks near Land's End, China Beach, and Baker Beach and become stranded when the tide is in.

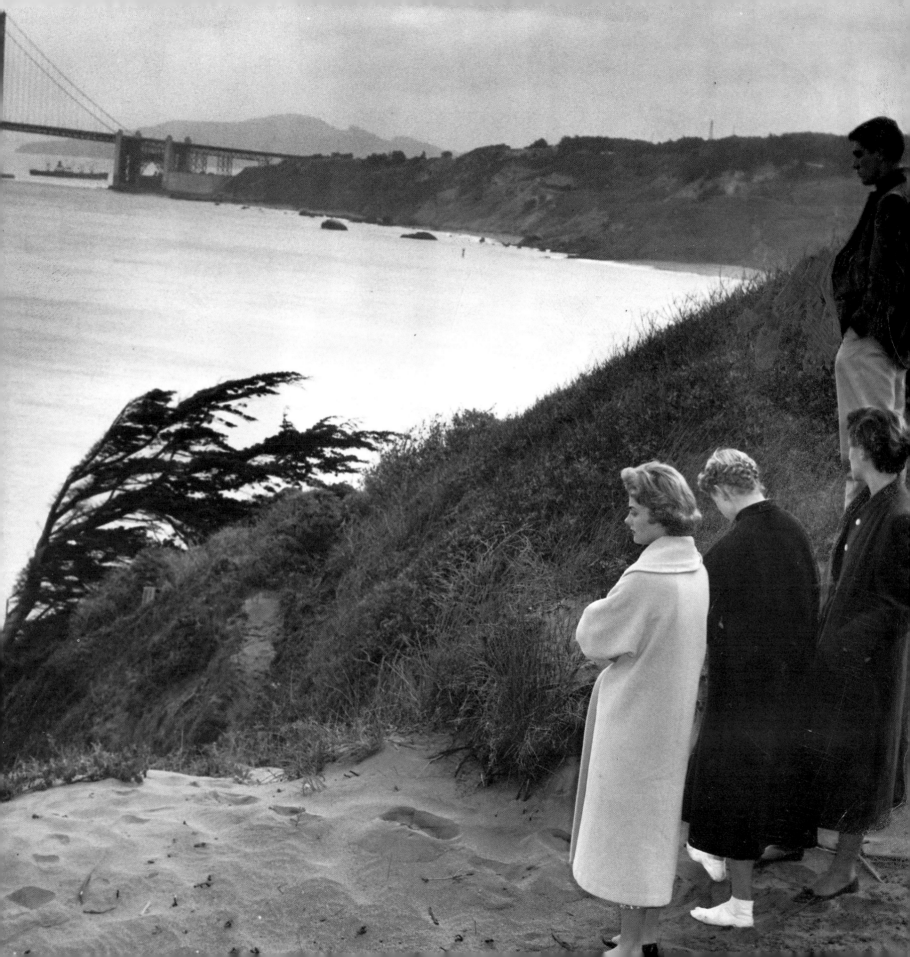

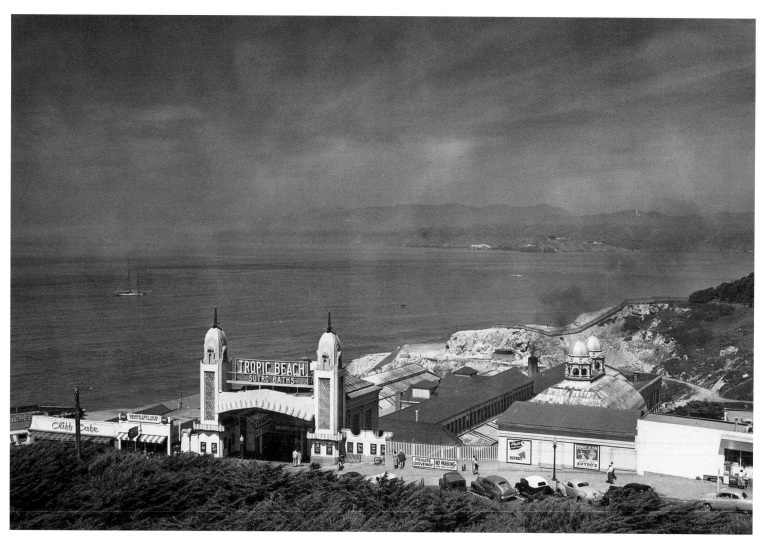

This 1952 photograph depicts the exterior of the Sutro Baths overlooking Ocean Beach. The beach, along the Pacific Ocean on the western shores of San Francisco, was developed in the late nineteenth century as a resort destination featuring the Cliff House and Sutro Baths. Trains took people from downtown through the undeveloped western end of the city, still known as the "Outside Lands." The Sutro Baths, once the world's largest indoor swimming pool, opened to the public on March 14, 1896. They consisted of seven pools and had a seating capacity of up to 8,000. The building was covered in 100,000 glass panes to allow for maximum sunlight to illuminate the building. Adolph Sutro (1830–1898), a Prussian immigrant, engineer, and former San Francisco mayor, built the baths. The Sutro Baths also housed a concert hall and museum with Sutro's personal collection of art, artifacts, and other curiosities.

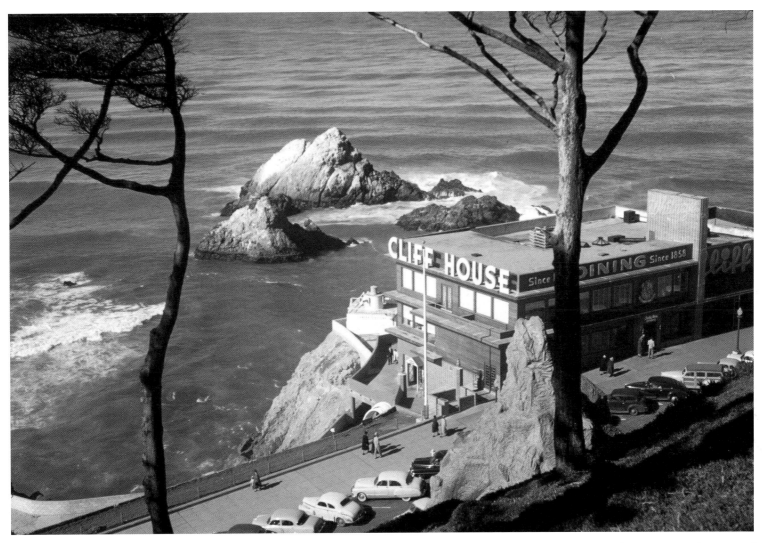

Seal Rocks and the world-famous Cliff House are pictured here in the 1950s. The Cliff House, immortalized in postcards, is one of San Francisco's oldest and best-known tourist attractions that sat overlooking the former Sutro Baths. For years, it has been a restaurant that sits atop the cliffs north of Ocean Beach. The Cliff House has gone through five incarnations over its history, which dates back to the 1860s. In 1896, Adolph Sutro built the famous seven-story Victorian chateau Cliff House, nicknamed "The Gingerbread Palace." Although it survived the 1906 Earthquake, it burned to the ground on September 7, 1907. Within two years, Sutro's daughter built a new Cliff House in neoclassical style, which remains the Cliff House San Franciscans know today. Tourists can still dine at the historic Cliff House, look out over the ghostly ruins of the baths below, and see the famous Camera Obscura on the site.

31

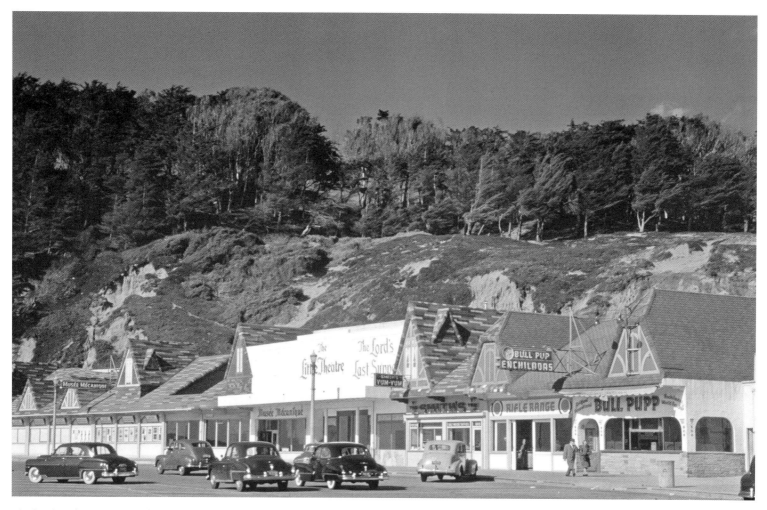

Playland at the Beach was the world-famous ten-acre amusement park next to Ocean Beach by the Cliff House and Sutro Baths along the Great Highway between Cabrillo and Balboa streets. In the nineteenth century, the area, nicknamed Mooneysville-by-the-Sea, was inhabited mostly by squatters. Over the first part of the twentieth century, independently owned and operated concessions, amusement rides, game stands, dance halls, and a variety of food stands and restaurants gradually sprung up at the beach. In 1926, George Whitney, known as "Barnum of the Golden Gate," became the general manager and officially named the park Playland at the Beach. This picture, taken on March 20, 1952, at the base of Sutro Heights, shows the Little Theatre, where a life-sized reproduction of Leonardo Da Vinci's masterpiece, *The Last Supper,* was on display; Musée Mechanique with its collection of antique, coin-operated music and arcade machines; the Rifle Range; and a concession where tasty Bull Pupps were sold.

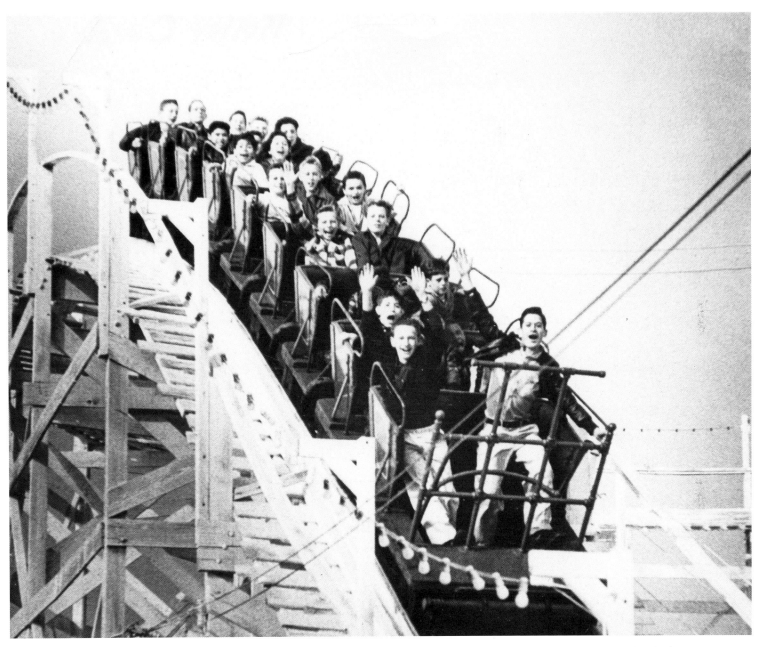

After having lunch provided by the Rotary Club in Golden Gate Park, members of the Columbia Park Boy's Club ride the Big Dipper at Playland at the Beach on November 29, 1952. The "Coney Island of the West" provided carnival-like entertainment and flourished, despite the Depression and World War II. Many older San Franciscans still have fond memories of Topsy's Roost Restaurant, Chutes at the Beach, the carousel, the Big Dipper wooden roller coaster, and Laughing Sal, the huge mechanical, gap-toothed, freckled-faced woman with rust-colored ringlets that greeted people—and scared children—at the entrance to the fun house. Playland was also the birthplace of the It's-It ice-cream sandwich, created by park owner George Whitney. It is still sold in stores today. The park closed in 1972.

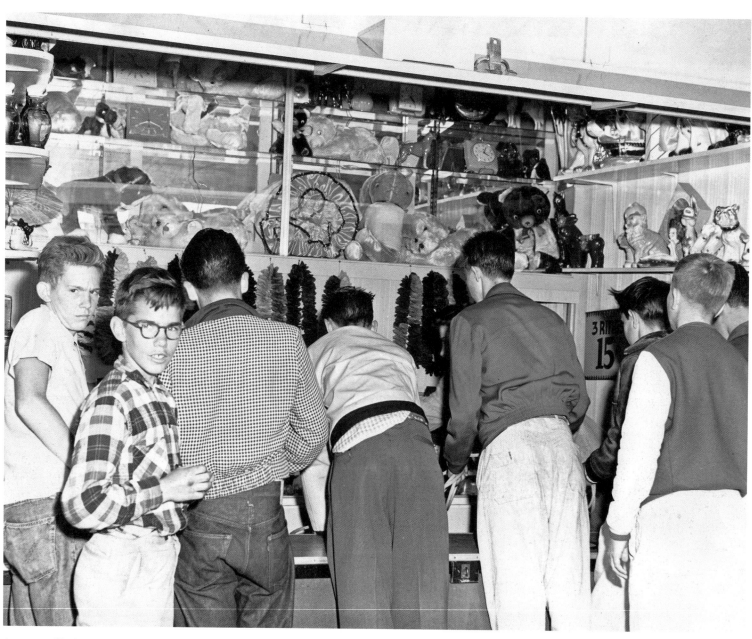

A group of kids is pictured here on August 9, 1955, leaning over at a Playland booth featuring a ring-throwing game. Three generations of San Franciscans enjoyed Playland's shooting gallery, Skee Ball, and numerous other midway games and dreamed of winning one of the stuffed animals or other prizes seen in the background in the picture.

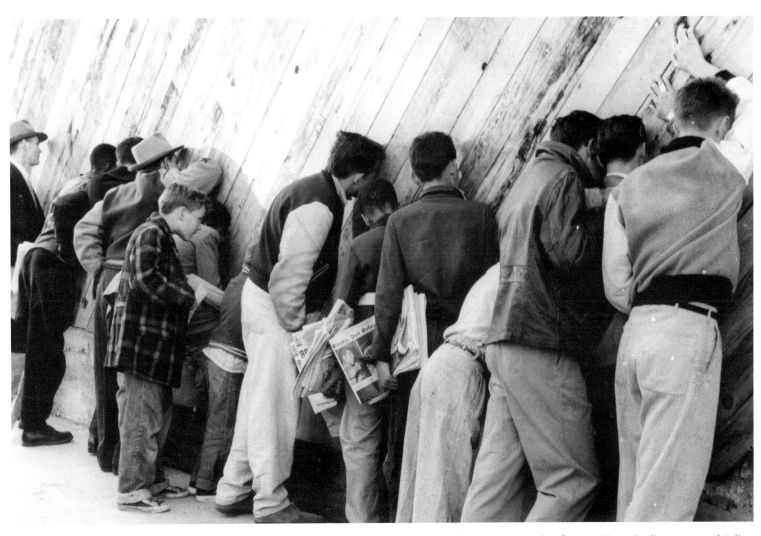

A group of young boys, "knothole gang" members, peer through holes in a wooden fence at Kezar Stadium, some whittling larger holes for a better view of the championship heavyweight boxing match between Rocky Marciano and Don Cockell on May 17, 1955.

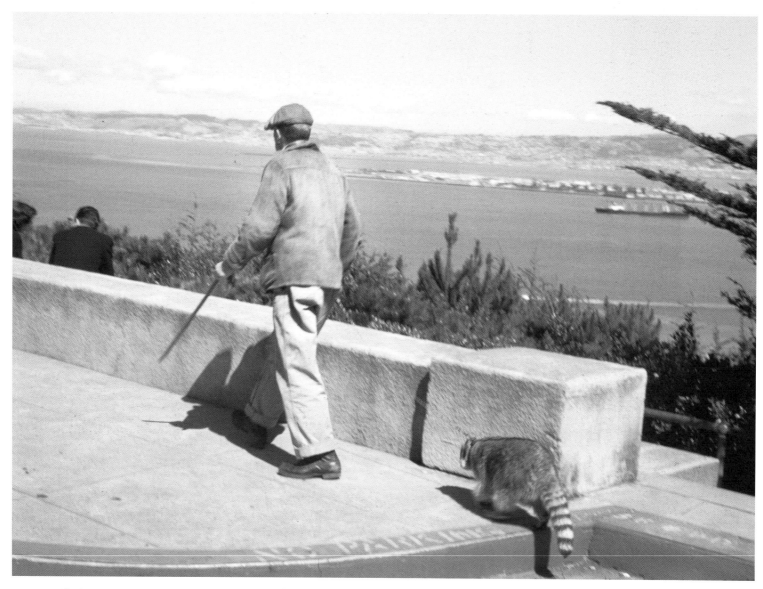

A man walks his pet raccoon on a leash on Telegraph Hill in the 1950s. San Francisco has always been known as a town with many eccentrics, and there is certainly no shortage of raccoons among the urban wildlife that reside in the many city parks and emerge at night, roaming the city and invading trash cans, or getting into other trouble.

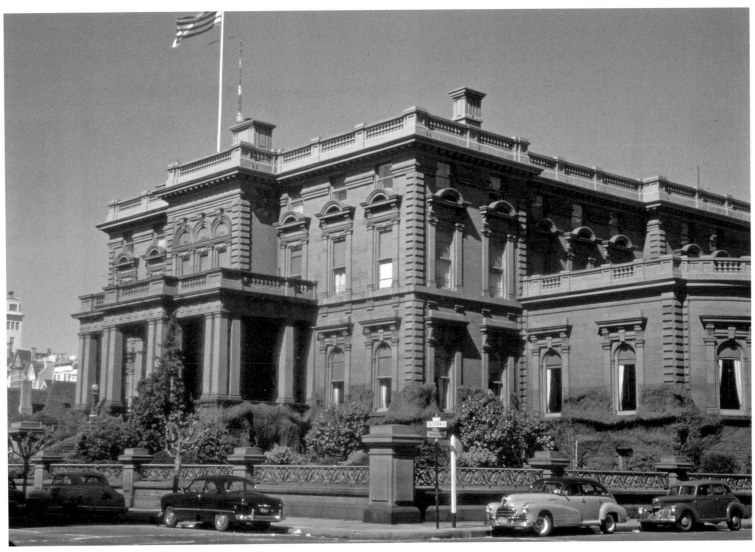

The Pacific Union Club, 1000 California Street at Mason Street at the top of Nob Hill, is pictured here in the 1950s. The Pacific Union Club, a private social club dating back to 1889, formed through the merger of the Pacific Club (founded in 1852) and the Union Club (founded in 1854). The club has had many prominent members, including Samuel Morse, inventor of the Morse Code; Secretary of Defense Robert McNamara; Henry J. Kaiser, founder of the Kaiser Foundation; and many men of the Hearst dynasty. The club's membership remains male-only to this day. This building and the Fairmont Hotel across the street are among the only structures on Nob Hill to survive the 1906 Earthquake and fires. The building was declared a National Historic Landmark in 1966.

For millions of Americans, buying a home was the American dream. People wanted stability and a refuge from the troubles of their earlier lives, and activity was centered on the home and family. In this 1950s photograph looking west from Noe Street, the row houses lining 21st Street all look the same. Noe Valley is situated in central San Francisco, with the Castro District to its north and the Mission District to its east. Named after Jose de Jesus Noe, the last Mexican mayor of Yerba Buena (now San Francisco), Noe Valley was developed in the late 1800s and early 1900s and contains some excellent examples of pre–1906 Earthquake Victorian and Edwardian homes. Considered upscale today, Noe Valley has the highest number of row houses in the city, built originally as efficient and inexpensive homes.

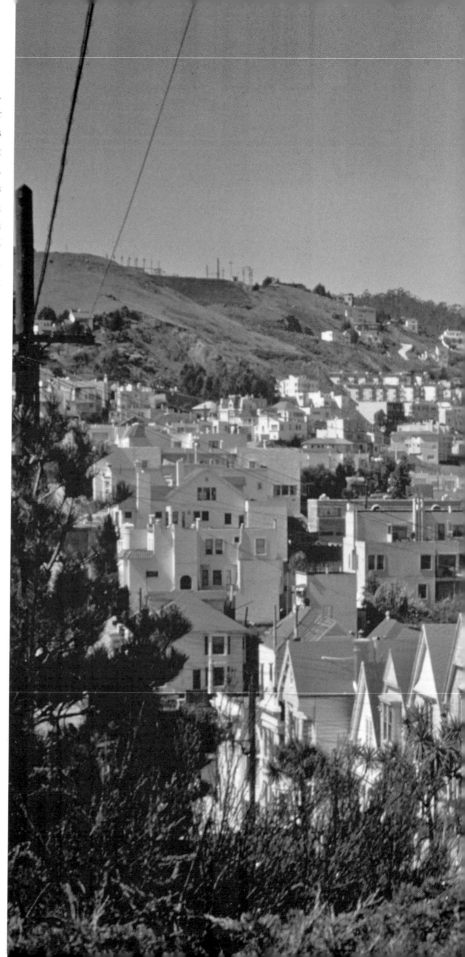

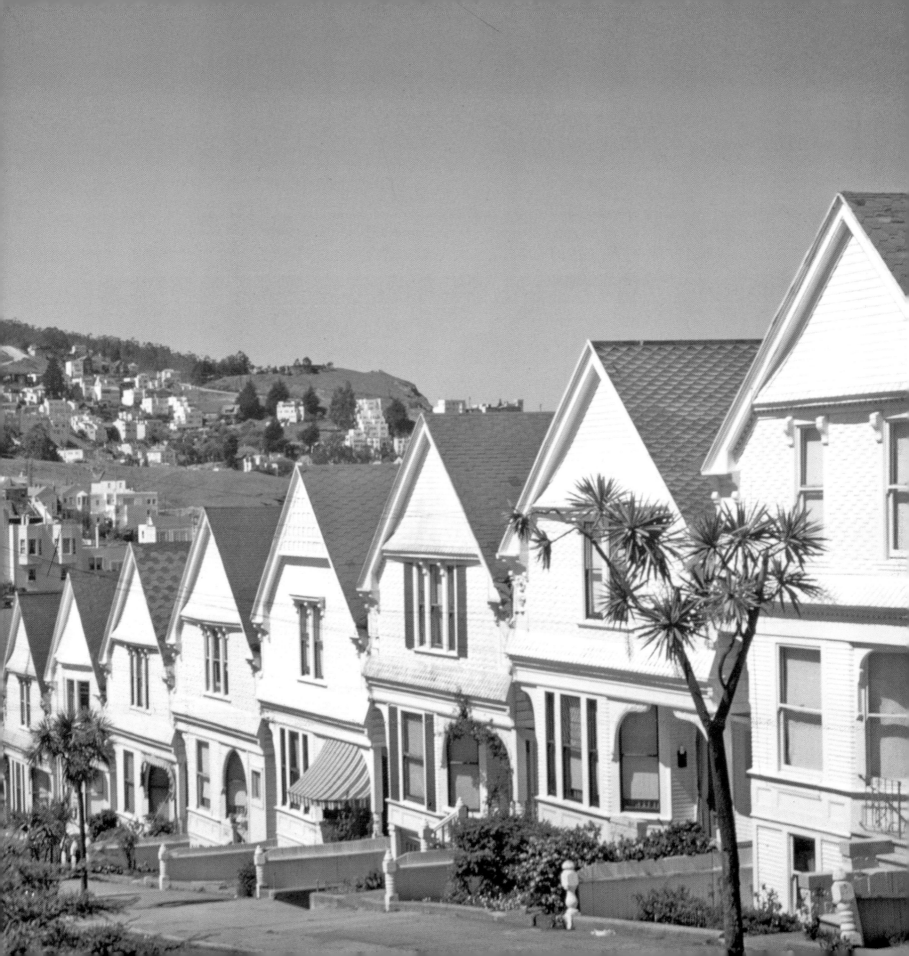

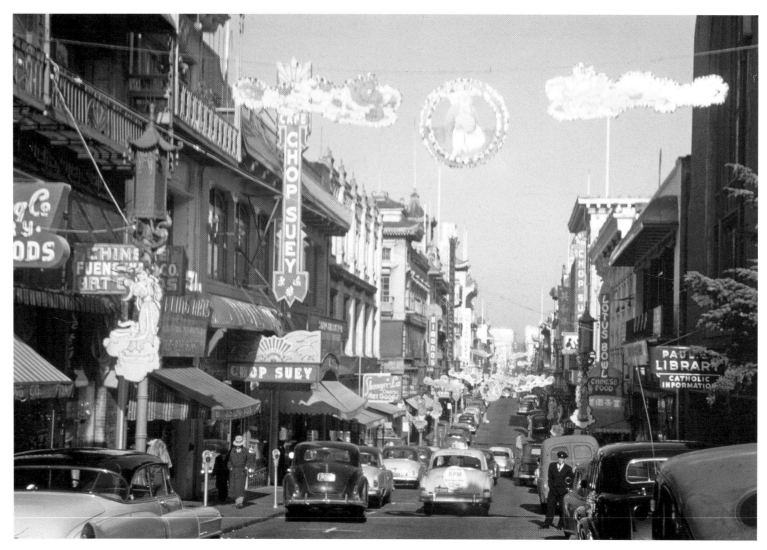

Chinatown is pictured here in the fifties, looking north on Grant Avenue from California Street. San Francisco is home to North America's oldest and largest Chinatown (circa 1850s), bordered on the west by Nob Hill, on the east by the financial district, and on the north by North Beach. Tens of thousands of Chinese began to immigrate to San Francisco during the Gold Rush, seeking prosperity in the gold mines, and later working on building of the Transcontinental Railroad. Grant Street is Chinatown's main thoroughfare, named in honor of the 18th U.S. president, Ulysses S. Grant. After the start of the Gold Rush and the establishment of Chinatown, Dupont Street, as it was then known, became the district's most important street. It quickly earned a seamy reputation for the opium dens, brothels, and sing-sing girls on the street along the notorious Barbary Coast.

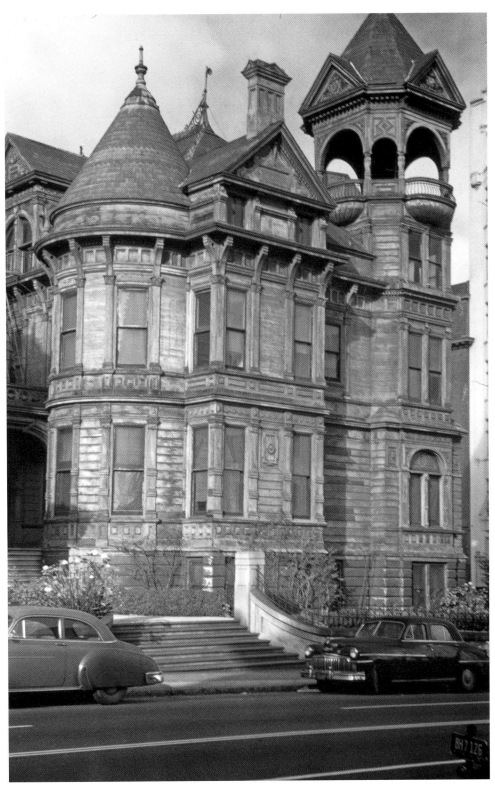

In the decade following World War II, some older homes in San Francisco that had fallen into disrepair were torn down and replaced by more modern housing. Pictured here on January 25, 1953, is an old frame house at the southwest corner of Franklin and Jackson streets, roughly a year before it was razed. Mayor George Christopher and Justin Herman, head of the Redevelopment Agency, began a campaign to tear down "blighted" areas of the city, mostly working-class neighborhoods. Huge tracts of land in the Fillmore, Western Addition, and other neighborhoods were razed, and new buildings and districts were erected, including Japantown and the produce district in Telegraph Hill, which moved to Alemany Boulevard. Many blacks were forced to move to housing projects in Hunter's Point and across the Bay in Oakland. This massive urban renewal project also led to the building of Yerba Buena Gardens, the unpopular Embarcadero Freeway, and Embarcadero Center.

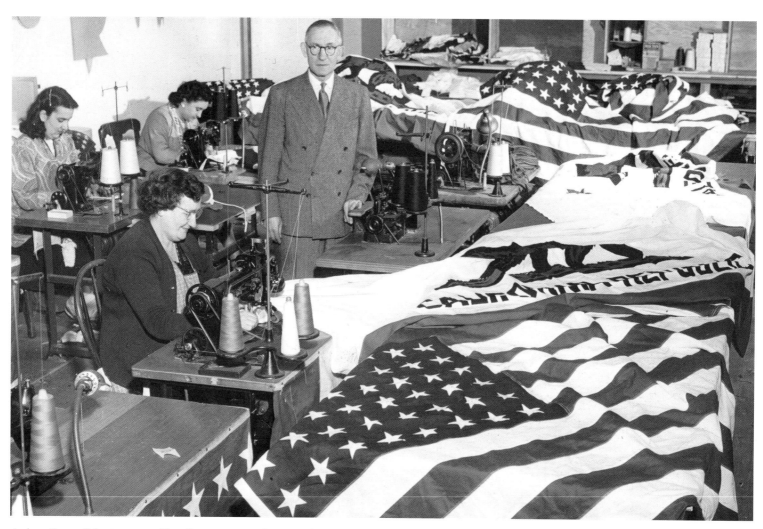

Arthur Ganz of the Argonaut Flag Corporation is shown in the 1950s with a seamstress sewing flags at Argonaut's new plant at 147 10th Street. Argonaut had a flag-manufacturing plant that was the most modern in the country, selling its products mostly to schools, steamship companies, and state and local governments in the West.

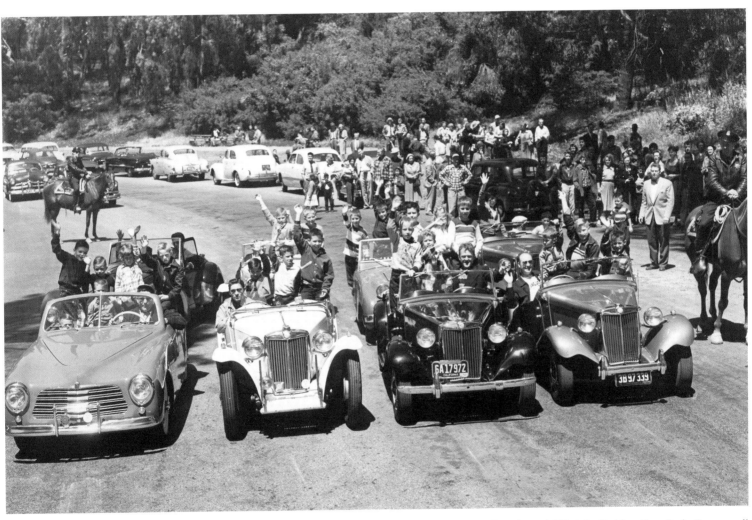

Children are pictured here on May 19, 1954, riding in imported sports cars during Guardsmen's Week in Golden Gate Park. For a small contribution to the Guardsmen Fund, boys and girls from the area had the thrill of riding in a sports car. The fund raised enough money to send 5,000 needy boys and girls to summer camp that year. With more than 1,000 acres open to the public, making it 20 percent larger than New York's Central Park, Golden Gate Park is treasured by San Franciscans. Thirteen million people visit the park annually, making it the third most popular park in the country. Looking at Golden Gate Park's lush vegetation and waterfalls, few would believe that until the 1870s, the land was entirely sand dunes. Field engineer William Hammond Hall prepared a topographic map and plan for the park site in 1870, and Hall and his assistant John McLaren refined the plan and stabilized the sand dunes by planting trees.

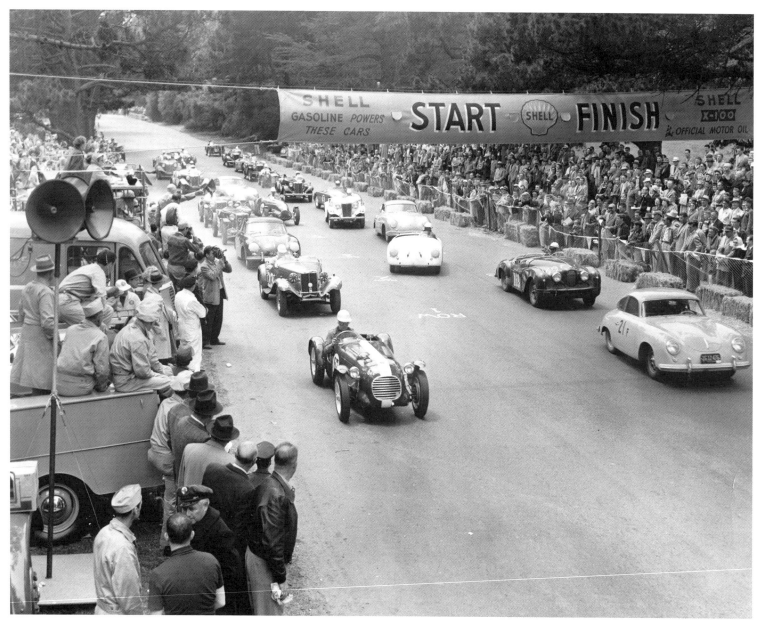

Sports cars roar away from the starting point of the Mayor's Trophy Race at Golden Gate Park in 1953. A crowd as big as 115,000 watched the annual event. Dion Holm, City Attorney, was the starter, and Hollywood's Ken Miller, driving an MG Special, won the race.

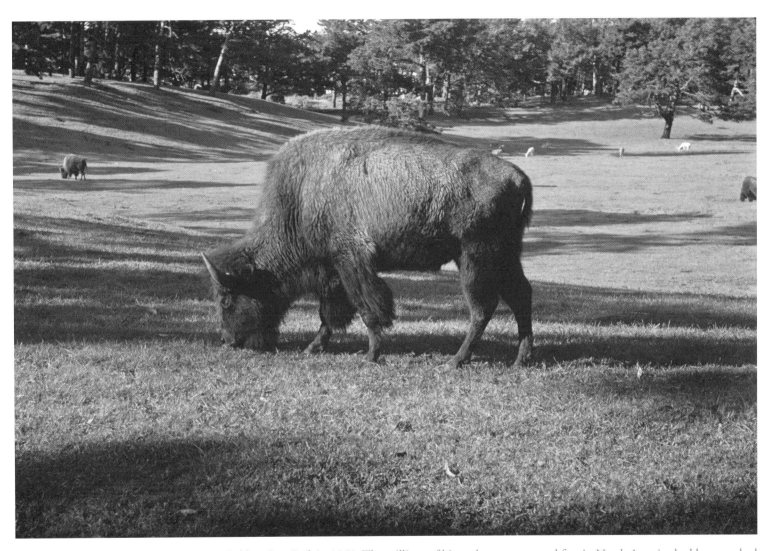

A bison grazes in Golden Gate Park in 1953. The millions of bison that once roamed free in North America had been pushed to near extinction by the late nineteenth century. The Park Commission has kept bison in the park since 1891, where for over a century they have resided in the Bison Paddock near 34th and Fulton streets. Golden Gate Park successfully bred them in captivity at a time in the late nineteenth century when the wild population reached its lowest level in history.

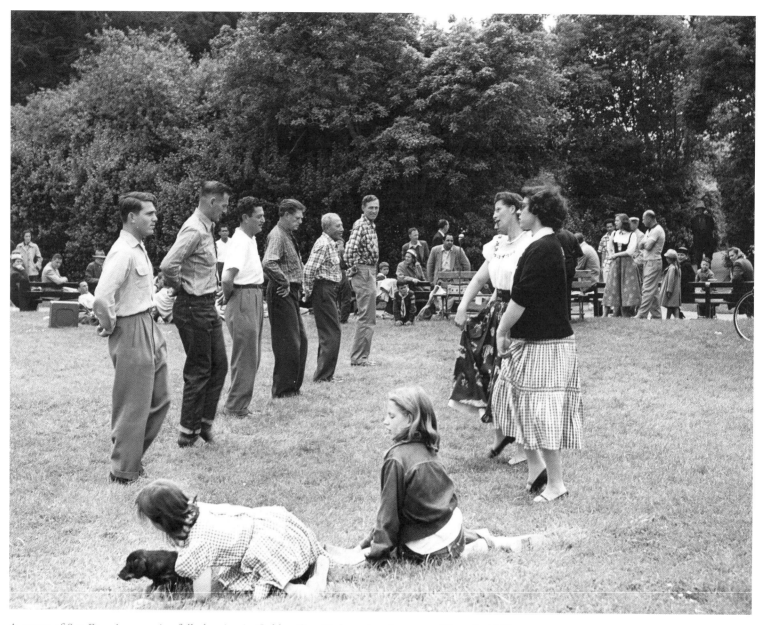

A group of San Franciscans enjoy folk dancing in Golden Gate Park on the afternoon of June 2, 1953.

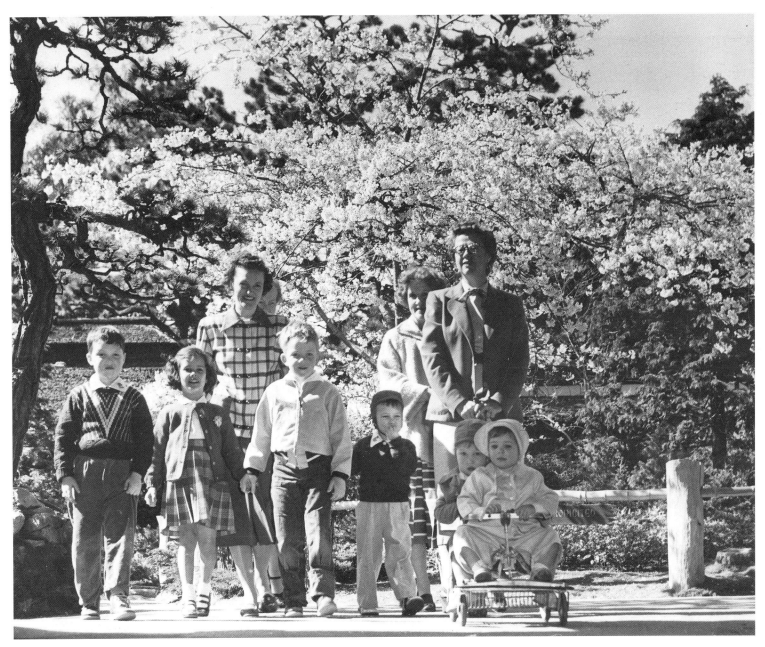

Tourists visit the Japanese Tea Garden in Golden Gate Park on April 2, 1954. Built originally as the Japanese Village for the California Midwinter International Exposition of 1894, the Japanese Tea Garden was converted to a permanent exhibit at the suggestion of Japanese immigrant and gardener, Makoto Hagiwara. Hagiwara and later his family became the garden caretakers until 1942, when they were forced to evacuate to an internment camp as a result of Executive Order 9066. During the war years, the garden was renamed the Oriental Tea Garden but became known as the Japanese Tea Garden in 1952. Today, the tranquil Japanese Tea Garden remains a popular destination for looking at the flowering cherry blossoms and other Japanese plants, beautiful birds, exotic koi swimming in the ponds, and Asian sculptures. Visitors to the garden's tea house can stop to sip a cup of green tea and sample delicious Japanese confections.

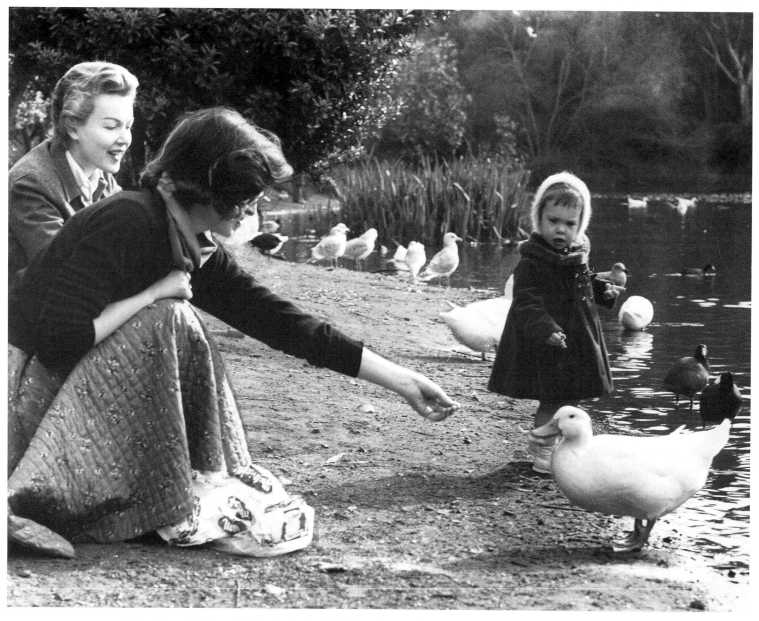

Mrs. Henry Timbrook feeds the ducks in Golden Gate Park on February 2, 1955, while her young daughter watches. Golden Gate Park and its numerous ponds and lakes, including Stow Lake, Mallard Lake, Metson Lake, Chain of Lakes, North Lake, Spreckels Lake, Lloyd Lake, and Elk Glen Lake, provide a natural habitat throughout the year for dozens of varieties of ducks such as mallards, American and Eurasian wigeons, ruddy ducks, lesser scaup, ring-necked ducks, buffleheads, green-winged ducks, cinnamon teals, tufted ducks, green-winged teals, gadwalls, northern shovelers, and common goldeneyes.

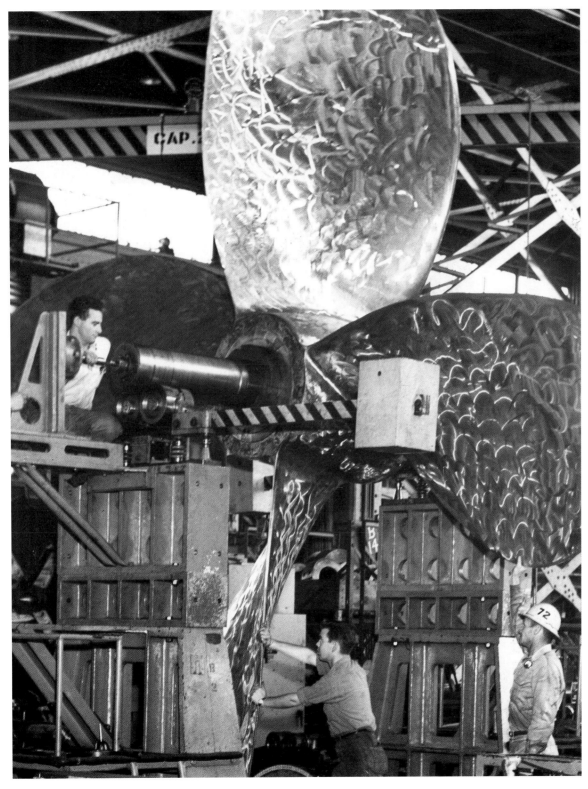

Machinists balance a 20-ton propeller in a shipyard on June 25, 1953, in Hunters Point. Built around 1870 and named after a wealthy landowner, Hunters Point was the site of a commercial shipyard and the West Coast's first drydocks. During both world wars, the U.S. Navy used the drydocks as a shipyard and naval base. Between World War II and 1974, the 500-acre shipyard employed 17,000 people at its peak. The Hunters Point area also became residential, with nearly 100 percent of the occupants being African-Americans who came from the south in the Second Great Migration during World War II to work in the Bay Area's naval shipyards. After the naval base closed in the postwar years, Hunters Point went into massive economic decline, but has been in the process of gentrification since the late 1990s.

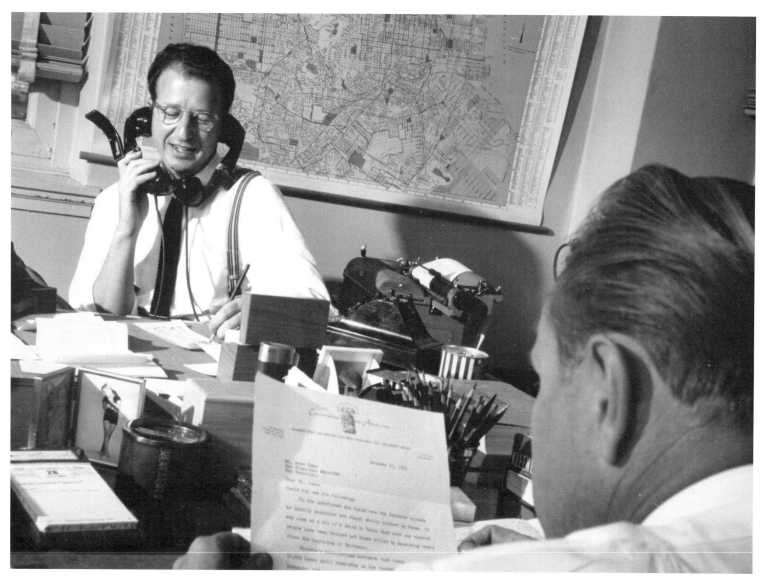

Pulitzer Prize–winning San Francisco columnist Herb Caen (April 3, 1916 – February 1, 1997) is pictured here on October 28, 1953, talking on the phone at his desk. Affectionately nicknamed "Mr. San Francisco" for his deep knowledge and passion for his adopted city, Caen wrote a column for the *San Francisco Chronicle* from the late 1930s until his death in 1997, except for an eight-year stint in the 1950s next door at the *Examiner*. Caen was known for his series of essays entitled *Baghdad-by-the-Bay* and his 1953 book, *Don't Call It Frisco*. Caen is attributed with coining the word "Beatnik" in an April 2, 1958, column on the new cultural phenomenon happening in San Francisco's North Beach, as well as popularizing the term "hippie" during the Summer of Love in the Haight-Ashbury neighborhood in 1967. When Caen died in 1997, his funeral was one of the most well-attended events in San Francisco history.

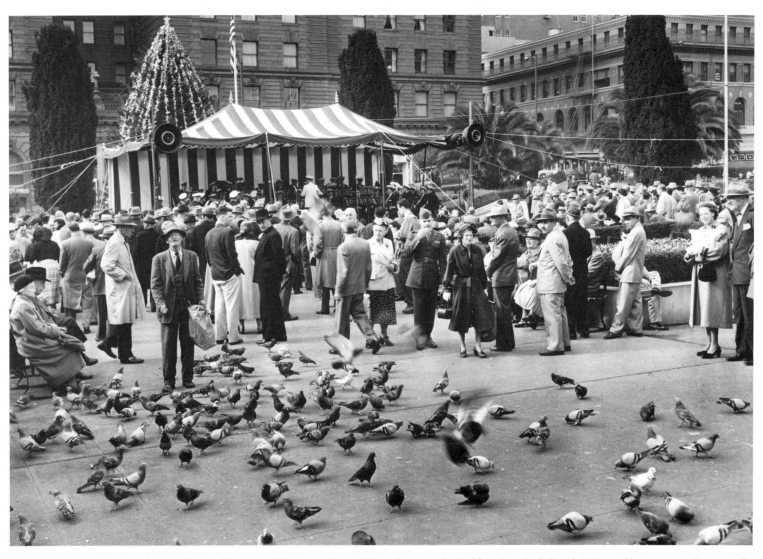

People gather in Union Square on Christmas Eve, 1953 to listen to the Golden Gate Park Band. "Merry Christmas to all, especially the pigeons" is inscribed on the original photo. Thousands of pigeons that fly around Union Square are known as San Francisco's "flying rats." Officials in San Francisco regularly look for ways to control the pigeon birthrate.

The iconic blond bombshell Marilyn Monroe, and Joe DiMaggio, New York Yankee baseball legend who grew up in San Francisco, are shown at San Francisco City Hall immediately after getting married on January 14, 1954. Monroe filed for divorce 274 days later, but after her untimely death in 1962, DiMaggio arranged her funeral and had roses delivered to her crypt three times a week for the following two decades.

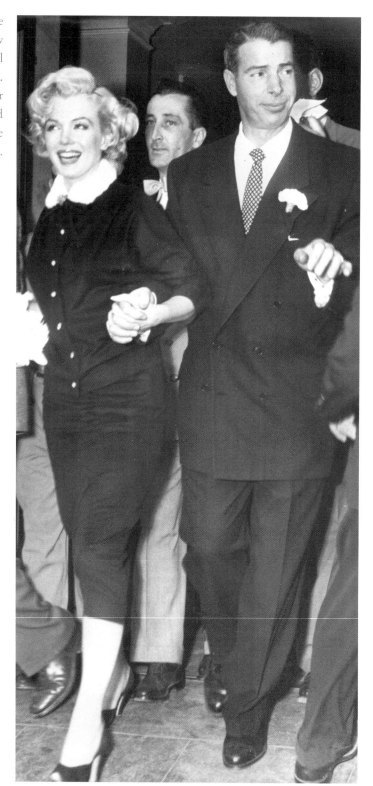

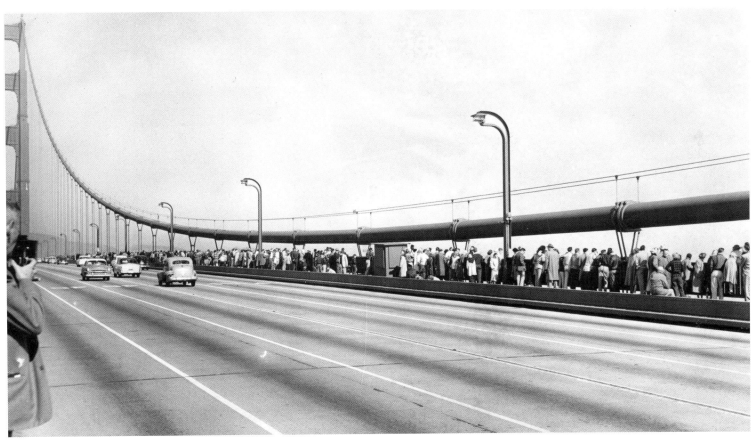

Pedestrians on the Golden Gate Bridge watch the Pacific Fleet enter San Francisco Bay on February 20, 1954. Though still wintertime, this was a wonderful spring-like day, and people flocked to the city's beaches and Land's End. Chief Engineer Joseph Strauss conceived of the majestic marvel of engineering, which spans 1.7 miles and connects San Francisco to Marin County. When this depression-era public works project was completed in 1937, the Golden Gate Bridge became the largest suspension bridge in the world. Painted the bold shade of "international orange" to stand out in the fog, the famous bridge is the only road exiting San Francisco to the North. Every day, 100,000 vehicles cross the Golden Gate Bridge, the most photographed bridge in the world.

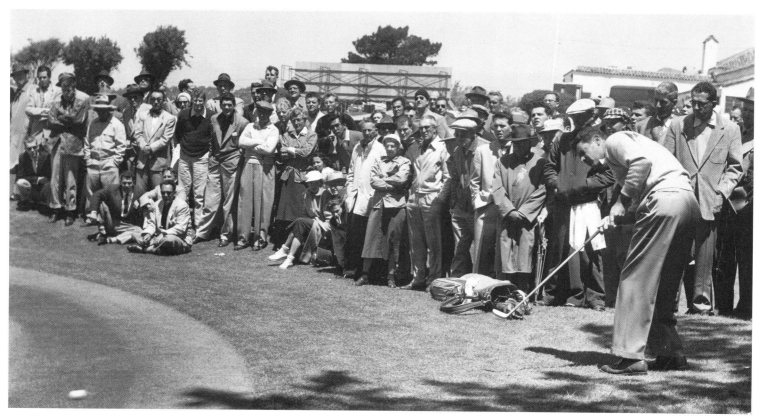

A crowd watches Dr. Cary Middlecoff competing in the San Francisco Open at Lake Merced Golf and Country Club on May 1, 1954. The nonpracticing dentist, one of the top traveling pros in the forties and fifties, is shown here making a chip shot on the first green against a background of windswept spectators. Named as the University of Mississippi's first golf All-American in 1939, Middlecoff won 40 professional tournaments, including the 1955 Masters and U.S. Open titles in 1949 and 1956, and was inducted into the World Golf Hall of Fame in 1986.

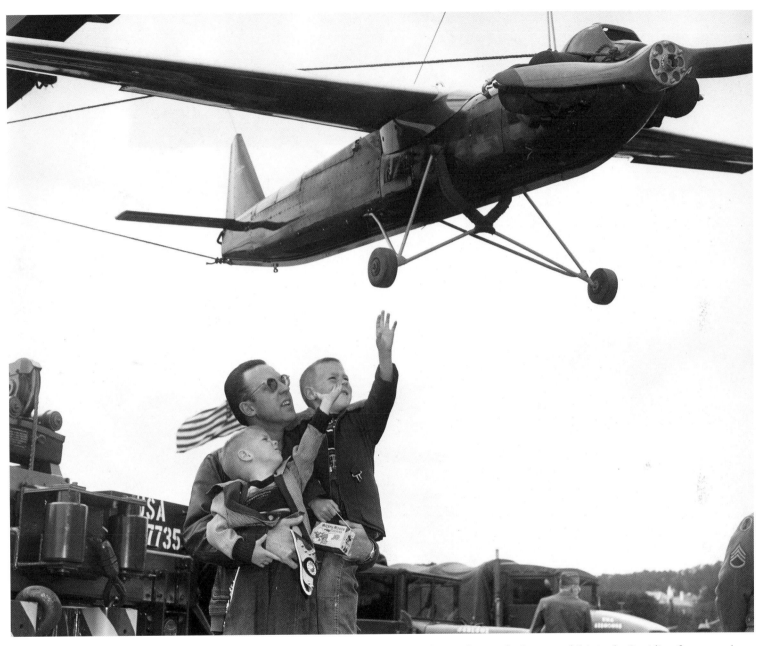

On May 15, 1954, Lieutenant Noel Taylor and his sons Stephen and Roger look at an exhibit in the Presidio of a target plane, one of the Sixth Army's many displays on Armed Forces Day when thousands of Bay Area residents visited military installations to see big ships, planes, and guns. A Spanish Imperial outpost from 1776-1821 and subsequently owned by Mexico until 1846, the Presidio became the most important army headquarters on the Pacific Coast from 1846 until 1994. Throughout the Cold War, it became a center of Nike missile development. Between the Korean War and 1972, Nike anti-aircraft defenses were based all around the area. By the 1970s, newer defense technology replaced the obsolete missiles, and all of the Nike facilities in the Bay Area except one were dismantled. The Presidio has been part of the Golden Gate National Recreation Area since 1994.

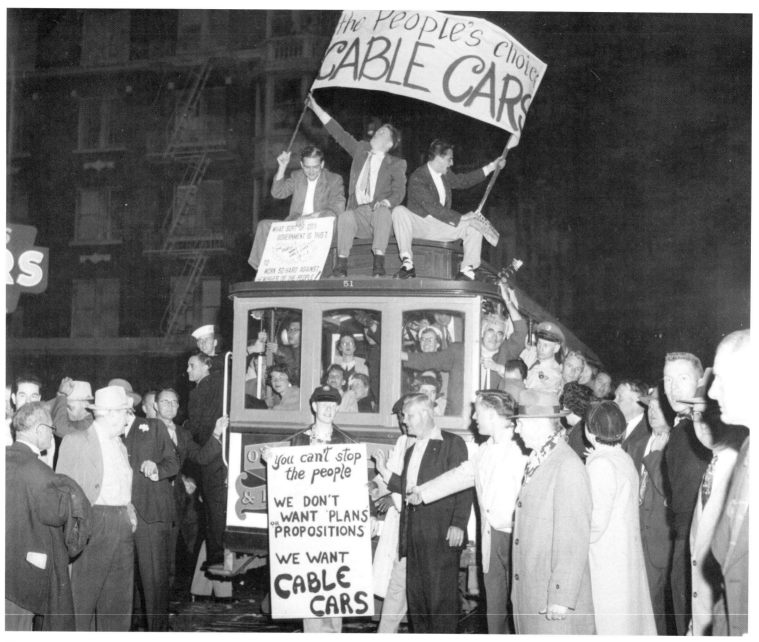

Here on May 17, 1954, is Old No. 51, a famed cable car on the O'Farrell, Jones & Hyde line, about to be retired from service. A crowd of people protested the replacement of O'Farrell, Jones & Hyde cable cars with gas buses and said farewell forever. Old No. 51 was the last car on the run and did not give up without a struggle, getting into the cable car barn at California and Hyde with the biggest and loudest load of passengers she ever carried. San Francisco's very first cable car ran down Clay Street on August 2, 1873. The California Street cable car continued to operate independently until 1952, when it became part of Muni. Six of the retired cable cars from the O'Farrell, Jones & Hyde line were taken on by the California Street line, including Old No. 51, which climbs up and down Nob Hill to this day. In 1964, the cable car system was designated a National Historic Landmark.

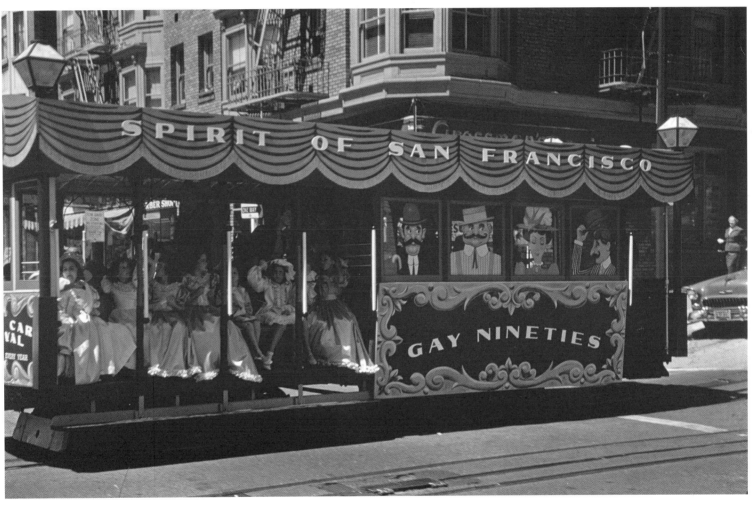

A decorated cable car is pictured here at the Cable Car Festival on April 23, 1955. The car is commemorating the "Gay 90s" in San Francisco, referring to the city's joyful 1890s, a rather ironic description considering that San Francisco would become a mecca for homosexuals a few decades after this photo was taken.

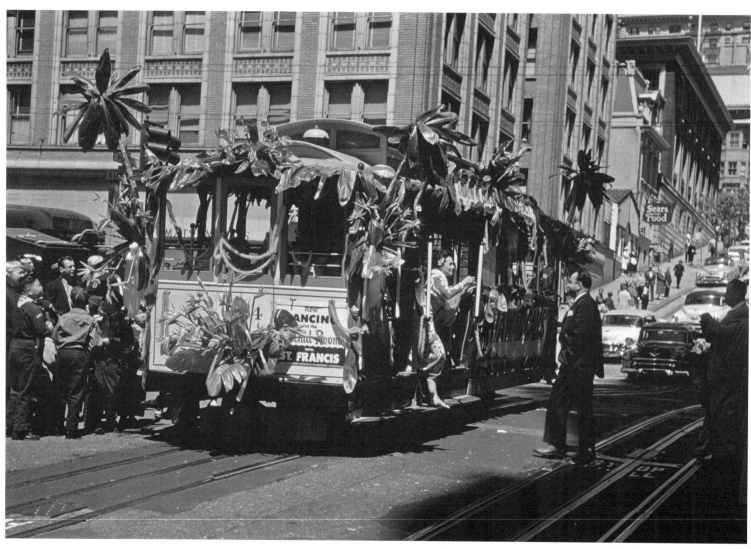

The Powell Street cable car is shown here in festive Hawaiian-themed decor during the Cable Car Festival in 1955.

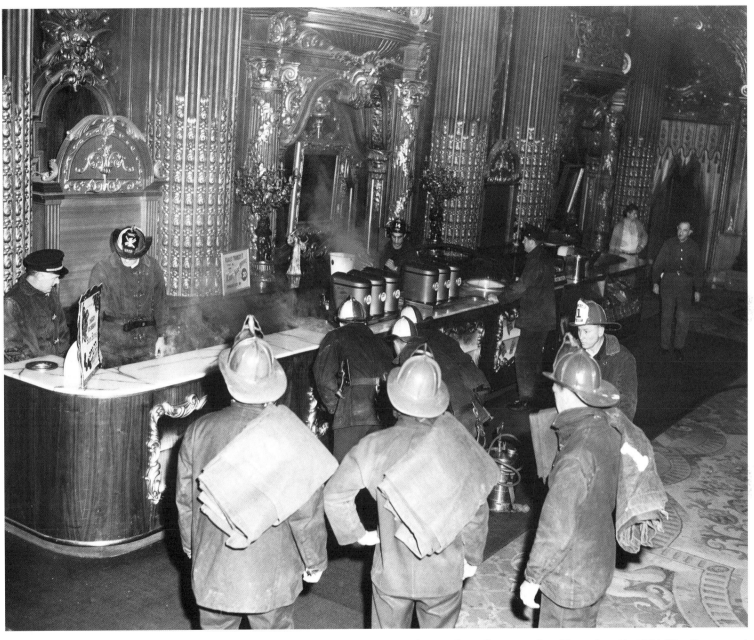

Firemen are seen in the snack bar of the famous Fox Theatre after a fire erupted on November 10, 1954. The Fox opened in 1929 at 1350 Market Street, between 9th and 10th streets, and at the height of its popularity, the 4,651-seat theater was considered the most ornate in the country. It was demolished in the 1960s and replaced with a modern skyscraper. Various artifacts from the Fox Theatre occasionally turn up around the Bay Area. The original curtain from the Fox is still in use today at the Grand Lake Theatre in Oakland.

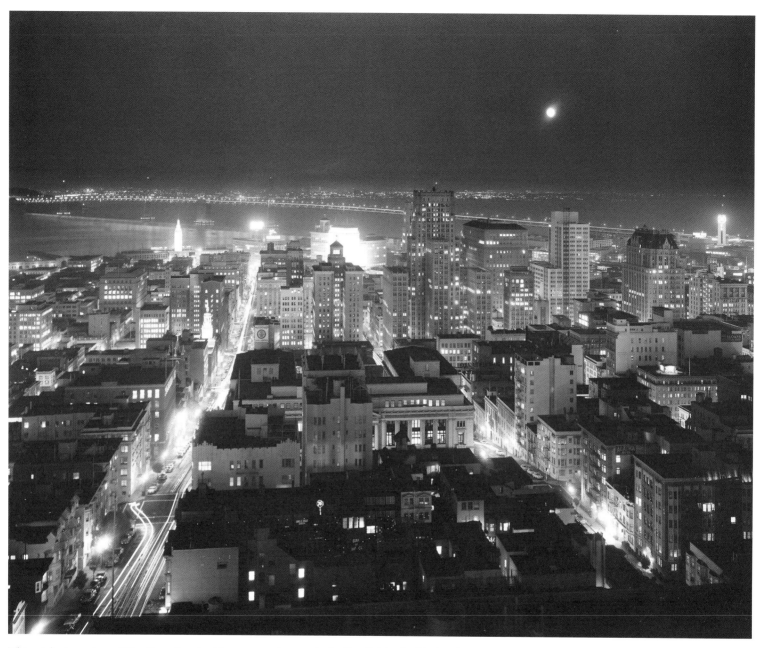

This nighttime view of San Francisco looking eastward towards the Bay Bridge highlights the city's skyline in 1955. Missing at the time from the San Francisco skyline were the Bank of America building on California Street, the Transamerica Pyramid, the Embarcadero Center buildings, and many other downtown and financial district high-rises that were not built until the 1970s.

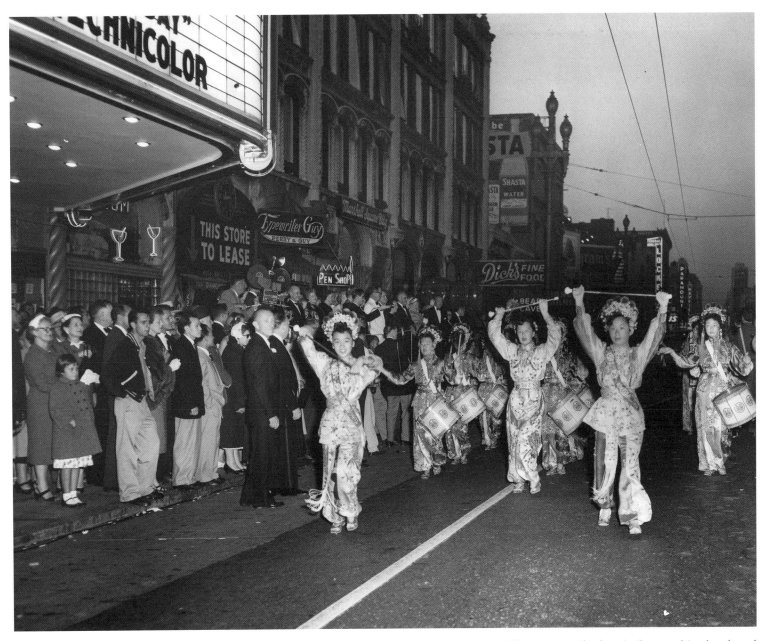

A Chinese drum corps is shown marching in a parade in San Francisco in 1955. This group and other similar marching bands and drum teams marched in San Francisco's annual Chinese New Year's Parade and other parades in the Bay Area and across the state.

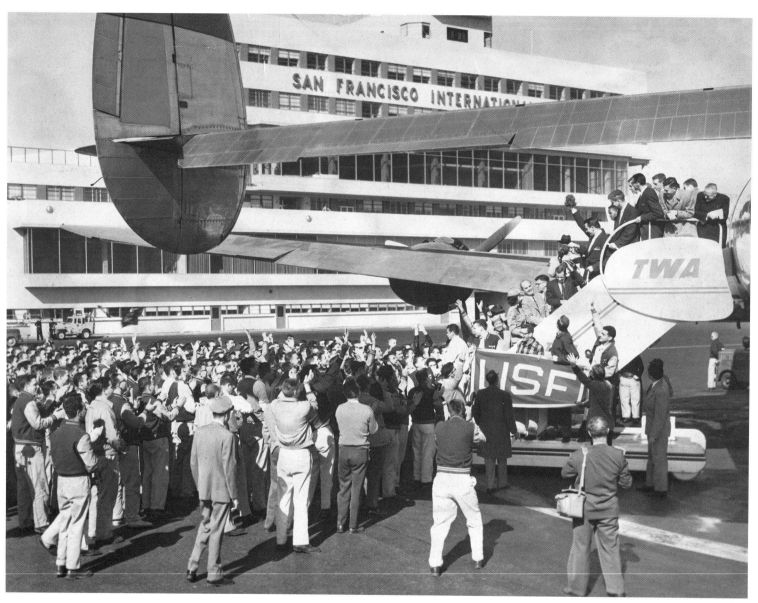

On March 16, 1955, several hundred University of San Francisco students send off the school's basketball team at San Francisco International Airport as they board a TWA plane for Kansas City to play Colorado in the Final Four of the NCAA tournament. The Dons won 62-50 and went on to win the national championship. The Dons would win the national championship once again in 1956, with both the 1955 and 1956 teams powered by future Hall-of-Fame center Bill Russell. They have not celebrated a national title since.

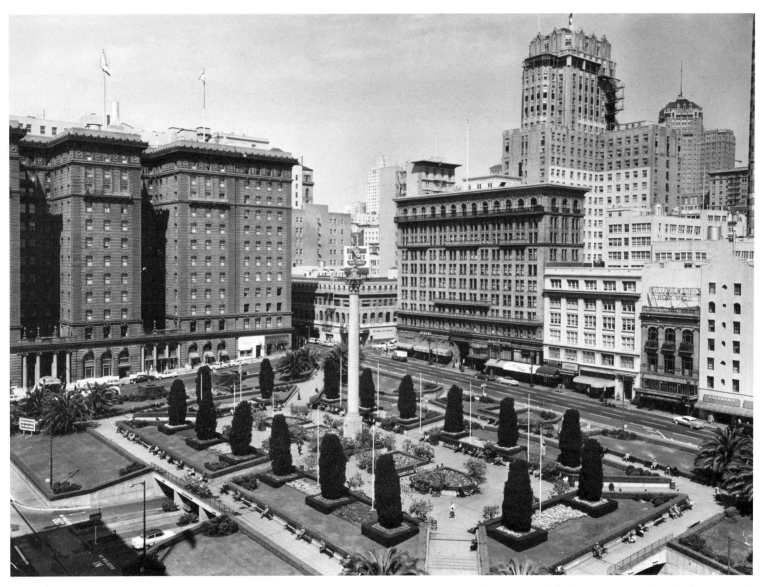

Union Square appears on April 18, 1955, with the Dewey Monument at the center and the St. Francis Hotel in the background. The St. Francis, modeled after Europe's grandest hotels, opened on March 21, 1904, and prided itself as one of the most modern hotels in the country. It immediately became a gathering point for the literary, artistic, and social life of the city. For over a century, people have planned to "meet at the clock" in the lobby, which has become emblematic of the hotel's endurance. When the 1906 Earthquake and fires reduced most of Union Square to ruins, the St. Francis was one of the only buildings to remain standing in the area. Actor John Barrymore stayed at the St. Francis the night of the earthquake, and in 1921, this was the site of the infamous scandal involving silent-film star "Fatty" Arbuckle and starlet Virginia Rappe.

St. Ignatius Church, pictured here on July 15, 1955, is actually the fifth church of that name to be built in San Francisco. Completed in 1914, the current church is built in Italian Renaissance and Baroque style and is located on the campus of the University of San Francisco. The church's hilltop location and its two spires and dome make St. Ignatius Church a prominent San Francisco landmark.

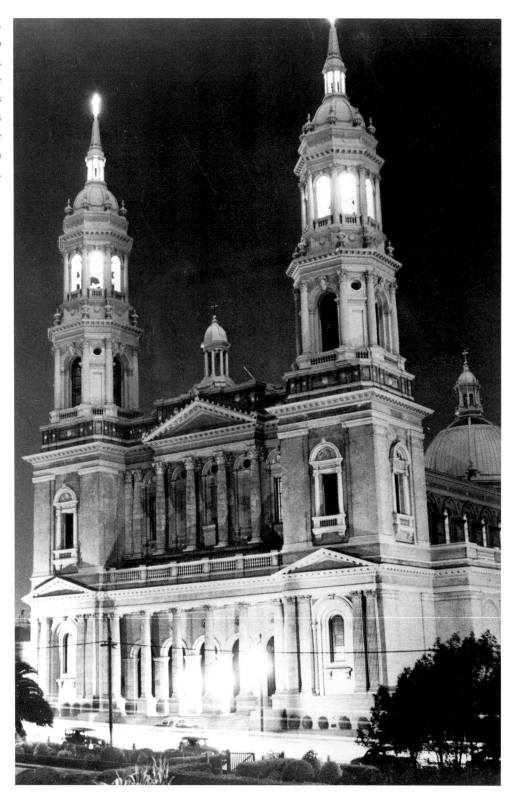

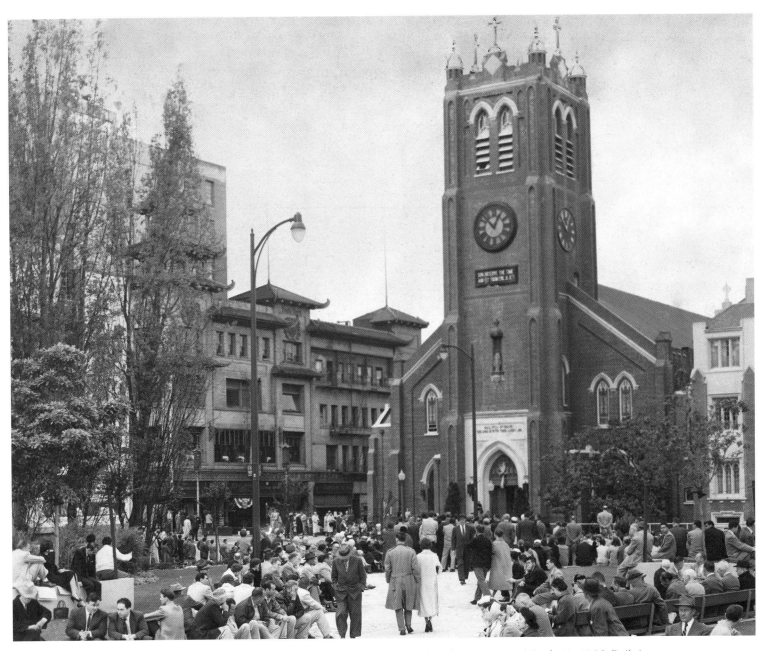

Worshippers enter Old St. Mary's Church on California and Grant streets for Good Friday services on March 31, 1956. Built in 1853 and 1854 from imported Chinese granite and New England bricks—scarce materials in Gold Rush San Francisco—Old St. Mary's was San Francisco's biggest building for a time. Brothels and other "un-Christian" activities surrounded the church into the twentieth century. Church leaders had hoped that the biblical quote, "Son, Observe the Time and Fly from Evil," prominently displayed on the front of the church clock, would resonate with neighborhood sinners, especially the prostitutes in the brothel located directly across the street, at eye level with the clock tower.

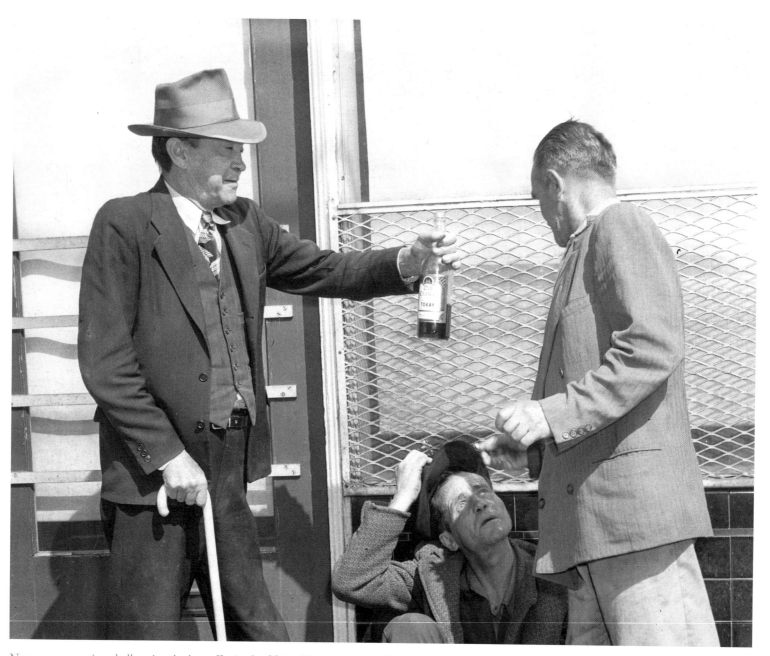

Not everyone enjoyed all society had to offer in the fifties. Twenty percent of Americans lived in poverty, and as people moved out of the cities to rich suburbs, the inner cities were declining. Like most major American cities, San Francisco has several areas that could be thought of as "Skid Row": the Tenderloin, South of Market, and in parts of Bayview-Hunters Point. Streets in these areas are lined with transient hotels, cheap restaurants, liquor and tobacco stores, pawn shops, and stores with "bargain" merchandise. In this May 30, 1956, photograph on "Skid Row," a group of people down on their luck loiter and share a bottle of liquor. Gentrification of the entire South of Market area began in the seventies as buildings were torn out, making room for huge modern buildings, including the Moscone Convention Center, the Marriott Hotel, and the San Francisco Museum of Modern Art.

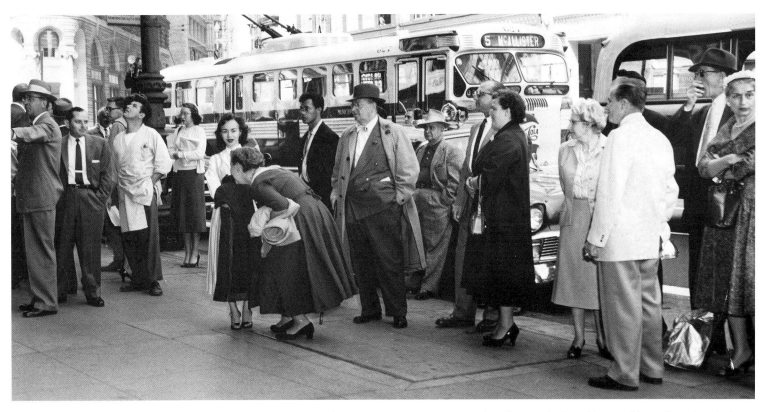

On June 20, 1956, a group of evacuees wait on a Market Street sidewalk outside the Balboa Building after a bomb threat was called in. They safely returned to the building after the San Francisco Police determined that no bomb was there.

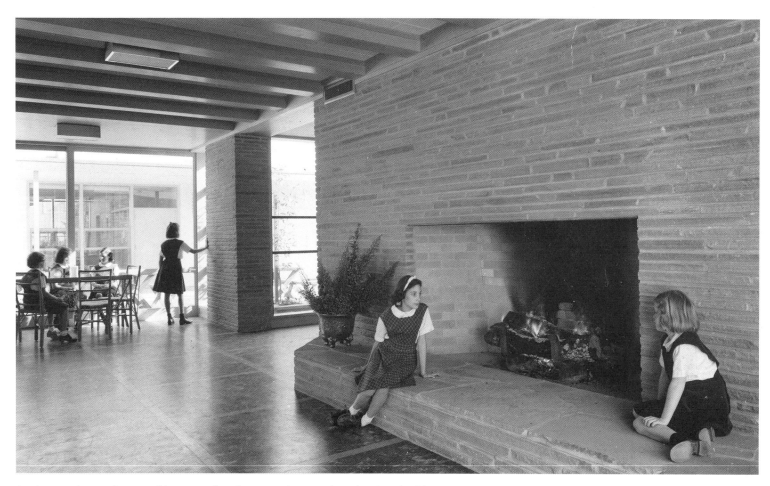

Students gather in the assembly room of Katherine Delmar Burke School in the fifties. Originally Miss Burke's School, it was opened in 1908 by Katherine Delmar Burke as an independent all-girls school. It moved to its Sea Cliff site at 195 32nd Avenue at California Street in the 1930s, where the campus remains today. The school used to go from kindergarten through high school, but in 1975 the high school, located in Pacific Heights, was discontinued, and the building was sold to the newly created San Francisco University High School. This fireplace was designed in the assembly room to make the girls feel more at home. Today, Burke's is one of three all-girls schools in the city and among the top-rated private schools in the Bay Area.

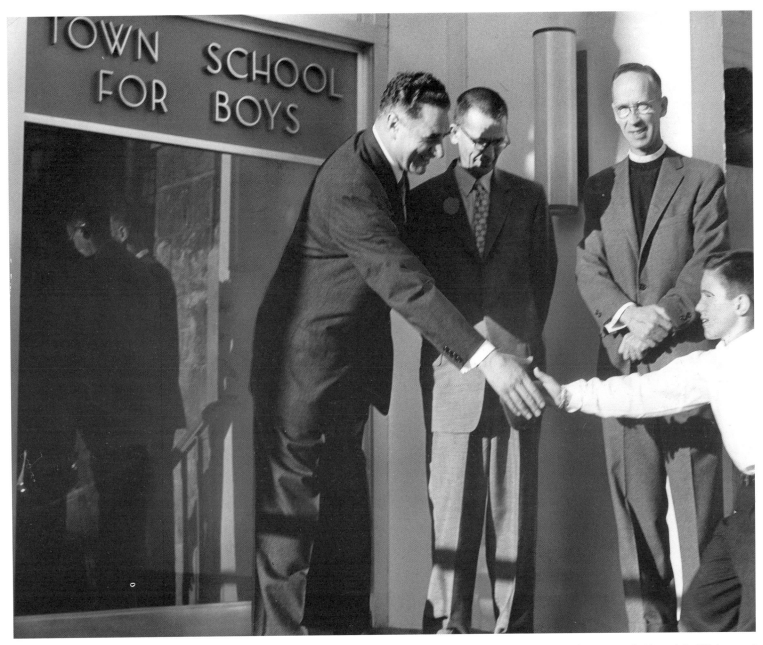

San Francisco mayor George Christopher, Town School for Boys headmaster Dr. Edwin Rich, Reverend Edward A. Wicher, and Pat McBaine, the 12-year-old student body president of Town School, are pictured here during the dedication ceremony of the new Town School building on September 28, 1956, at its current location on Jackson Street in Pacific Heights. Town was founded in 1939 by the parents of students from Damon School, a private school that had closed. At the time this photo was taken, the school was the only all-boys elementary school in the city and had an enrollment of 300 students. Today, Town School is one of the top private schools in the Bay Area.

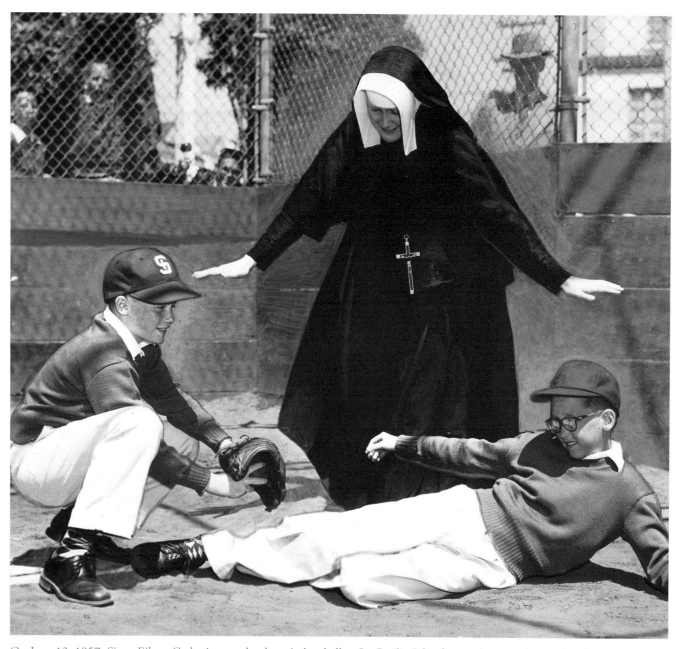

On June 13, 1957, Sister Eileen Catherine coaches boys in baseball at St. Cecilia School, a coeducational Catholic elementary school founded in 1930 during the Depression and located at 660 Vicente Street. Father John Harnett, the second pastor of St. Cecilia, built the grammar school for $80,000, and the Sisters of the Holy Names of Jesus and Mary were invited to staff the new school when it opened.

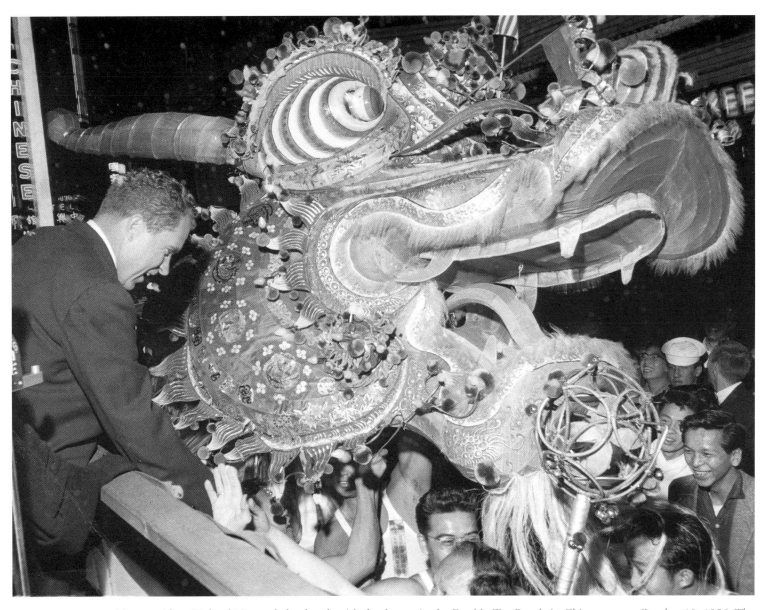

Vice-president Richard Nixon shakes hands with the dragon in the Double-Ten Parade in Chinatown on October 10, 1956. The parade celebrates the anniversary of the Chinese Republicans taking control of China from Emperor Ching in 1911. Double-Ten Day is celebrated in China, Taiwan, Hong Kong, and in overseas Chinese communities around the world. Nixon's visit to San Francisco occurred a few months after the August 1956 Republican National Convention was held in San Francisco, when President Dwight D. Eisenhower and Vice-president Nixon were renominated as the party's candidates for the 1956 presidential election. During the campaign, Nixon and his wife made many appearances around the country before being re-elected in November.

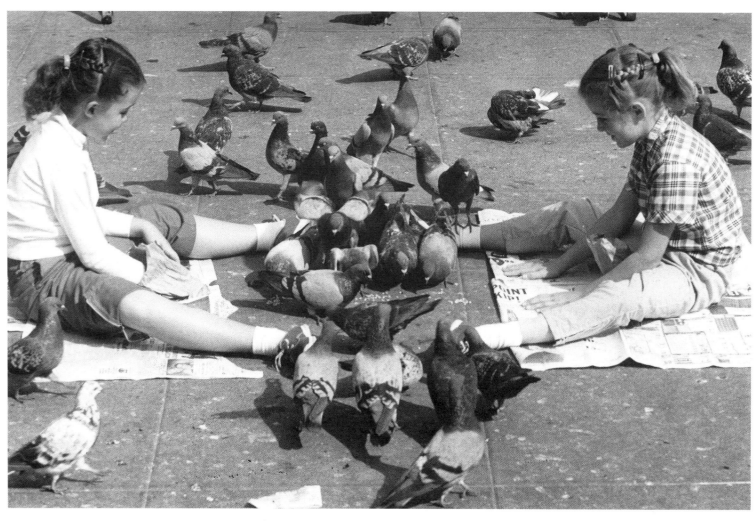

Two young girls from Des Moines, Iowa, drop breadcrumbs in Union Square on September 11, 1957, and they are immediately surrounded by a flock of hungry pigeons.

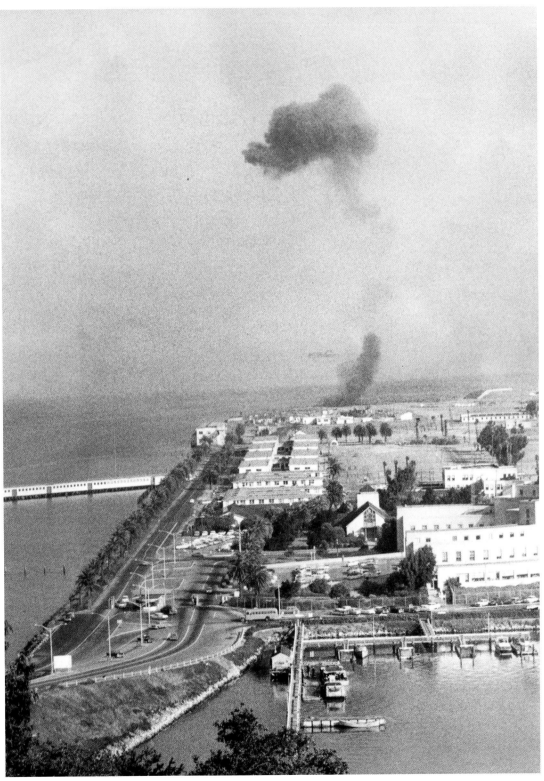

On September 19, 1957, the U.S. Navy exploded a dummy atomic bomb on Treasure Island shot from Yerba Buena Island. Treasure Island was created for the Golden Gate International Exposition in 1939 from landfill dredged from San Francisco Bay. Named after the novel *Treasure Island* by Robert Louis Stevenson, who lived in San Francisco from 1879 to 1880, the island was supposed to be turned into an airport after the Exposition, but Mills Field on the San Francisco Peninsula was used instead. During World War II, Treasure Island became part of the Treasure Island Naval Base. Decommissioned in 1996, the island is now part of San Francisco but is still owned by the Navy. While the island is currently used for rental housing and occasional television filming, debates are continually waged about its long-term purpose.

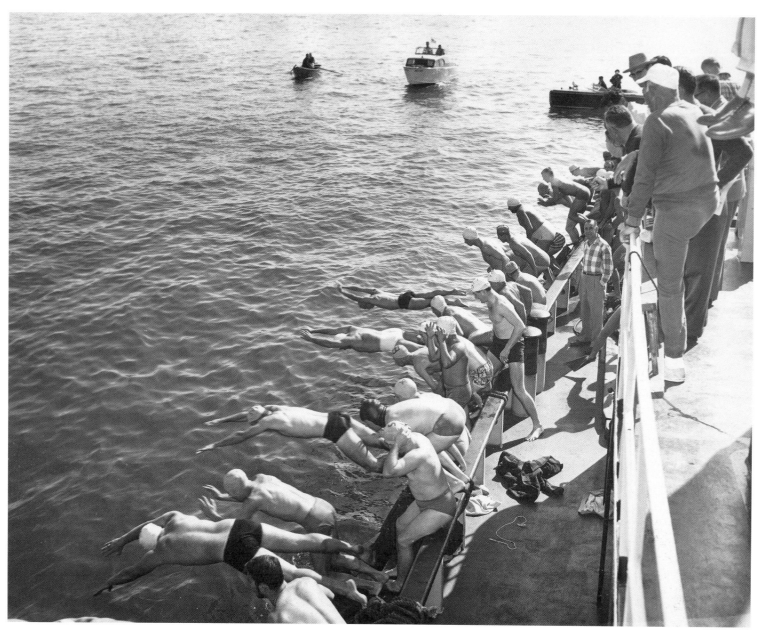

Swimmers from the Dolphin Club race in San Francisco Bay on October 2, 1957. In 1877, John Wieland and his brothers, along with the Kehrlein brothers, all immigrants from Germany, founded the male-only Dolphin Club in San Francisco for swimming and rowing. Membership was limited originally to 25 men. It was not until 1976 that women were allowed to join the Dolphin Club. From 1957, when this photograph was taken, to this day, club members swim year-round in the waters of Aquatic Park, where temperatures vary from about 50 degrees Fahrenheit in January to about 61 degrees Fahrenheit in September.

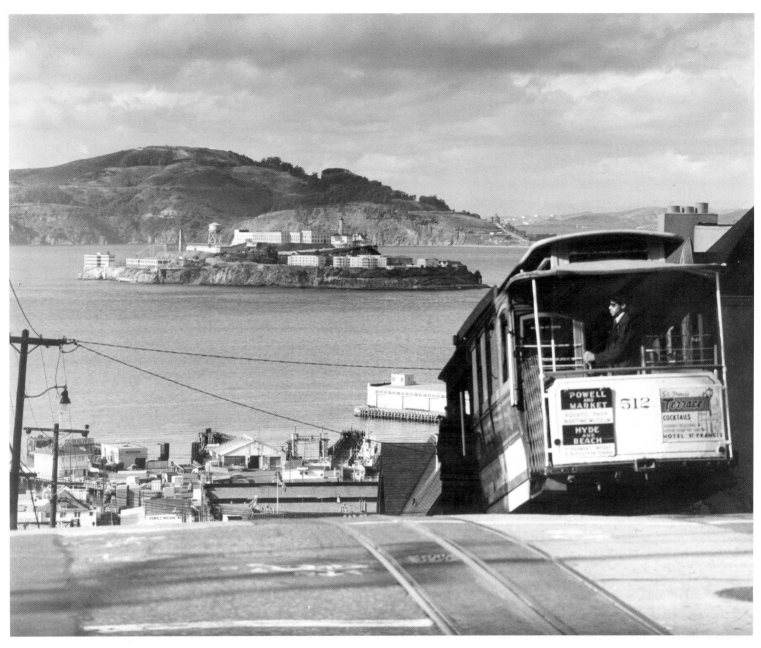

Alcatraz is seen from the top of Hyde Street Hill on October 4, 1957. Spanish explorer Juan Miguel de Ayala, the first European to discover the island, referred to it in the 1770s as La Isla de los Alcatraces, meaning Pelican Island. In the 1850s, the Coast Guard was contracted to build the West's first lighthouse on the island. Alcatraz Island became an official military prison on August 27, 1861, and was used during the Civil War to imprison those whose loyalty to the Union was dubious, foreshadowing the island's future as a prison.

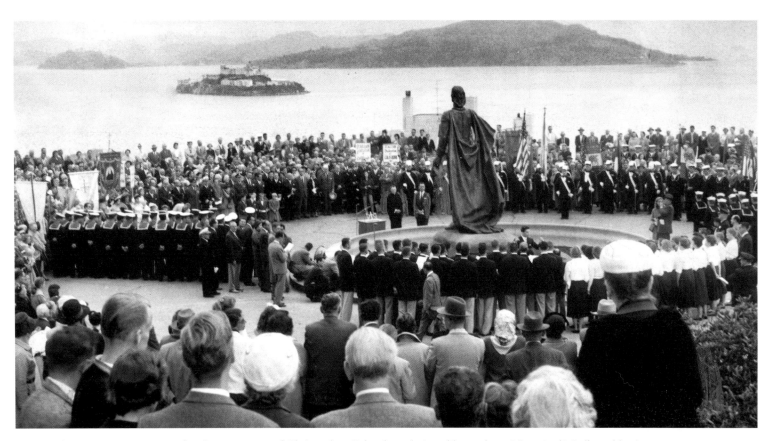

On October 12, 1957, a new 12-foot bronze statue of Christopher Columbus, designed by sculptor Vittorio di Colbertaldo, is dedicated at the top of Telegraph Hill in front of Coit Tower. The statue, which depicts Columbus gazing west towards the Golden Gate, was funded by Italy and the city of San Francisco. Coit Tower was built in 1933 at the bequest of Lillian Hitchcock Coit for beautification of the city of San Francisco.

A work crew begins to tear up the Washington-Jackson cable car tracks on Steiner Street before the work was halted by a court order, as shown in this photo taken on February 12, 1957. This cable car line was eventually merged with two others, resulting in the current Powell-Hyde line.

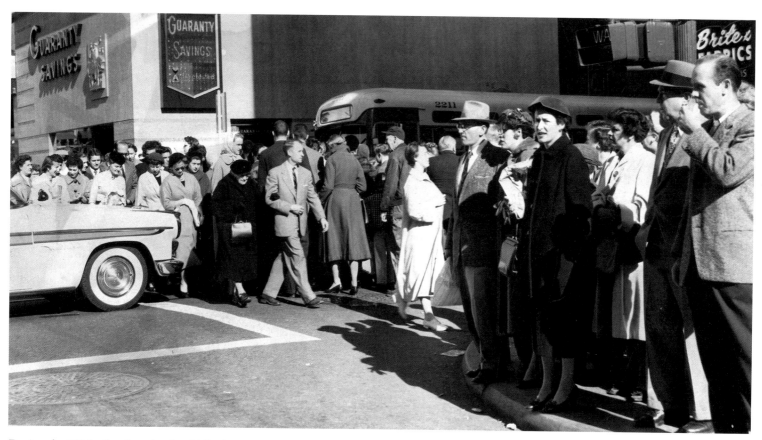

During the 1950s, San Francisco's middle class was growing, and people had more disposable income than they had had in decades. Advertisements suggested that buying certain products or clothes would result in happiness. Showing pictures of the ideal home and the perfect, well-dressed family surrounded by all of the modern conveniences encouraged people to shop more, and the busiest time for shopping was the month before Christmas. In this photograph taken on Friday, November 29, 1957, a crowd of San Franciscans cross the street at the intersection of Geary and Stockton streets at Union Square, a favorite place to shop in downtown San Francisco at the beginning of the holiday shopping season.

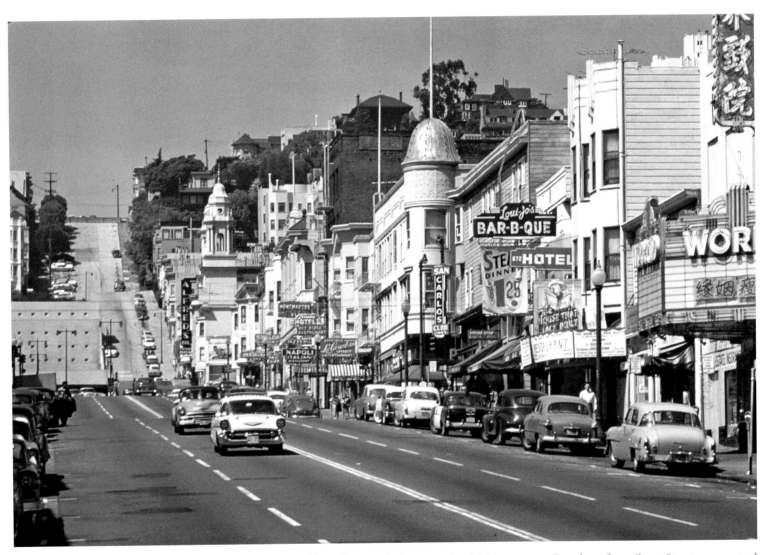

The Broadway Tunnel, seen in this fifties photograph that was taken looking west on Broadway from Grant Street, was opened in 1952. The tunnel passes underneath Russian Hill and provides a quick route for cars traveling between Chinatown and North Beach in the east and Russian Hill and Van Ness Avenue in the west. Seen on the right of Broadway before the entrance to the tunnel are Loui-Jo's Bar-B-Que and the San Carlos Club.

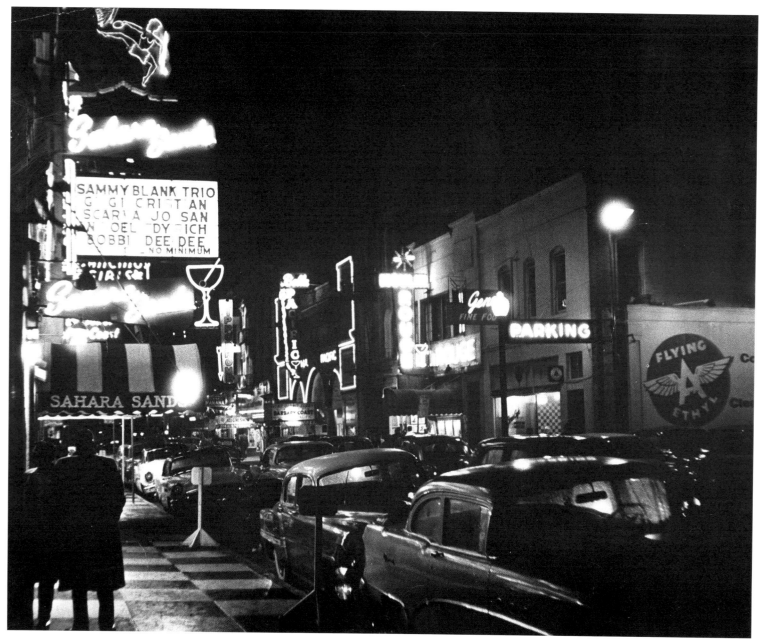

The International Settlement on Pacific Avenue, pictured here on April 30, 1956, was all that was left of the Old Barbary Coast. Although the district had been tamed after the 1906 Earthquake, during the 1930s and 1940s, a small section of Pacific Avenue between Montgomery and Kearny had a brief renaissance. The International Settlement was at the center of this. Contrary to its name, the area was neither international nor was it a settlement, but rather it was a decadent place of drinking, dancing, and prostitution. Its ambiguous and intriguing name, glittering lights, and loud music drew in men before and during World War II. Also known as "Terrific Street," it was so busy during the war that cars could not get down the road. It was not uncommon to see bar scuffles spilling into the street. Some of the area's most notorious establishments included the Moulin Rouge, Sahara, Gay 'N' Frisky, Pago Pago, Spider Kelly's, Bela Pacific, and Arabian Nights.

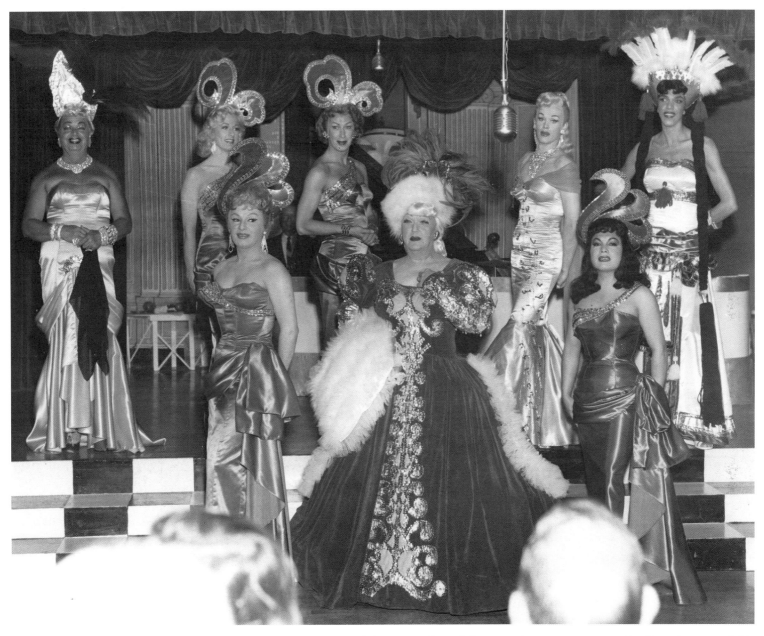

The cast of the floor show at Finocchio's Nightclub is pictured in a fashion parade on June 28, 1958. Joe Finocchio opened this club on June 15, 1936, with male cross-dressers performing as female impersonators in wigs and glitzy costumes. Finocchio's was a popular tourist destination until Joe Finocchio's widow closed the club on November 27, 1999. When Lawrence Ferlinghetti heard that Finocchio's had closed, he commented, "What a drag."

Lawrence Ferlinghetti is shown here on August 6, 1957, at his City Lights Bookstore, the hub of Beatnik activity and publishing in the fifties. The city of San Francisco was preparing for the case filed against Ferlinghetti for selling a book of poems, *Howl,* by Allen Ginsburg. The District Attorney's office prosecuted him for violating the Penal Code which prohibits writing, composing, printing, publishing, or selling "any obscene pictures or print."

The U.S. Customs Office in San Francisco had earlier confiscated copies of the book but was overruled by its Washington office, which did not view the book as obscene. J. W. Ehrlich, the high-priced trial lawyer, represented Ferlinghetti.

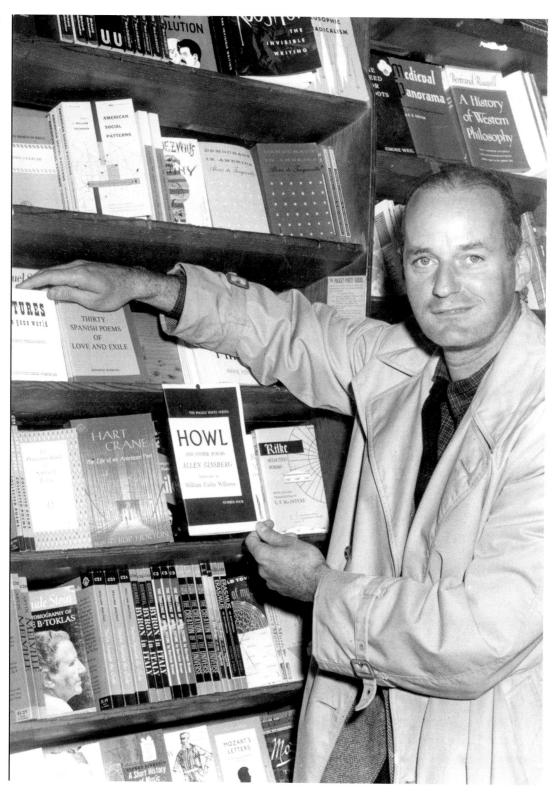

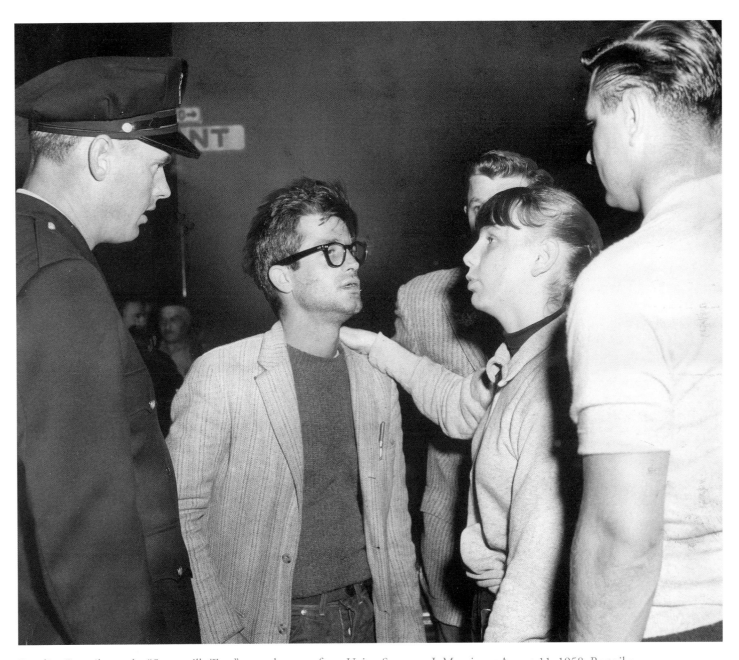

Parading Beatniks on the "Squareville Tour" cross the street from Union Square to I. Magnin on August 11, 1958. Beatniks challenged the idea of conformity by ridiculing mainstream San Franciscan and American values that based self-worth and identification on material things. The Beatniks were opposed to this excessive materialism and consumerism, as symbolized by the wealthy clientele of I. Magnin, an upscale clothing store founded in 1876 by Mary Ann and Isaac Magnin. I. Magnin was responsible over the decades for making women in San Francisco among the best dressed in the world. The business later relocated to a larger store, but the 1906 Earthquake destroyed it. Mary Ann and Isaac operated their business from their home until they could rebuild a luxurious store on Union Square. The store was eventually acquired by Macy's in 1988.

Over 100,000 baseball fans welcome San Francisco's new baseball team, the San Francisco Giants, in a parade on April 13, 1958, that ran along Montgomery Street to Market Street. A citywide obsession with the new team followed, and all-stars like Willie Mays and Willie McCovey became the new heroes of the day. The fact that the team came from New York gave a new air of prestige to the city. In the Giant's first game, the first major league game to be played on the West Coast, the team beat the Dodgers 8-0 and won 83 games in their first year alone. Seen in this picture taken from the 7th floor of the Sheraton Palace Hotel is San Francisco mayor George Christopher standing under the welcome sign. Reportedly, as he stood there, the crowd cheered that "George brought the Giants."

For over 50 years, fans have eagerly anticipated another Giants parade down Market Street to celebrate a World Series win, but this has yet to occur. The team has made only three appearances in the World Series, losing in 1962, 1989, and 2002.

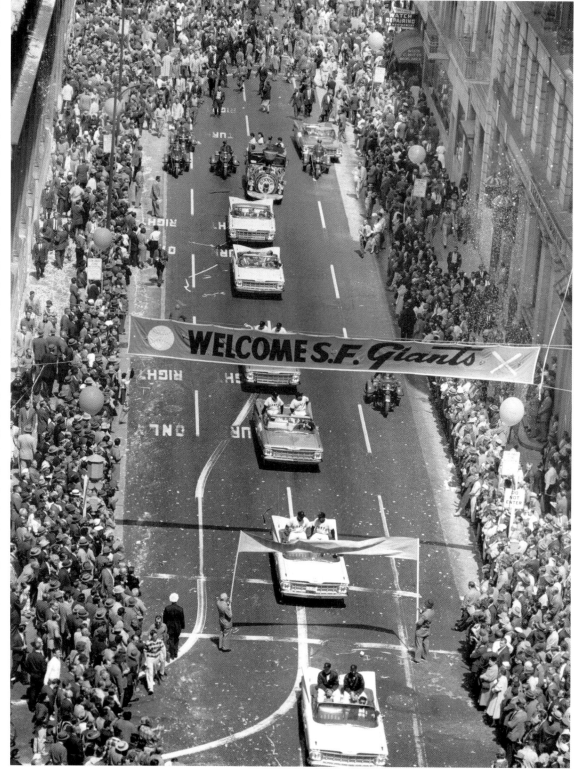

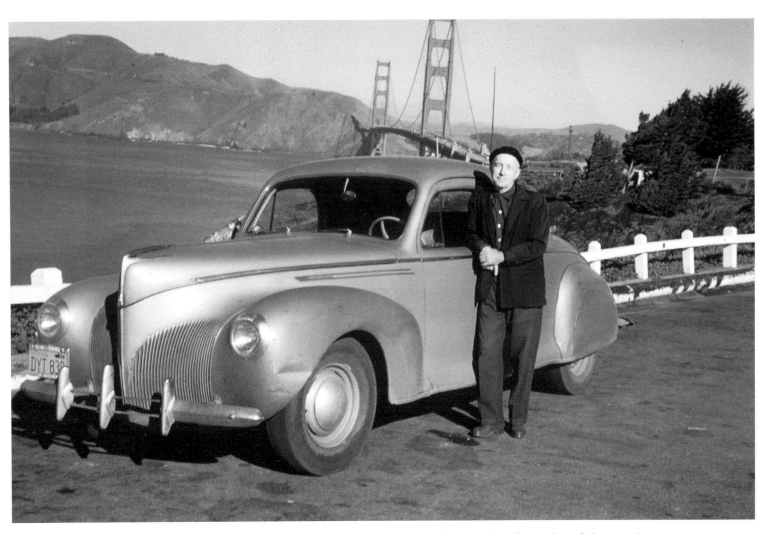

With a stunning view of the Golden Gate Bridge behind him, Charles W. Cushman, photographer of a number of photographs in this book, is pictured in the Presidio in 1958 with his Lincoln Zephyr. The original Zephyr model, introduced in November 1935, was a modern automobile, styled with aerodynamic features that were considerably smaller than other luxury cars of the era. In the fifties, the demand for cars soared. The new Highway Act of 1956 led to a $32 billion expenditure to build 41,000 miles of new roads, the start of the modern interstate highway system. The 15-foot-high overpasses enabled military traffic or missiles to easily move in the event of a national crisis.

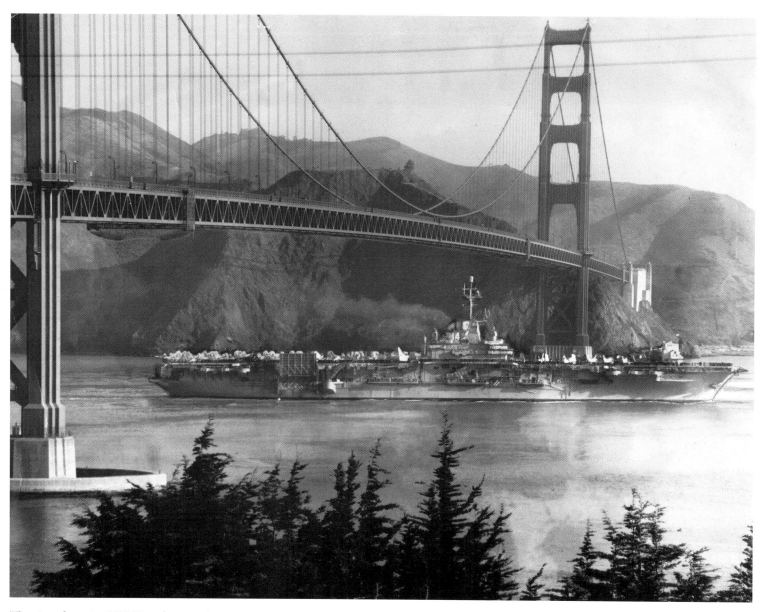

The aircraft carrier *USS Ticonderoga* is shown passing underneath the Golden Gate Bridge on April 25, 1958. The "Big T," as it was referred to, was at the end of a seven-month tour of the Western Pacific and was carrying 2,400 sailors at the time. The *Ticonderoga* was one of 24 *Essex*-class aircraft carriers built in America during World War II. Named after the famous fort of the American Revolution, it served in the Pacific during the second world war, earning five battle stars, and was decommissioned before its end. After updates, the *Ticonderoga* was recommissioned in the early 1950s as an attack carrier and antisubmarine carrier. It was decommissioned one last time in 1973, and finally sold for scrap metal in 1975.

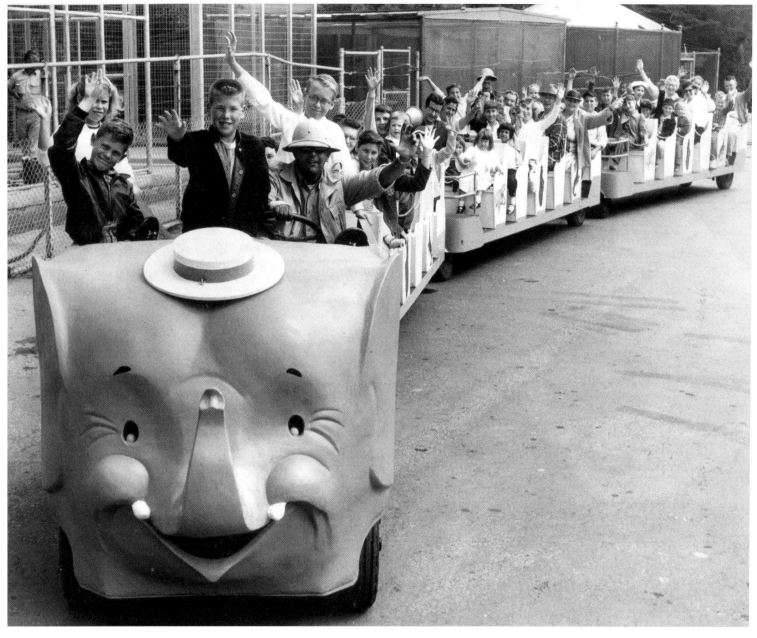

People ride the elephant train at the San Francisco Zoo on June 19, 1958. The zoo tour cost 30 cents for adults and 15 cents for children. The zoo, built along the Great Highway by Sloat Boulevard during the Great Depression as part of a New Deal W.P.A. project, is Northern California's largest and oldest zoo. It was founded by San Francisco philanthropist Herbert Fleishhacker in 1929. Originally called the Fleishhacker Zoo, it was completed by 1940 at a total cost of $3.5 million. The zoo's earliest residents came from Golden Gate Park, and included a buffalo, a pair of zebras, some rhesus and spider monkeys, and three elephants. The pit design allowing people to easily see the animals was highly innovative at the time, as most other zoos still kept animals in traditional barred cages.

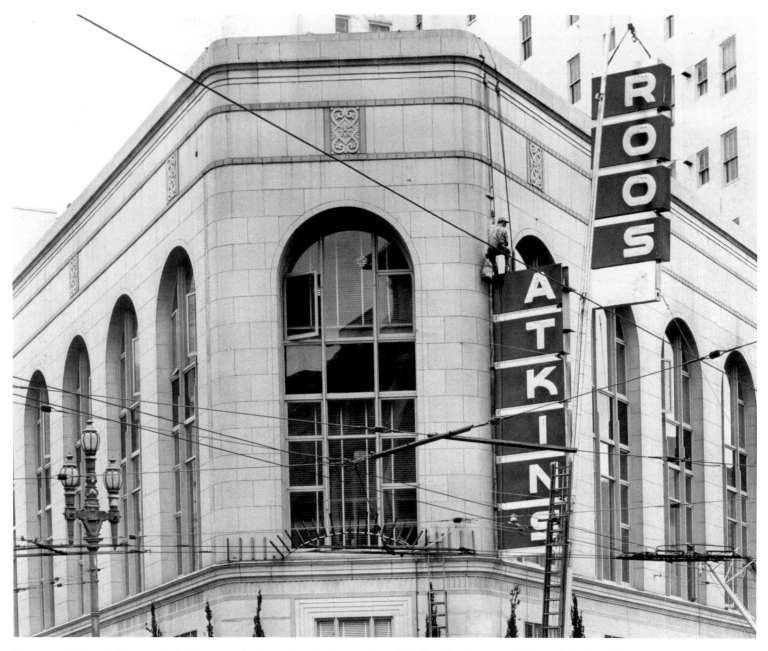

The upscale Roos-Atkins men's clothing store is pictured at the intersection of Market, Stockton, and Ellis on July 28, 1958, marking the merger of the two firms that were started by Robert Atkins and the Roos brothers. Roos-Atkins operated stores throughout Northern California but closed all of them in the early 1990s following sagging sales.

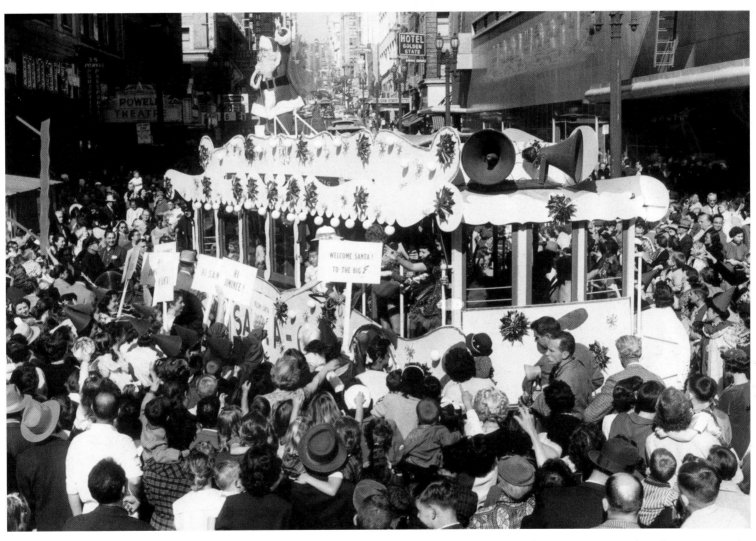

The Emporium was spreading holiday cheer to thousands of children on November 8, 1958. Santa Claus always came to the Market Street department store atop a cable car.

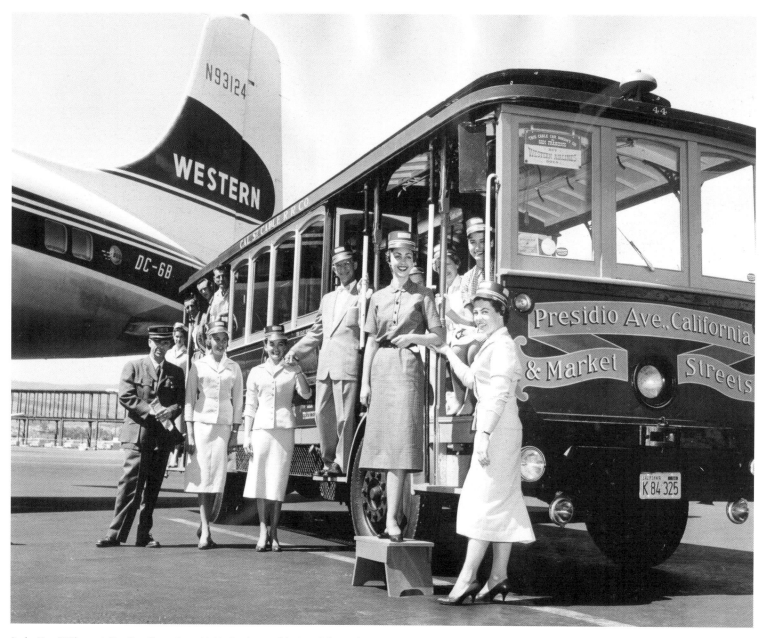

Judy Rae Wilson, Miss San Francisco 1958, is pictured being delivered to San Francisco Airport by a motorized California Street cable car on Saturday, September 13, 1958. She then flew via Western Airlines to Mexico City where she took part in Independence Day festivities of the Mexican Republic on September 15.

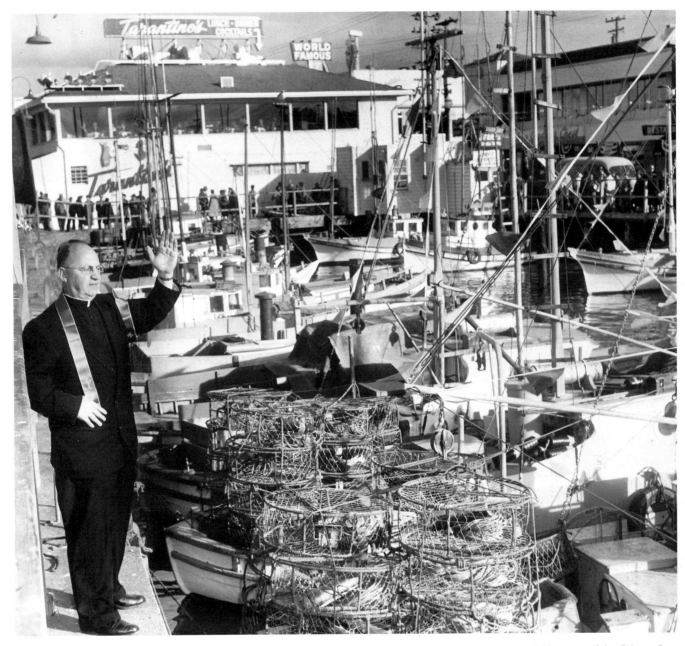

Reverend Gabriel Zavataro blesses the fishing fleet at Fisherman's Wharf in 1957. Annual blessings of the fishing fleet take place each fall. Fisherman's Wharf extends from Ghirardelli Square by Van Ness Avenue along the waterfront to Pier 35, near Kearny Street. The area dates back to Gold Rush days when Italian immigrants settled there and caught fish and crabs. It still remains the home of the San Francisco Fishing Fleet. In the 1970s and 1980s, Fisherman's Wharf became much more of a tourist attraction, but it is still a lively fishing spot. Tourists come from all around the world to line up for clam chowder served in sourdough bread bowls, fresh steamed Dungeness crab, and seafood cocktails.

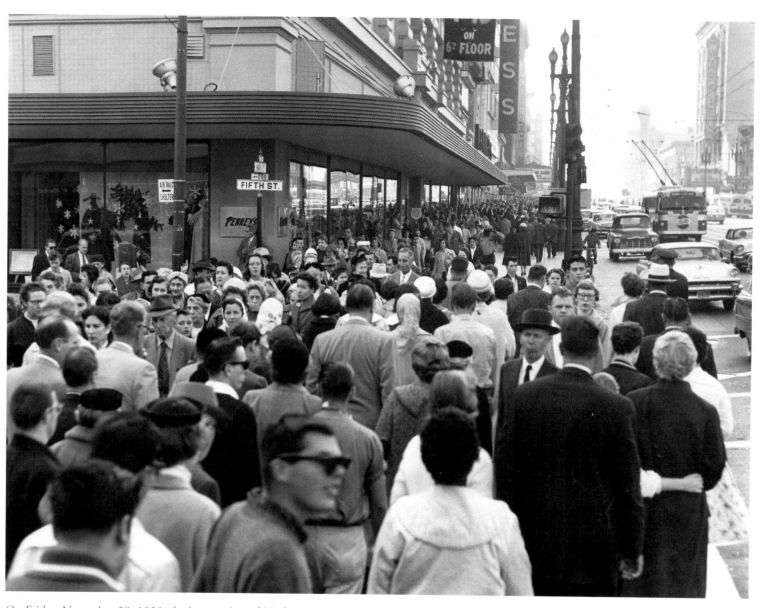

On Friday, November 28, 1958, the intersection of Market and 5th streets is mobbed by well-dressed holiday shoppers looking to beat the crowds and start their holiday shopping at the wide range of downtown stores.

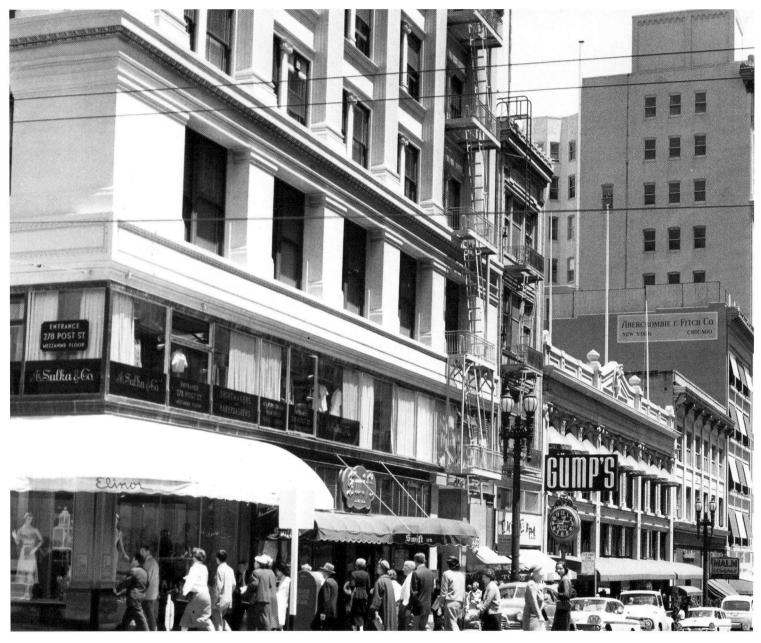

Post Street, a popular downtown shopping street near Union Square, is pictured on May 8, 1959. Gump's is an eminent purveyor of unusual gifts and high-quality merchandise, especially items from the Pacific Rim. The Gump's sign on the lower center of the photo hangs outside the entrance to this popular San Francisco store. Gump's, in operation since 1861, moved in the 1990s from the location shown in this picture to a larger building further down Post Street.

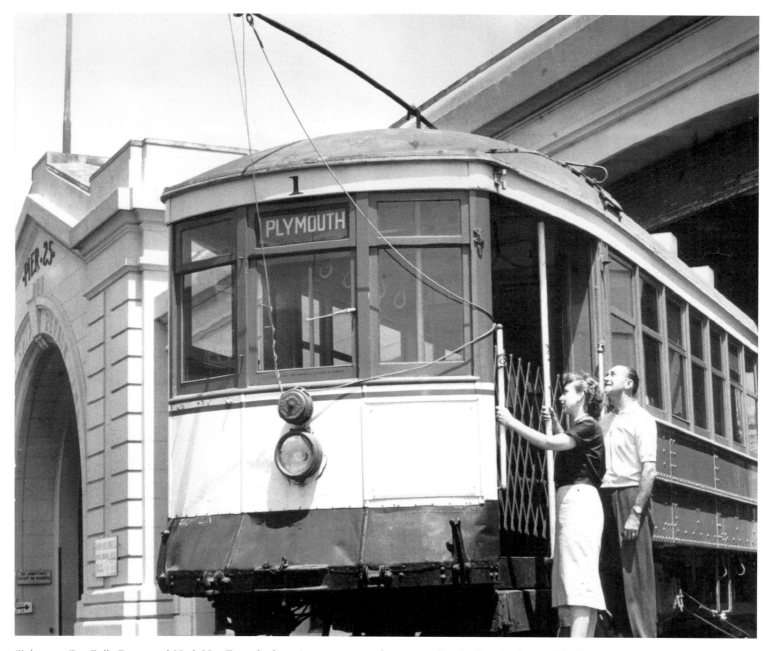

Sightseers Ova Belle Royce and Herb Van Zante look at vintage streetcars being stored at the Port Authority Warehouse at Pier 25 on July 10, 1959. The streetcars were later stored at the Maritime Museum. Vintage streetcars from San Francisco and other U.S. and foreign cities have been operating on Market Street for more than two decades, with a popular extension to Fisherman's Wharf along the Embarcadero added in 2000.

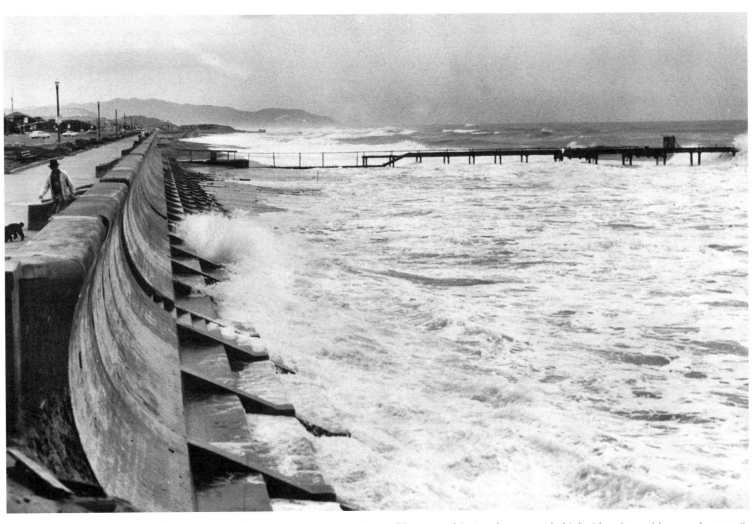

Ocean Beach has virtually disappeared under a layer of foamy surf during the extremely high tide, pictured here on January 8, 1959. High waves, a severe undertow, and the extremely cold Pacific waters make Ocean Beach treacherous for most swimmers, especially during high tide, though serious surfers can be found year-round in these waters.

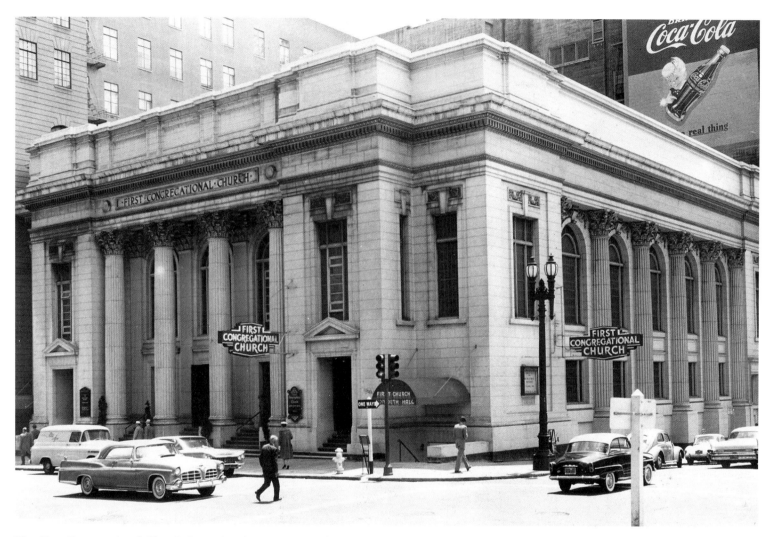

The First Congregational Church, located at 491 Post Street when this photo was taken on January 8, 1959, was celebrating its 110th birthday. The church opened in 1850 at Jackson Street and Virginia Place and had a membership of eight worshippers. It moved in 1853 to a new building at California and Dupont streets, and after membership grew, a new Gothic-style building was dedicated May 19, 1872. At the time of the 1906 Earthquake, the First Congregational Church had the largest Protestant church membership in San Francisco. The Gothic steeple, a symbol of the 1872 building, crumbled in the earthquake, and a new building was dedicated in 1915. After a special service creating the United Nations was held here in 1946, flags from around the world were mounted in the sanctuary. The church moved again in 2001 and now is located at Polk and Bush streets.

THE 1960s:

PROTESTS, HIPPIES, AND CIVIL RIGHTS

At the beginning of the sixties, the oldest president of our time, Dwight D. Eisenhower, was succeeded by the youngest, John F. Kennedy, a president for a new generation. The 1960s was a time of historic and unparalleled social and political protests in modern American history. The country found itself fiercely divided over the Vietnam War and the issue of civil rights, which fundamentally changed social relations in America and encouraged political activism among America's youth. A clear generation gap existed—the children whose parents proudly served in World War II and the Korean War found themselves at odds with the older generation, and developed entirely new and free attitudes towards music, sex, fashion, and lifestyle. People devoted themselves to changing the world by entering the Peace Corps and promoting racial harmony. This dynamic energy pulsated in San Francisco, which emerged in the 1960s at the vanguard of the antiwar and hippie movement. San Francisco's youth were proactive and rebelled against the established order of mainstream America, causing general social upheaval.

At this time, America was still deeply involved in the Cold War. The HUAC, the House of Un-American Activities Committee, was looking for Communists in San Francisco's City Hall, prompting violent protests in May of 1960 and resulting in 64 arrests and 12 hospitalizations. To some, it seemed that the biggest threats to American democracy were coming from within rather than from foreign enemies. In the autumn of 1962, the Cuban Missile Crisis showed how close the two superpowers could come to nuclear catastrophe. San Francisco grieved with the rest of the country after President John F. Kennedy's assassination in Dallas in 1963. Public optimism seemed to die with him.

San Francisco had an explosion of social movements in the early 1960s devoted to ending racism, inspired by the Southern civil rights movements. Racist hiring and housing practices existed in many places in the Bay Area for years, and student groups fought for social and economic change by strategies such as picketing and protesting local employers known for unfair hiring practices. The protests in the 1960s achieved important groundwork for racial equality, but at a cost—over 500 people were arrested in just six months, and those arrested faced expensive trials, juries that often found people guilty, and judges who issued harsh punishments. In 1964, the landmark Civil Rights Act was passed with the support of President Lyndon B. Johnson, which made racial discrimination illegal in voting and public facilities such as hotels and restaurants.

These movements inspired more student groups to organize, which eventually turned their attention to the antiwar movements. Groups became more radical and militant as the decade went on, deepening the divide between the protesters and conservative corporate America.

However, while the protests were in a formative stage, people still sought out old-fashioned entertainment. In 1962 in the Venetian Room at the Fairmont Hotel, Tony Bennett first performed his new song, "I Left My Heart in San Francisco," which became an official anthem of the city. North Beach in the 1960s underwent its own transformation. On June 19, 1964, the Condor nightclub changed history when a young dancer named Carol Dodo danced topless, and other clubs citywide and nationwide followed. In August 1964, the Beatles came to San Francisco and returned two years later, giving their last-ever public performance of their career at Candlestick Park.

In 1967, 100,000 baby boomers made a pilgrimage to San Francisco during the legendary Summer of Love to the Mecca of the hippie counterculture movement in the Haight-Ashbury District and Golden Gate Park, where they "expanded their consciousness" with mind-altering drugs and lived according to the mantra of free love, drugs, and rock-and-roll. San Francisco also experienced a musical and cultural renaissance in the 1960s. The "San Francisco Sound" became highly influential in the new rock music scene, with local San Francisco artists and groups representing the era, including Janis Joplin, the Grateful Dead, and Jefferson Airplane, who blended rock, jazz, and folk music, and was lyrically influenced by the Beatniks to create a whole new type of music.

The war in Vietnam was the longest and most unpopular war in American history, and people ultimately lost trust in their leaders. Unlike other wars in which returning soldiers were treated as heroes, people showed ambivalence or outright hostility to Vietnam veterans. The Presidio played a role in the Vietnam War, and war protesters held antiwar demonstrations at the gates of the Presidio throughout the war.

The final years of the 1960s proved to be constantly tumultuous times nationally and in the Bay Area. In 1966, the Black Panther Party formed across the Bay in Oakland to fight for social justice and against police brutality. When Nixon assumed office in 1968, he inherited inflation, war, and intense social unrest. The death of civil rights leader Reverend Martin Luther King, Jr., that same year brought riots to many American cities, and for a time it seemed that the entire fabric of American society was coming apart. In November 1968, students at San Francisco State began the longest student strike in American history, which ended the following spring with the creation of the Black Studies Department. In the late sixties, the Zodiac Killer terrorized the Bay Area, murdering innocent victims in the area, including Presidio Heights in San Francisco, and sent cryptic and taunting letters to the *San Francisco Chronicle* and *San Francisco Examiner* to publish. In November 1969, a group of 90 "Indians of All Tribes" claimed and occupied Alcatraz Island to bring attention to the plight of the American Indian and to demand "Red Power."

Despite the intense social upheaval at this time, Americans also had a new cause for hope. On July 20, 1969, over a billion people watched as Neil Armstrong became the first man to walk on the moon—a tribute to American technology, and one of the greatest feats in human history. Many felt renewed optimism that the conflicts on earth might too someday be resolved.

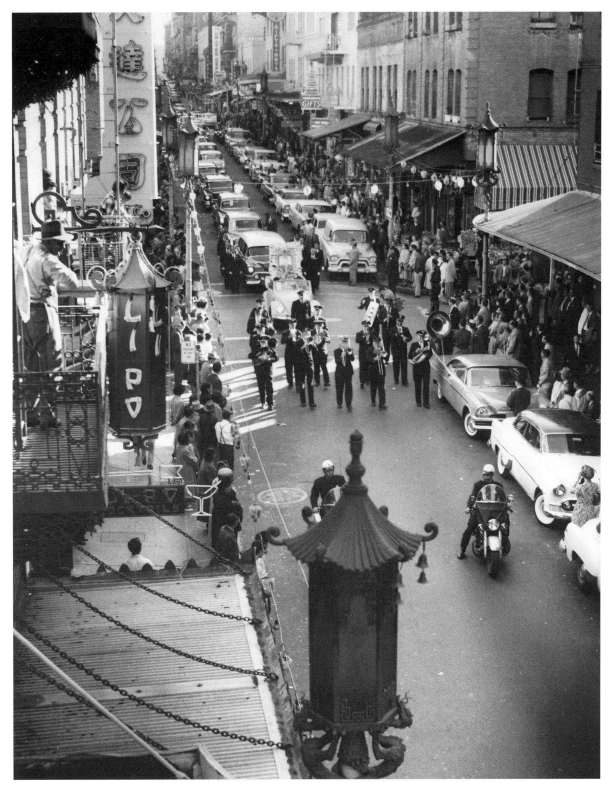

Pictured here on June 13, 1962, through the streets of Chinatown is the funeral procession for local politician and community advocate, Albert Chow. Similar to many Chinese funeral processions, this one resembles a parade, led by police motorcycle escorts and a full-size marching band that is playing hymns. Family members and friends of Mr. Chow follow and throw out spirit money to ward off malicious ghosts as they carry a large picture of him. The parade stops at Mr. Chow's former homes, workplaces, and other places familiar to him so that his spirit can make one last visit.

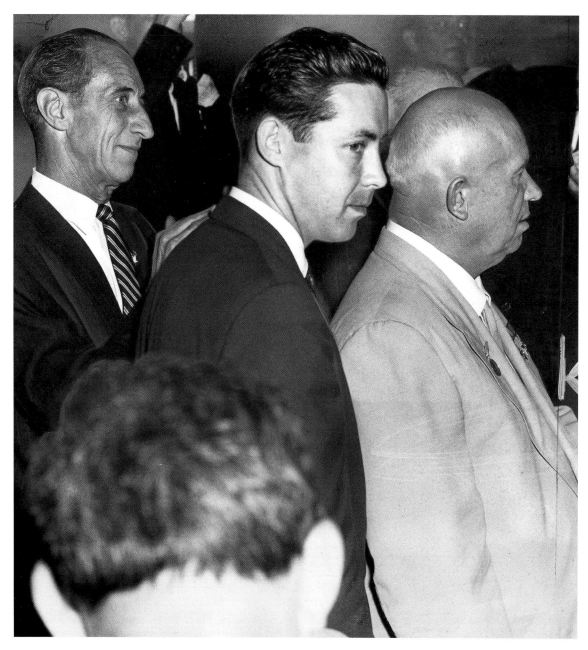

Harry Bridges, the San Francisco Longshoremen leader, smiles as his distinguished and unexpected guest, Nikita Sergeyevich Khrushchev, the Soviet Premier (right), speaks to the cheering dockers at the ILWU Hall on September 21, 1959. At the center of the picture is chief interpreter Oleg Troyanovsky. Khrushchev (April 15, 1894 – September 11, 1971) was in charge of the partial de-Stalinization of the Soviet Union and was involved in the development of the Soviet Space Program. In the fall of 1959, the United States invited Khrushchev to visit this country, and he accepted, becoming the first Soviet Premier to visit the United States. Khrushchev spent nearly two weeks touring the country, including a visit to San Francisco, a historic footnote to the Cold War.

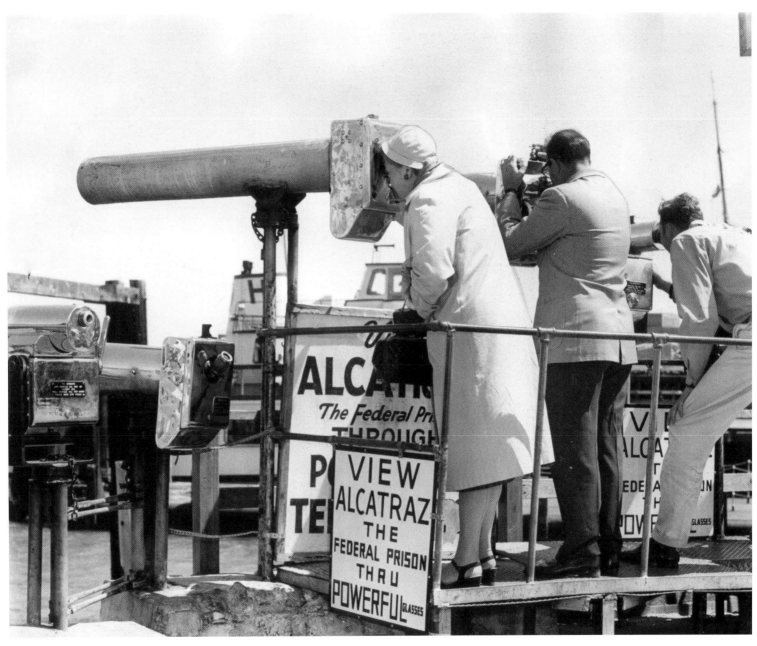

Tourists look at Alcatraz Island on May 20, 1960, through telescopes located at Fisherman's Wharf. At the time, Alcatraz was still being used as a maximum security federal prison.

Columbus Tower, shown here on April 3, 1960, was completed in 1907 following extensive damage to the construction site during the 1906 Earthquake. Its distinctive copper-green edifice is one of the few remaining San Francisco buildings designed in the flatiron style of early-twentieth-century American architecture. Also known as the Sentinel Building or the San Francisco Flatiron Building, the tower is now a designated landmark. The building once housed Caesar's, credited with creating the popular Caesar Salad (other stories suggest Tijuana, Chicago, or other locales as the origin of the piquant dish). By the early 1970s, the building had fallen into a state of disrepair, and film director Francis Ford Coppola purchased and renovated it.

Pictured here is a Balloon Derby at Stonestown on September 12, 1960, commemorating the 50th anniversary of Frank Werner Co. shoe stores. The person whose balloon made the longest flight won a trip to Disneyland (which had just opened five years before) in a promotion sponsored by the popular shoe store.

President Dwight D. Eisenhower speaks at the Sheraton Palace Hotel on October 21, 1960. During his address to 1,800 people, the President criticized John F. Kennedy, the Democratic presidential nominee, when he denounced anyone who said that the United States had become a secondary power. Eisenhower's presidency brought prosperity to Americans and allowed many to achieve what they thought of as the "American dream." Although Eisenhower was a Republican and disliked government spending, he kept many of Franklin Roosevelt's New Deal Programs, expanded Social Security, increased minimum wage for workers, and even created the Department of Health, Education, and Welfare.

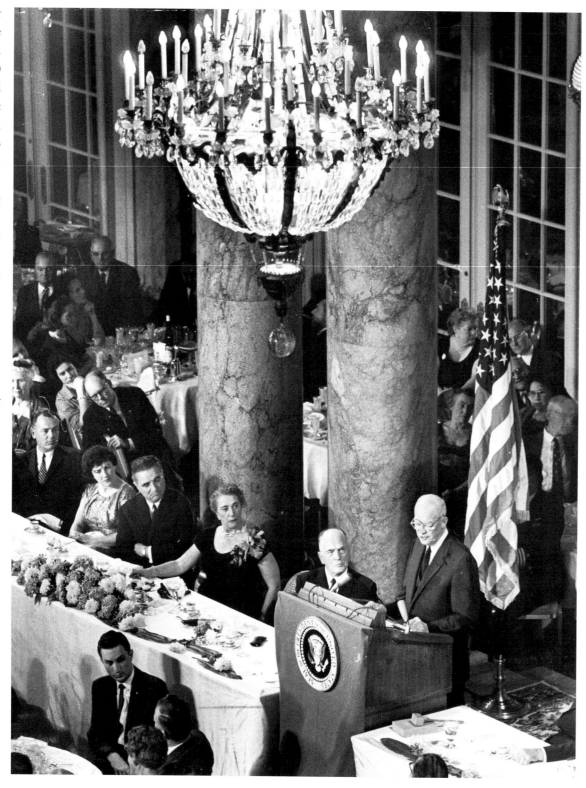

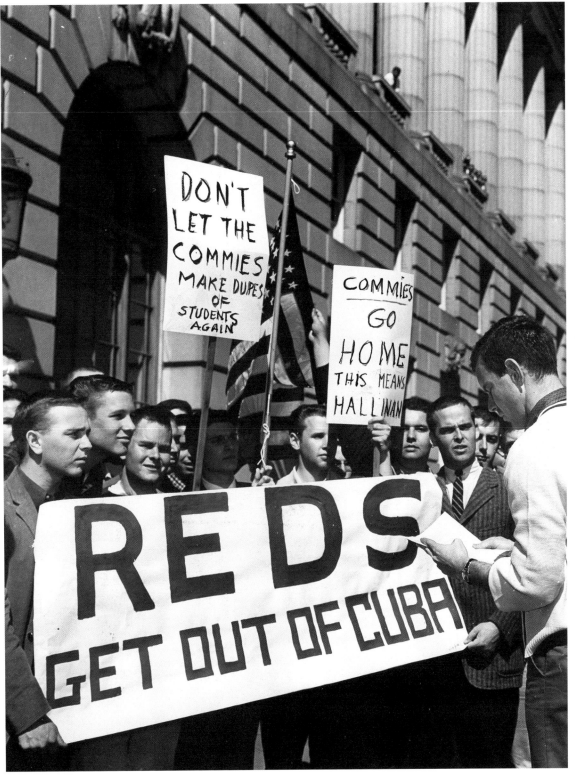

An anti-Castro group of young people is shown before the Federal Building clashing with pro-Castro supporters on April 20, 1961. The "pros" were from some Bay Area colleges, and the "antis" were from San Francisco State and the University of San Francisco. Fidel Castro was a leader of the 26th of July Movement in the Cuban Revolution, culminating when the American-backed Fulgencio Batista dictatorship was overthrown on New Year's Day, 1959. The Cuban Revolution was Marxist in nature, and Castro became closely allied with the Soviet Union during the Cold War. Once Castro took control, everything went under government control. It is estimated that any given point, 20,000 dissenters were being tortured or imprisoned. Castro also put Cuban homosexuals in internment camps and had thousands of his own people executed. Hundreds of thousands of Cubans escaped to the United States by the early 1960s.

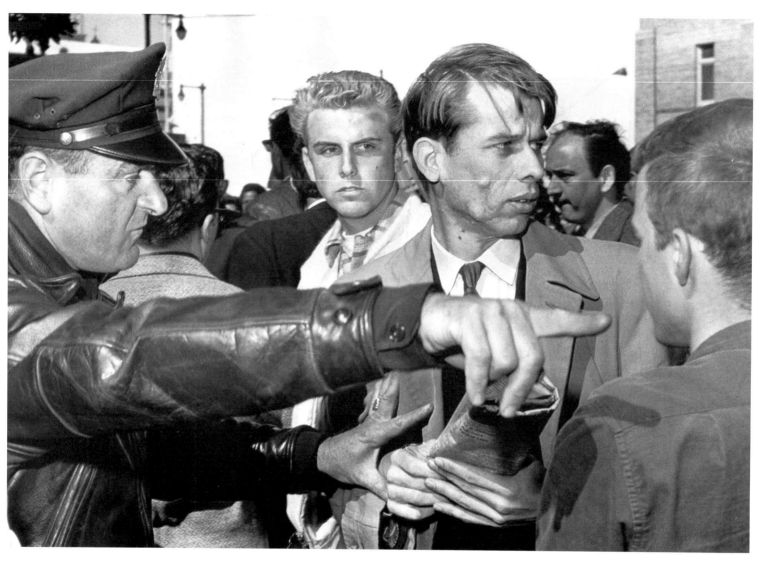

A policeman is ordering a pro-Castro demonstrator to move on after he started an argument with an anti-Castro heckler before the Federal Building.

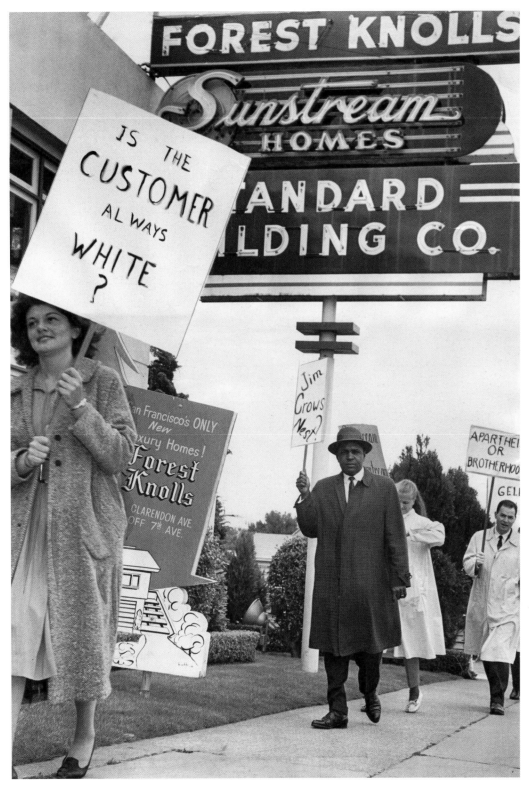

Picketers march in front of the offices of the Standard Building Company on June 5, 1961, in protest against alleged racial discrimination after black attorney Willie Lewis Brown, Jr., charged that salesmen refused to show a model home at 301 Christopher Drive in Forest Knolls. Brown helped organize the public protest and attracted media coverage. His role in the protests gave him broad notoriety, and in 1964, he was elected in his second attempt to the California Assembly, where he became the Democrats' whip in 1969 and Speaker in 1980. Brown was later elected as mayor of San Francisco, serving from January 8, 1996, until January 8, 2004.

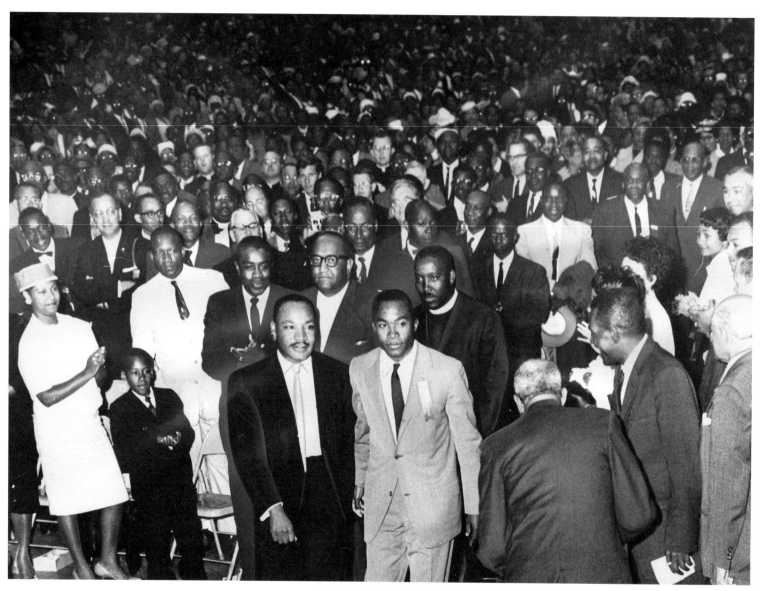

On July 24, 1961, Reverend Dr. Martin Luther King, Jr., spoke at a huge Freedom Riders rally at the Cow Palace. Dr. King made an impassioned plea for stepped-up resistance to segregation to almost 15,000 people, a thousand of whom were whites. Ultimately, he raised $16,000 for the Freedom Riders. The civil rights movement began in the 1950s and reached its height in the 1960s, adopting new tactics to achieve its aims modeled after the nonviolent, passive-resistant methods of Gandhi in India. Jim Crow laws were in effect in the South, and much of the country was still segregated. A major milestone was achieved on May 17, 1954, when the United States Supreme Court in the landmark *Brown* v. *Board of Education* decision, declared the segregation of schools unconstitutional. Southern states were slow to comply with this ruling, and the National Guard had to be called out in many states to enforce it. King would be assassinated in the spring of 1968.

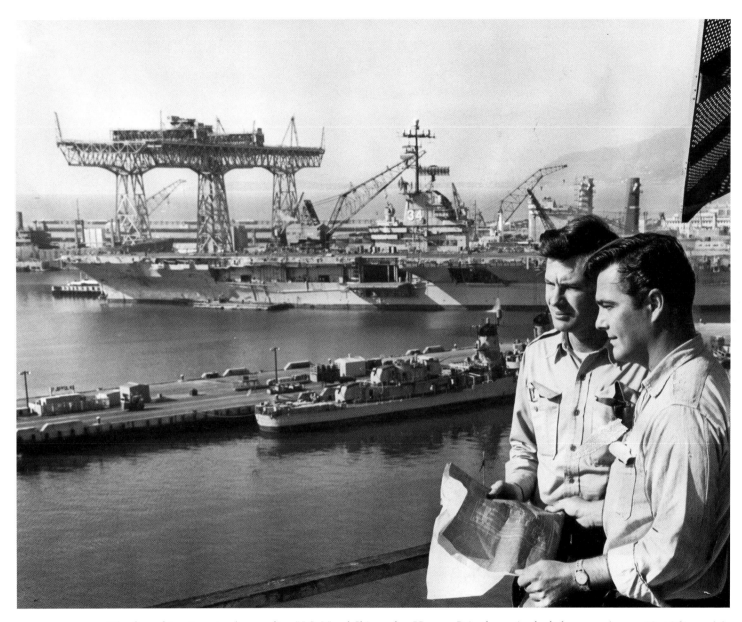

The fate of San Francisco's sprawling U.S. Naval Shipyard at Hunters Point hangs in the balance on August 18, 1961, as civic leaders, spearheaded by Mayor George Christopher, map plans to battle the recommendation of the Defense Department that the facility be closed. Christopher's efforts were implemented by Congressman John F. Shelley in Washington. Albert Drain, at left, and Richard Capell look out over the shipyard. Hunters Point remained a naval base and commercial shipyard until 1994, when it was permanently closed along with other military bases in the Bay Area and around the country.

An aerial view of Golden Gate Bridge, recorded on August 9, 1961, shows the fog rolling in. San Francisco is surrounded on three sides by the frigid waters of the Pacific Ocean and San Francisco Bay, which combine with the heat from the California mainland to produce the thick fog that San Francisco is famous for. Because of this topography, there is little variation in average temperature between the seasons, and San Francisco maintains a yearly average close to 60 degrees Fahrenheit.

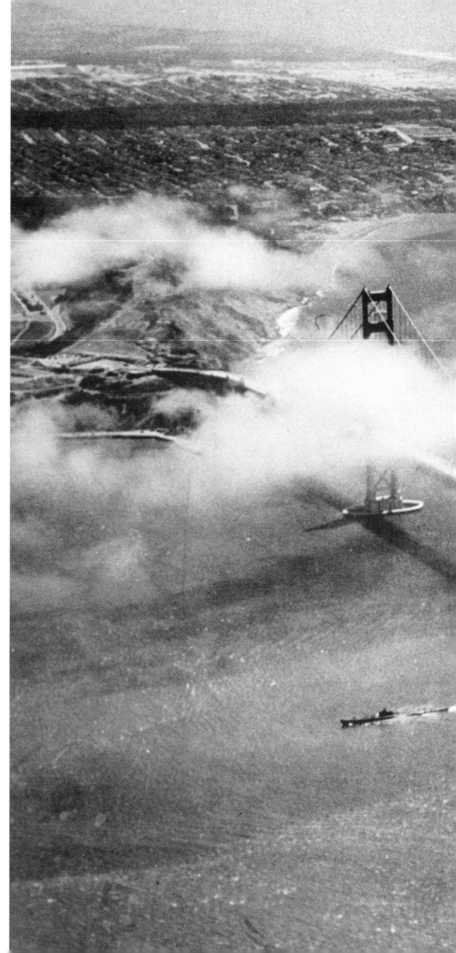

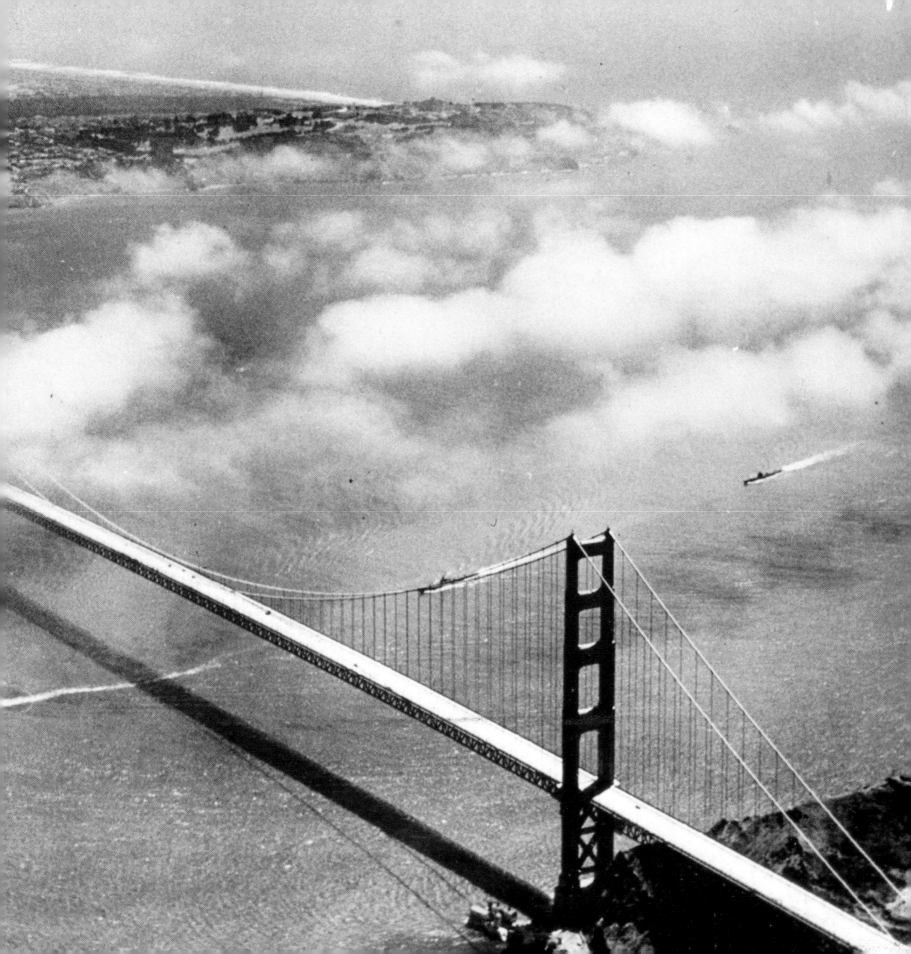

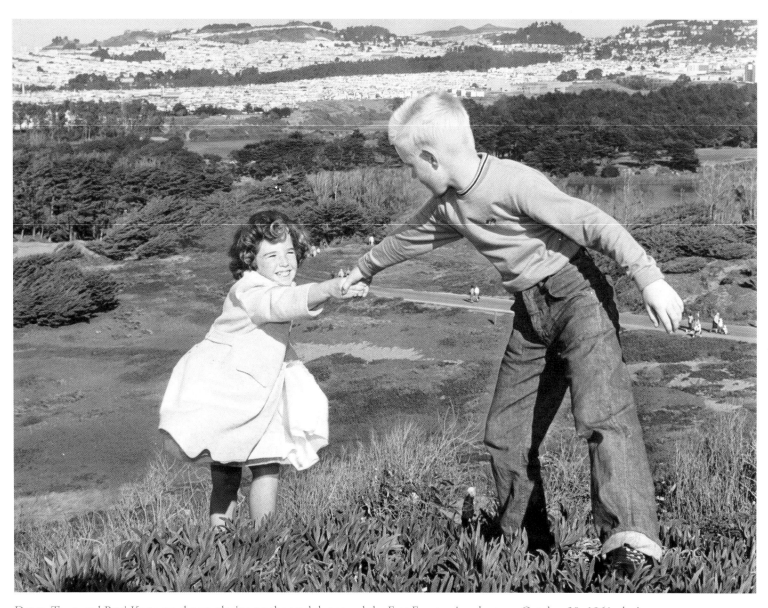

Danny Town and Patti Keate are shown playing on the sand dunes and the Fort Funston ice plants on October 30, 1961, during an open house. The former military installation was built in 1938 and deactivated in 1948. The open house was sponsored by the Citizens Committee for Proposition B, the November 7 election bond issue, which would allow the city to buy 116 acres for $1.1 million, half the parcel's appraised value.

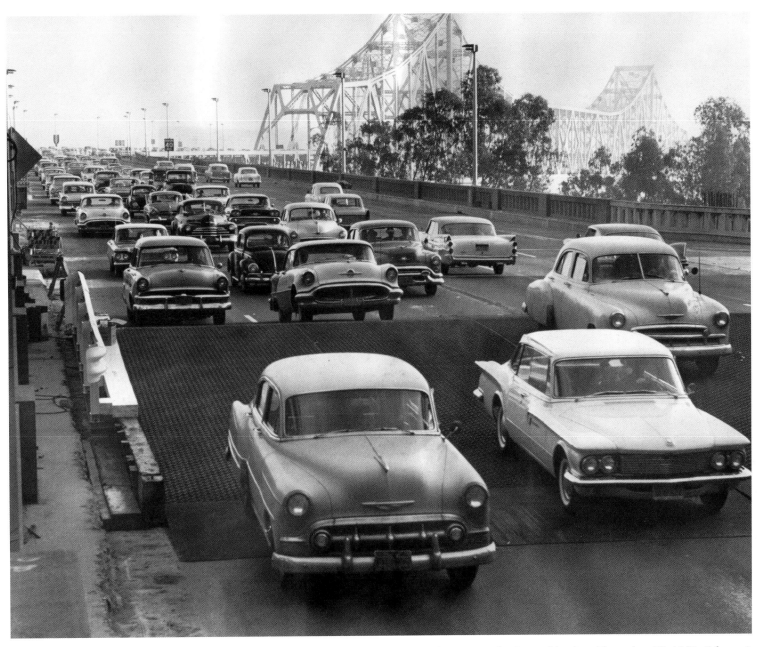

Traffic on the upper deck of the Bay Bridge is passing over a hump at Yerba Buena Island on November 17, 1961. Of note is the two-way traffic on the top deck. At the time, the lower deck of the bridge carried trucks and Key System trains from San Francisco's Transbay Terminal to destinations throughout the East Bay. Railroad service on the bridge ended in 1958 as the Key System routes were converted to buses, and the Bay Bridge was reconfigured to have westbound lanes on the upper deck and eastbound lanes on the lower deck in 1963. Tolls were collected in both directions until 1969, when today's westbound-only toll collection system began.

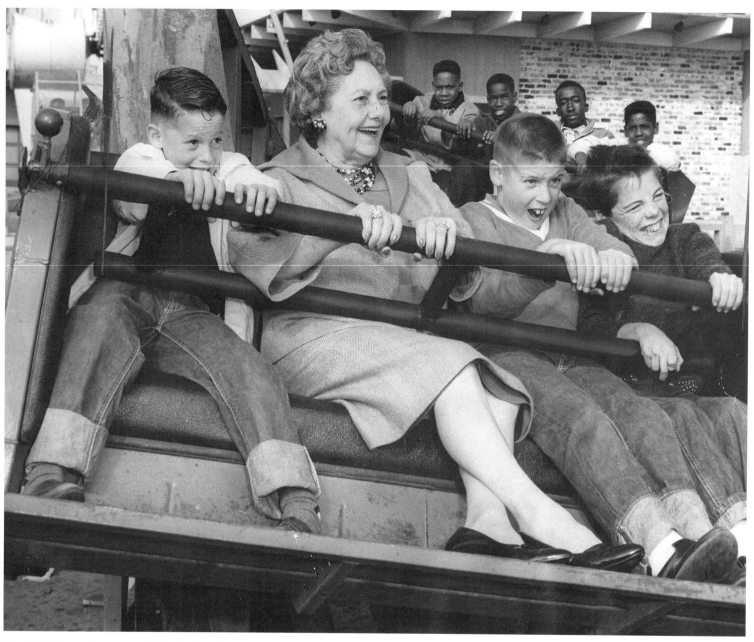

Eva C. Whitney, the owner of Playland, and three boys enjoy the "Barrel" at Playland at the Beach on February 3, 1962, during the annual Boys Club Day. The event was started by Eva's husband, the late George Whitney, when he was director of the Boys Clubs in the 1930s. Mrs. Whitney continued this tradition after her husband's death.

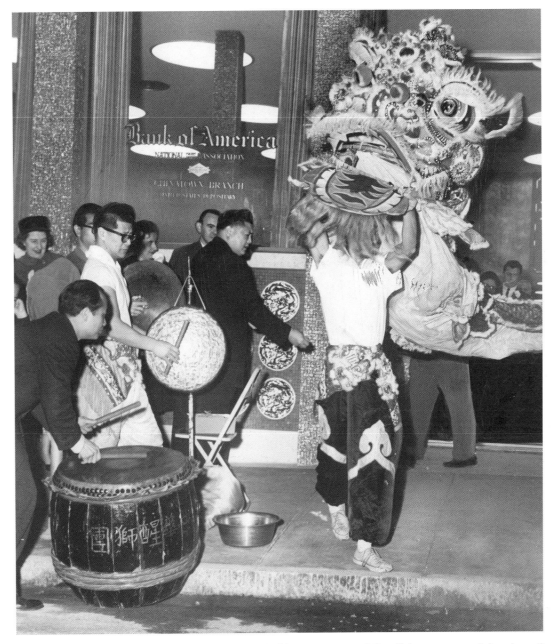

On March 7, 1962, a ceremonial tiger is unleashed by Anna Wong, Miss Chinatown, to subdue the evil spirits in the vicinity of Grant Avenue and Sacramento Street at the celebration for the opening of Bank of America's Chinatown branch at 701 Grant Avenue. Hundreds of firecrackers exploded for over an hour as the tiger danced though the crowd.

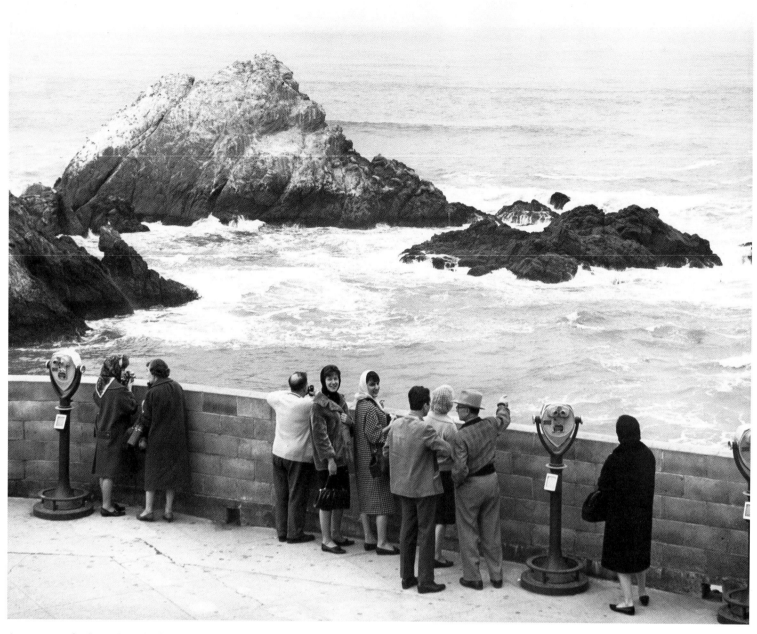

A group overlooks Seal Rocks from the Cliff House on Valentine's Day, 1963.

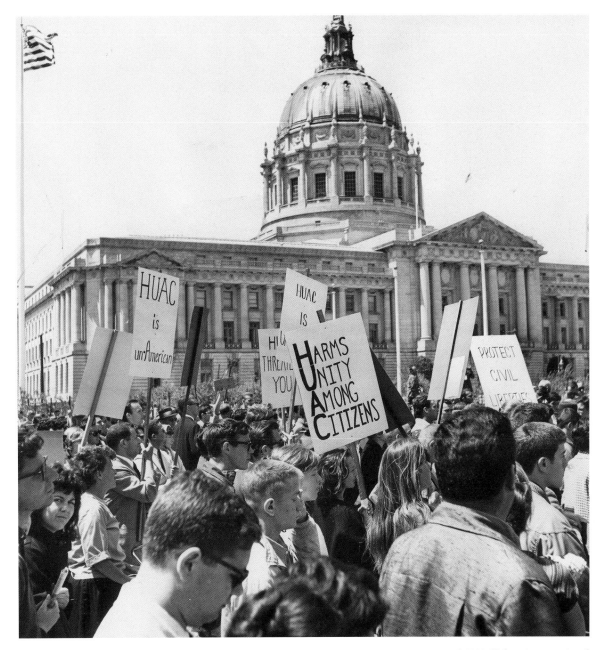

Demonstrators are shown protesting the House on Un-American Activities Committee (HUAC) hearings on April 26, 1962. Communism became a dirty word in America during the Cold War. To support Communism in any way was un-American and treasonous. This fear and anti-red fervor was fueled by politicians telling Americans that there were Soviet spies in their midst on a daily basis. In 1947, the HUAC, led mostly by conservative Republicans, including a young man named Richard M. Nixon, went on a witch-hunt for Communists. Hollywood was a big target as directors, actors, and writers tended to be very politically liberal; some were placed before committees who accused them of pro-Communist activities, while others were blacklisted.

On May 31, 1962, Mr. and Mrs. Barton Stone and nine-week-old baby Allan join the crowd to protest against the Everyman hearings in the hallway of the Marshals Office in the Old Post Office Building.

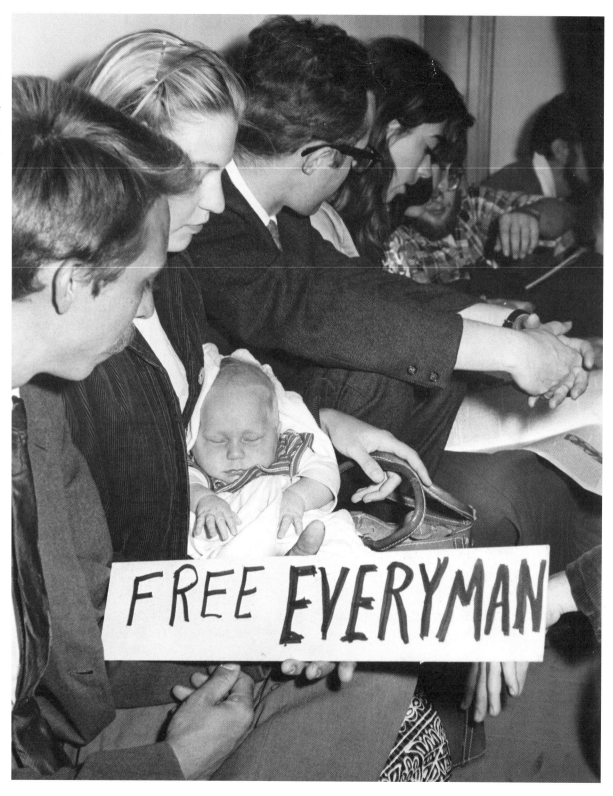

Believed to be an inescapable locale in the middle of San Francisco Bay, Alcatraz Island became a famous U.S. Federal Prison in 1934. From then on, many simply referred to the island and the prison itself as "the Rock." Frequently depicted in film and literature, notorious criminals such as Al Capone and Robert Stroud, the "Birdman" of Alcatraz, were incarcerated here. There have been 14 separate escape attempts in its history as a federal prison, the most famous of which was carried out in June of 1962. Three inmates, Frank Lee Morris and brothers Clarence and John W. Anglin, dug a hole through their cell walls, climbed up a chimney to the ventilation shaft, which led to the roof, and climbed down to paddle away from the island on a rubber raft made from prisoners' raincoats. Pictured here on June 13, 1962, Senior Officer Waldron is inspecting a hole in the wall of escaped convict Frank Morris's prison cell. Spoonful by spoonful, Morris created the hole in the cell block.

On the morning of June 12, 1962, guards at Alcatraz Prison discovered that the Anglin brothers and Frank Morris were missing from their cells. Alcatraz cell 150, from which convict John W. Anglin made his escape, is pictured on June 13, 1962. The lifelike self-portrait plaster head, which Anglin left in his bunk, was concocted from soap, toilet paper, and human hair, and was moved off the pillow and tossed in the center of the cot. The pillow and blanket were used to shape the form of what appeared to prison guards to be the sleeping prisoner. Although the FBI conducted an exhaustive investigation, there was no evidence that the three escaped convicts ever reached the shore. Since their bodies were never found, the three escapees are believed to have drowned in the frigid San Francisco Bay waters, though they still remain on the FBI Wanted List. Clint Eastwood starred in the 1979 film *Escape from Alcatraz* about this famous prison escape.

During their second phase of military training on June 14, 1962, soldiers at Fort Mason make their way across a horizontal ladder, swinging from rung to rung on bars 18 inches apart and nine feet above the ground. The men had to complete the 36-rung course in one minute, then do an obstacle course, a grenade throw, and a mile-run in boots.

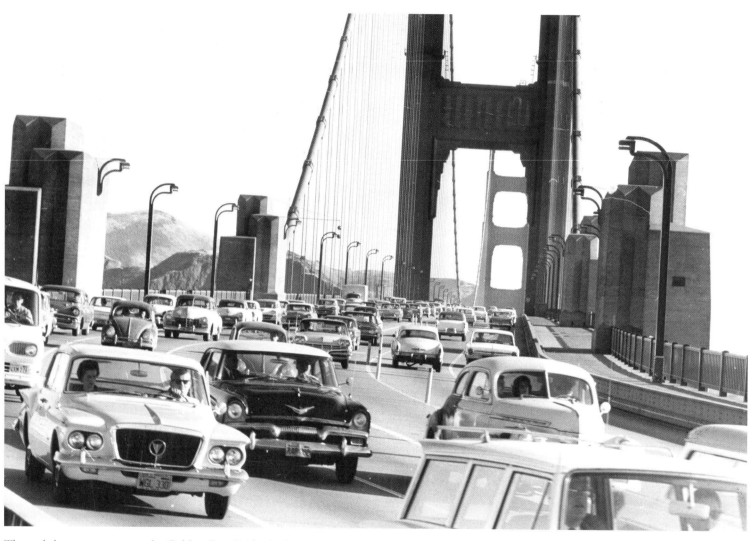

The rush-hour commute on the Golden Gate Bridge is shown on August 24, 1962. At this time, city planners implemented a new plan to provide an extra lane to the direction with the most rush-hour traffic. Dividers were shifted, making four southbound lanes and only two northbound lanes during the morning rush from Marin County into San Francisco. The system continues to this day, with the opposing directions of traffic separated only by flimsy posts, though proposals for a more substantial but still movable wall-type barrier occasionally surface.

Women measure for points during a game on the bowling green in Golden Gate Park on September 10, 1962. Fifty years before, the first women's bowling green in America opened here in September of 1912 by Mayor James Rolph, Jr. The club numbered 68 women when this was taken, and matches were held twice a week.

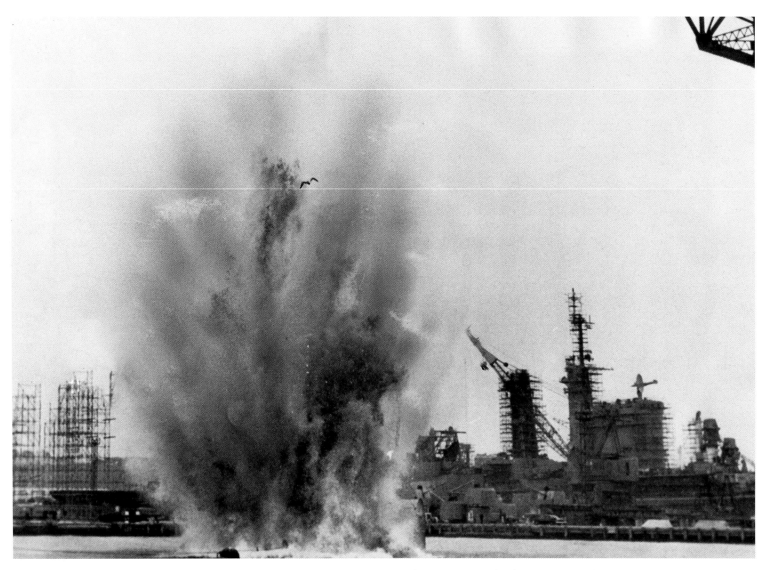

Sixty pounds of high explosives are detonated underwater at the U.S. Navy's shock test center at the San Francisco Naval Shipyard at Hunters Point, inaugurating the Navy's new West Coast test facility on January 29, 1963. The explosives were set off 24 feet below the surface of the water, sending a geyser of muck and water 100 feet into the air. Between 1946 and 1969, the shipyard was also used to study the effects of nuclear weapons and the development of countermeasures. Several of the buildings at the facility were used for radioactive laboratory operations, cyclotron operations, animal research studies, and radioactive material storage.

On President's Day, 1963, Laura Hortencia Palmarez sits on the statue of President Abraham Lincoln on Polk Street by City Hall. The statue outside City Hall was designed in bronze in 1928 by Armenian-American sculptor Haig Patigian, who also unveiled a statue of Thomas Starr King in 1831 in Washington, D.C. San Francisco was the site of an earlier statue of Abraham Lincoln as well. Artist Pietro Mezzara created a plaster statue of Lincoln in 1866, said to be the first statue of the 16th President in the western United States, but the statue was destroyed in the 1906 Earthquake.

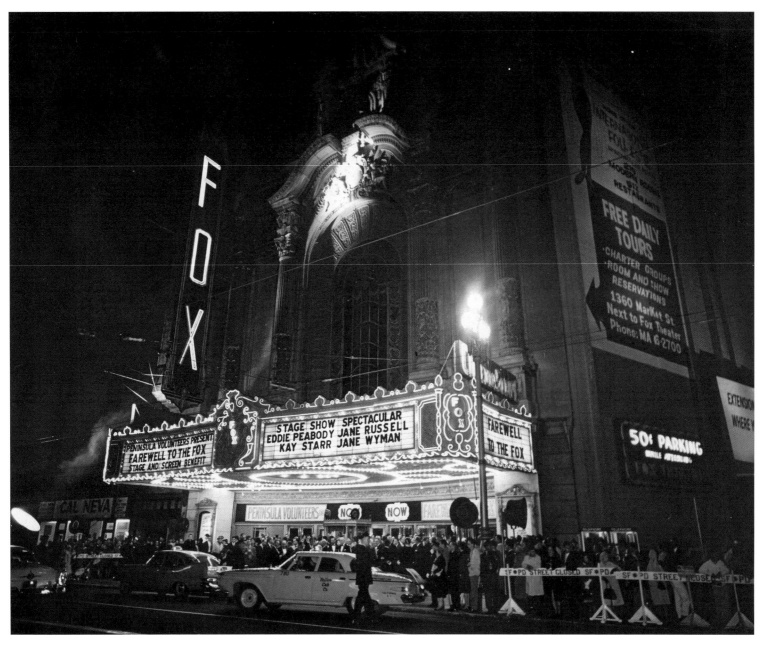

Before the famous Fox Theatre, known as the "Showplace of the West," closed it doors in the winter of 1963, the management scheduled four farewell events for the public, each one packed to the theater's 4,651-person capacity. On Saturday, February 9, the second night of farewells, organist George Wright played his final number, "I Left My Heart in San Francisco," on the famous Wurlitzer theater pipe organ before it descended into the orchestra pit for the last time. The last Farewell to the Fox Benefit is pictured on February 16, 1963, shortly before the Fox lowered its curtains for the last time and closed its brass doors forever.

Lowell High School students, in tune with the spirit of student protest in San Francisco and around the country in the sixties, are pictured boycotting the school cafeteria on April 27, 1963. Strikers were angry because profits from the cafeteria's soft-drink machine were going to the citywide cafeteria fund and not into the school's student-body treasury. Student strikers wanted more money for better football equipment, improved dances, and to help a former student in the Peace Corps in Africa. Even though this was the second strike, principal J. A Perino did not expel anyone, explaining that the strikes were an indication of "springtime exuberance." Lowell, founded in 1856, is located near Lake Merced and is the oldest public high school west of the Mississippi in the continental United States.

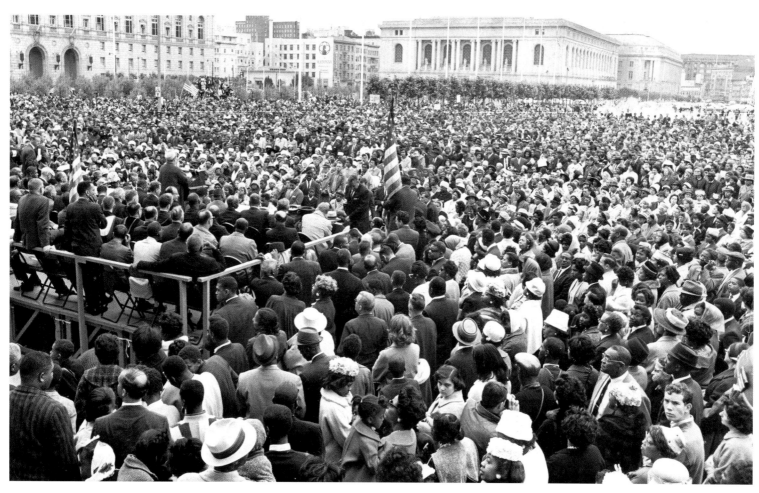

San Francisco supervisor Clarissa McMahon addresses a crowd at the Civic Center Plaza on May 27, 1963. Twelve thousand marched up Market Street, singing the *Battle Hymn of the Republic* in protest against racial oppression. The event, organized by the San Francisco Church Labor Conference as an observance of Human Rights Day, was peaceful without any of the disturbances that were commonplace in strikes at this time.

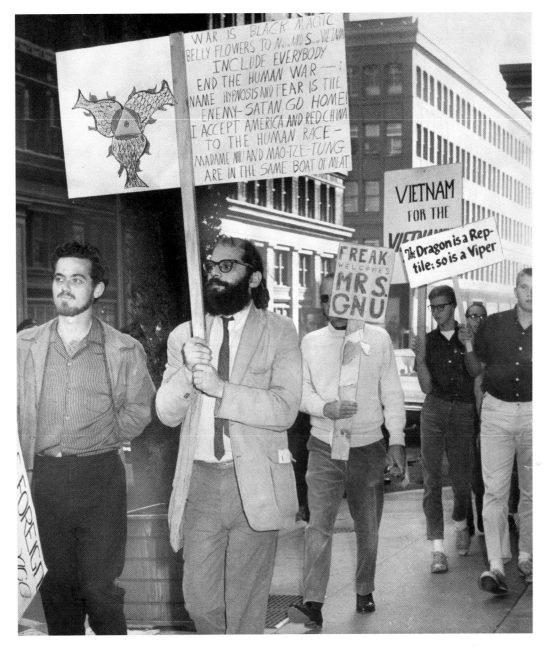

American poet and outspoken political activist Allen Ginsberg (June 3, 1926 – April 5, 1997) is marching with a group protesting U.S. policies in Vietnam on October 28, 1963. Ginsberg has been immortalized as a founding member of the Beat Generation and author of the controversial *Howl* from 1956. Ginsberg, like a lot of Americans, felt misled and betrayed by the government's stance on Vietnam and believed it to be criminal to drag on with a war that was costly. Over 58,000 Americans were killed and 304,000 were wounded in the war, at a cost of $150 billion dollars.

Steve Matthews sits in a field of floats used to support harbor defense nets at Hunters Point Naval Shipyard on December 18, 1963.

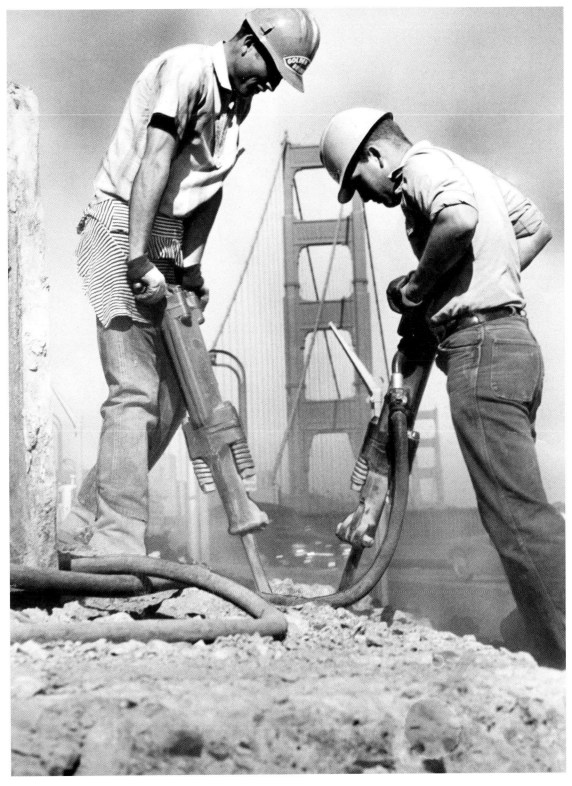

In order to improve San Francisco–bound traffic, men with jackhammers chip away at 60-year-old Battery Lancaster foundations on February 7, 1964, to widen the approach at the Golden Gate Bridge southern end. Today, Battery Lancaster is adjacent to the bridge's toll plaza. Its emplacements are partially incorporated into the pedestrian walkway to the bridge and the Visitor Gift Center. The left side of the battery, which contains interior magazines, is visible today, and the gun platform has been filled with dirt and gravel.

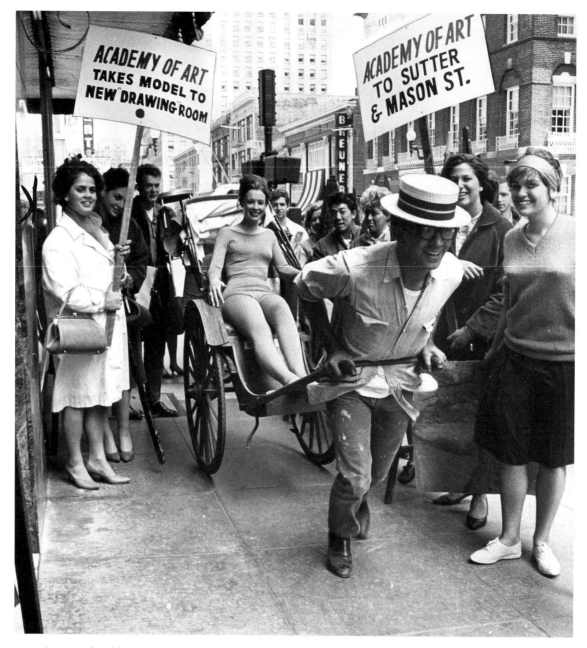

Because the old Academy of Art campus at 431 Sutter Street was too small, the college moved in 1964 to a new building at 604 Sutter Street. The exodus was accomplished in just a single day, as 30 students carried all the equipment and supplies. Larry Herrera is pictured here pulling model Alice Marie Beckman in a cart on moving day on April 30, 1964. Reportedly the largest art and design school in the United States, the Academy of Art University, founded in 1929, has nearly 16,000 students enrolled and occupies 31 buildings in downtown San Francisco.

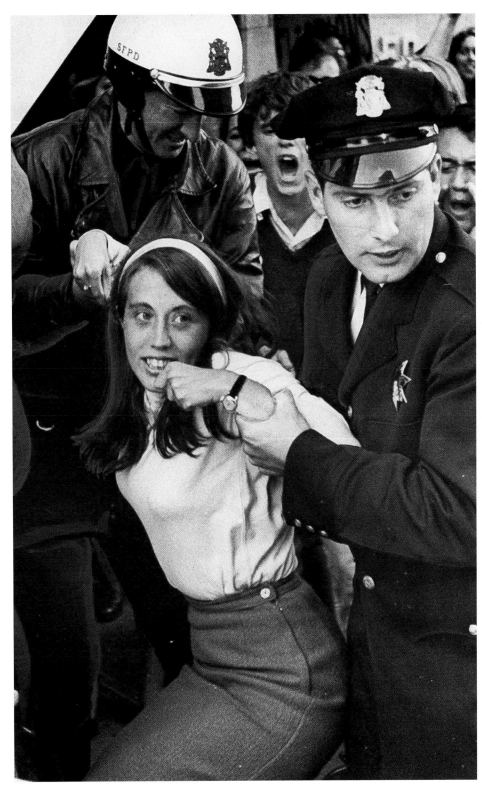

While people fought for civil rights in the South, students in the Bay Area were politically charged in the summer of 1964. They targeted the most famous high-end hotels, such as the Fairmont, the Sheraton Palace, and the Mark Hopkins, thinking that if these hotels succumbed to the strikers and agreed to hire more blacks, then other hotels would follow. Here, policemen take a young woman to a police wagon after she refused to leave the Sheraton Palace entrance during protests at the hotel in March 1964. The demonstration was held by the Ad Hoc Committee to End Discrimination. Linked arm-in-arm, 500 demonstrators—including both black and white local civil rights activists—laid down, blocking the exits of the upscale hotel at 4 A.M., while they chanted and sang. Of the 550 employees of the hotel, only 19 were black, and all held menial jobs. After several days of protest and almost 100 arrests, the strikers sat down, and police pulled them apart.

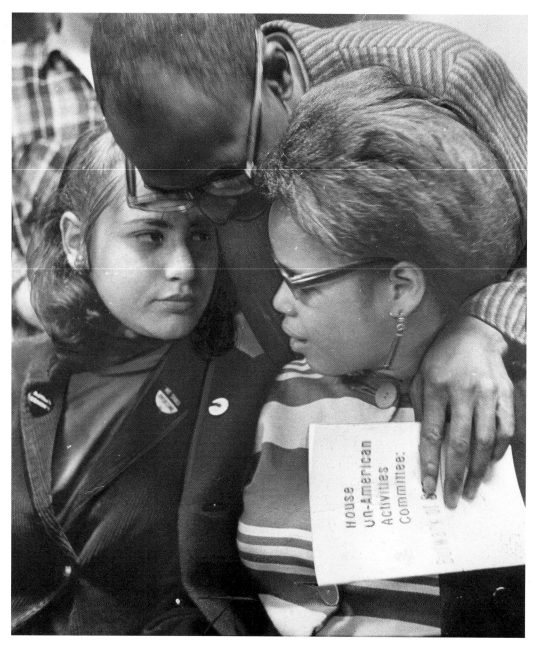

Civil rights activist Tracy Sims, at right, is being comforted by Heather Evans (left) and Percy Jones (middle) after her conviction on May 1, 1964. A judge sentenced Sims to 90 days in jail and a $200 fine. The 18-year-old leader of the Ad Hoc Committee to End Discrimination was the only one among 14 defendants found guilty of disturbing the peace during the Sheraton Palace Hotel sit-in. The others were acquitted by a jury of ten whites and two African-Americans. The first big demonstration organized by the Ad Hoc Committee was a sit-in at Mel's Drive-In, where blacks could eat but not work. Demonstrators sat in all the tables and booths and refused to order. Over 100 were arrested.

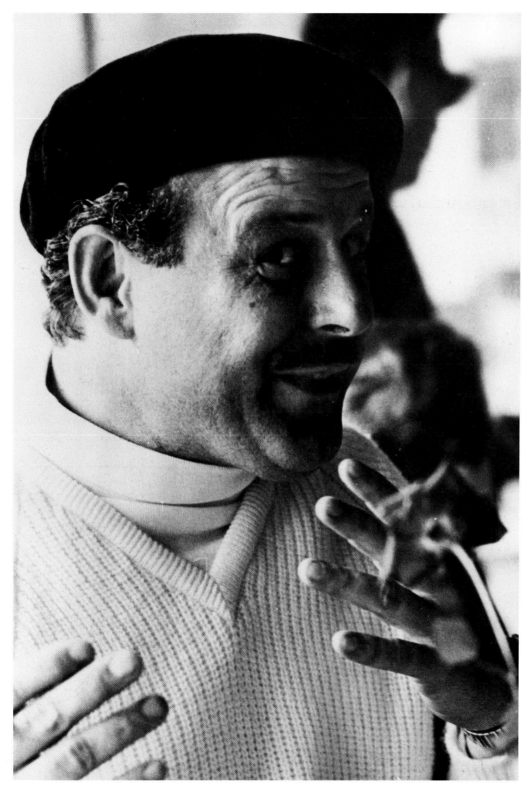

Enrico Banducci, pictured here on May 7, 1964, was the famed impresario of North Beach who ran the hungry i nightclub in the basement of the International Hotel at Kearny and Jackson streets. Banducci bought the club in 1948 from the previous owner, Eric "Big Daddy" Nord, for $800 (which he had to borrow). Banducci helped launch the careers of a teenaged Barbara Streisand, who made her debut there in the early 1960s, as well as Bill Cosby, Woody Allen, Richard Pryor, and others. His featured comedians performed in front of a red brick wall, now a staple in comedy clubs, and felt uncensored, free to poke fun at American cultural and politics. The meaning of the "i" in the hungry i was a bit ambiguous. It stood for either "intellectual," or, according to Banducci, for the "id" in Freudian thought. Banducci had a reputation for being an eccentric, which made him fit right into the San Francisco cultural scene. He married five times and always wore his trademark beret. Although it is estimated that he made up to $10 million over the years from the club and other ventures, he spent all his money, went bankrupt, sold the club, and even served time in prison at one point.

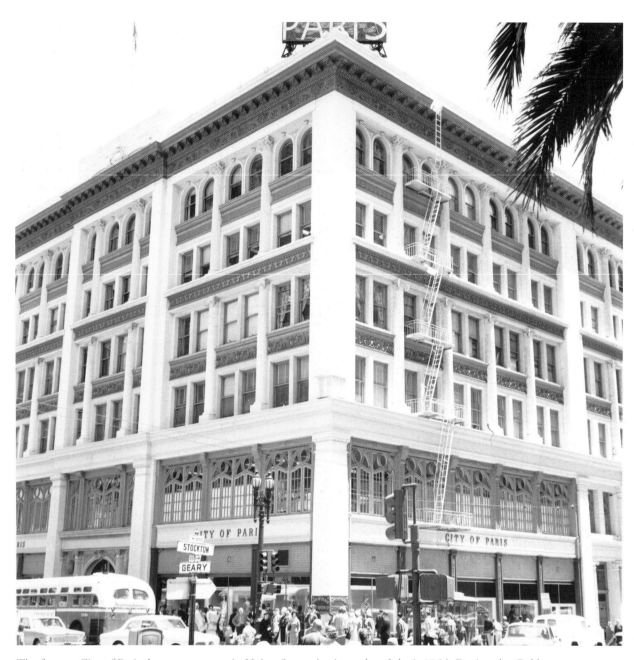

The famous City of Paris department store in Union Square is pictured on July 5, 1964. During the Gold Rush, the French Verdier brothers opened up a store called La Ville de Paris ("the City of Paris") on a ship in San Francisco Bay to cater to the needs of Argonauts passing through the city. In 1896, the business moved into a beautiful Beaux-Arts building, designed by architects John Bakewell and Arthur J. Brown, at the corner of Geary and Stockton streets in Union Square. It was demolished in 1981 and replaced with the Nieman Marcus that is there today, but the glass dome and part of the original rotunda from the City of Paris was salvaged and is still in the building.

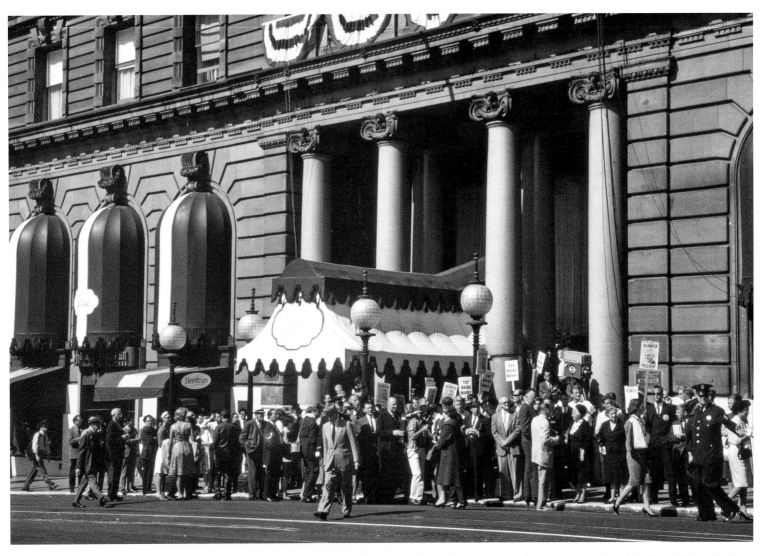

A crowd waits for Republican nominee Barry Goldwater in Union Square during the pre-convention of the Republican Platform Committee on July 10, 1964. Barry Goldwater (January 1, 1909 – May 29, 1998) served as the U.S. senator from Arizona and was the Republican candidate in the 1964 presidential election. Goldwater is credited for the resurgence of American conservatism in the 1960s. He was for less government, ending federal welfare, and a stronger military. He lost the election to Lyndon B. Johnson and returned to the Senate for three more terms before he retired in 1987.

137

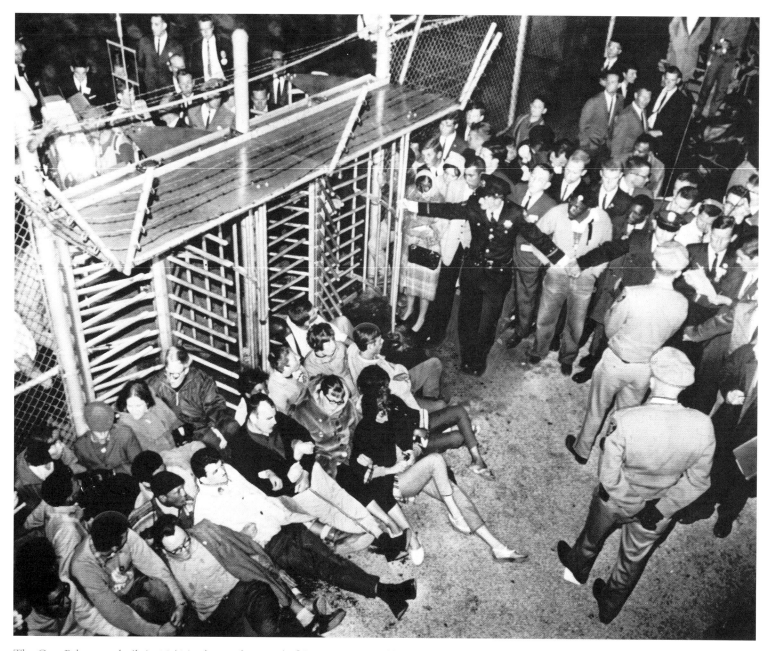

The Cow Palace was built in 1941 in the southern end of San Francisco and hosted both the 1956 and 1964 Republican National Conventions. Many San Franciscans feared that this signified the rise of the Republican Party in the West. Civil rights demonstrators are pictured blocking an exit from the Cow Palace during the Republican Convention on July 15, 1964. Conservative Barry Goldwater ran against Nelson Rockefeller to be the Republican candidate. It was the only Republican convention between 1948 and 2008 that did not have the names Nixon, Dole, or Bush on the ticket.

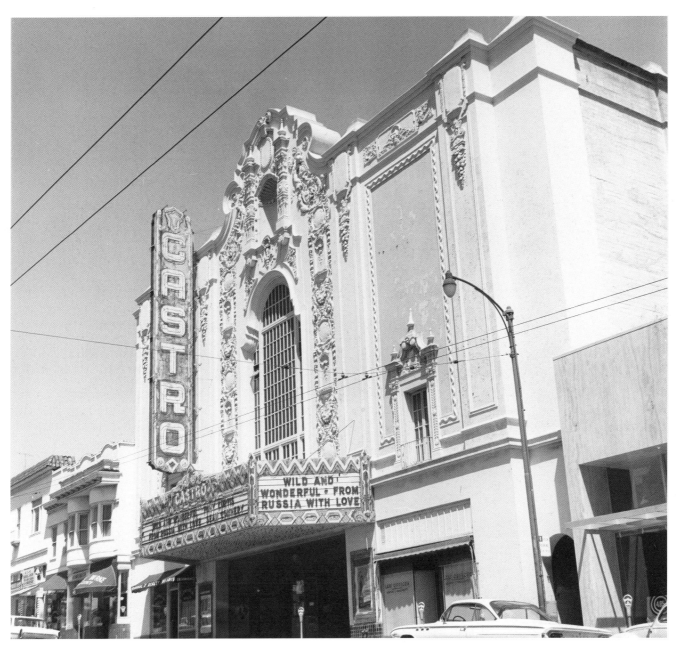

The Castro Theatre at 429 Castro Street is pictured on August 12, 1964. People now know the Castro District as San Francisco's and the nation's gay haven, but at this point, the neighborhood was still largely a conservative Irish-Catholic area. The Nasser brothers, pioneers in the early theater business in San Francisco, founded the theater in 1922. It was designed by famed architect and interior designer Timothy L. Pfluger, who later gained notoriety for building the Top of the Mark lounge at the Mark Hopkins Hotel, the Patent Leather Bar at the St. Francis Hotel, and the Fairmont's Cirque, and overseeing design of the Bay Bridge and the Golden Gate International Exposition in 1939. The Castro, which seats 1,400, features a Spanish Colonial Baroque exterior and ornate Italian, Spanish, Asian, and even Art Deco interior.

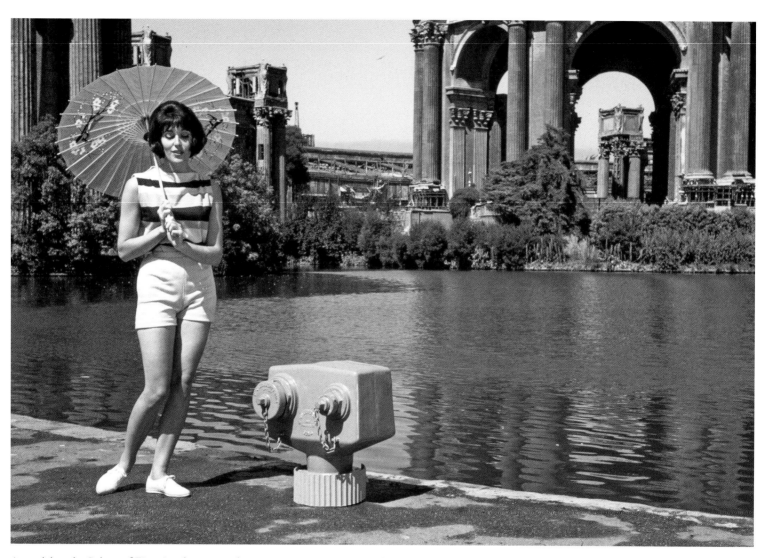

A model at the Palace of Fine Arts lagoon in the Marina District is pictured on September 11, 1964. After the devastation of the 1906 Earthquake and fires, San Francisco began a massive rebuilding project, adding almost 20,000 new buildings to its streets within a few years. After nearly a decade of rebuilding, the city celebrated the 1915 Panama Pacific Exposition. It officially signified the completion of the Panama Canal, which substantially shortened the voyage to San Francisco from the East, but more than anything, this exposition was a tribute to the old city lost in the quake and a celebration of the rebuilt city's endurance. Architect Bernard Maybeck designed the Palace of Fine Arts for the exposition to resemble the grand structures of antiquity. Construction on the Palace began on December 8, 1913, and today, the Exploratorium science museum is housed in the Old Exhibition Hall.

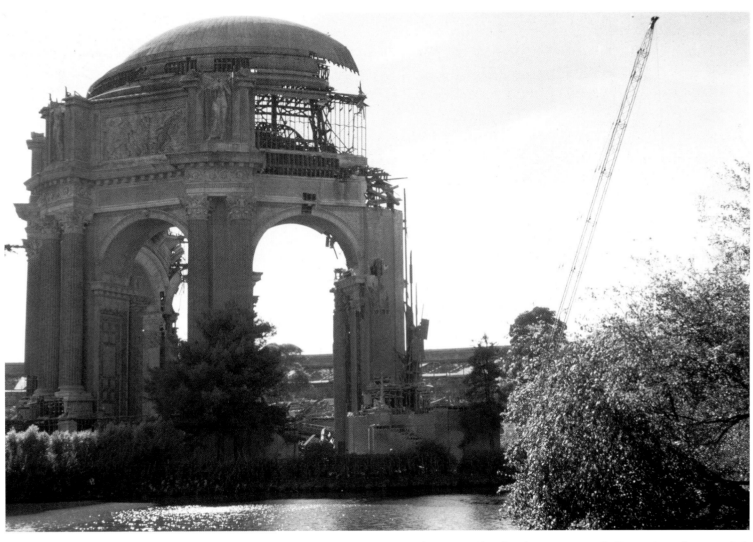

The dome of the Palace of Fine Arts is being restored on October 15, 1964. After the Panama Pacific Exposition of 1915 ended, San Franciscans were not yet ready to let the palace go, and efforts were made as early as October 1915 to preserve it. Initially, the San Francisco Art Association maintained the palace, and the U.S. Army used it during World War II as a motor pool. But after that, the building deteriorated considerably and was deemed a public hazard. The palace closed down in the 1950s, and the city planned to demolish it. However, philanthropist Walter Johnson led concerned citizens in efforts to save the palace and restore it. On July 20, 1964, reconstruction began. The dome was redone to ensure its longevity, and everything except the steel foundation was torn down and put back up with concrete reinforcement. In September 1967, work was completed.

Curious humans observe Mr. Inia Geoffrensis (better known as "Whiskers"), a freshwater pygmy pink porpoise from the Peruvian Amazon, at the Steinhart Aquarium in Golden Gate Park in 1964. The Steinhart Aquarium is part of the California Academy of Sciences, which began in 1853 as the first society of that type in the American West. The academy's original museum opened in 1874 at California and Grant in Chinatown and then moved to Market Street, only to be destroyed in the 1906 Earthquake. In 1916, it moved to its current site in Golden Gate Park, and in 1923, the Steinhart Aquarium opened. After the 1989 Earthquake severely damaged the museum building, the eco-friendly $500 million academy reopened in 2008 after extensive rebuilding. Today, over 38,000 animals live in the Steinhart Aquarium, including the albino American alligator.

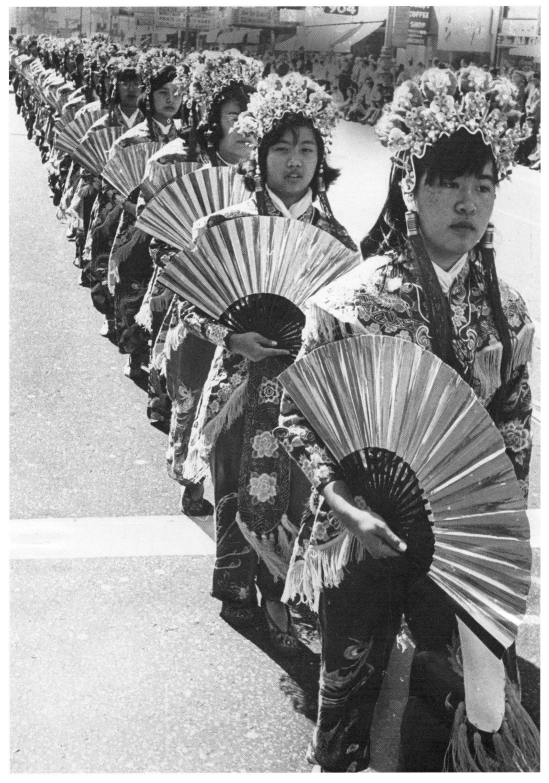

The St. Mary's Chinese Girls Drum Corps march in the Columbus Day Parade on October 10, 1964. Their uniforms were carefully selected to reflect their Chinese heritage. This renowned group has marched at parades around the state and across the country for 60 years and has won over 300 first-prize awards and received other recognitions.

Workers react enthusiastically on November 19, 1964, to news that Hunters Point Shipyard would not be closing. During World War II, Hunters Point was an exciting hub of wartime activity. Millions came to San Francisco to work in the new shipping industries opened by the war, especially a large number of African-Americans escaping the segregation and oppression of the South. Many stayed after the war.

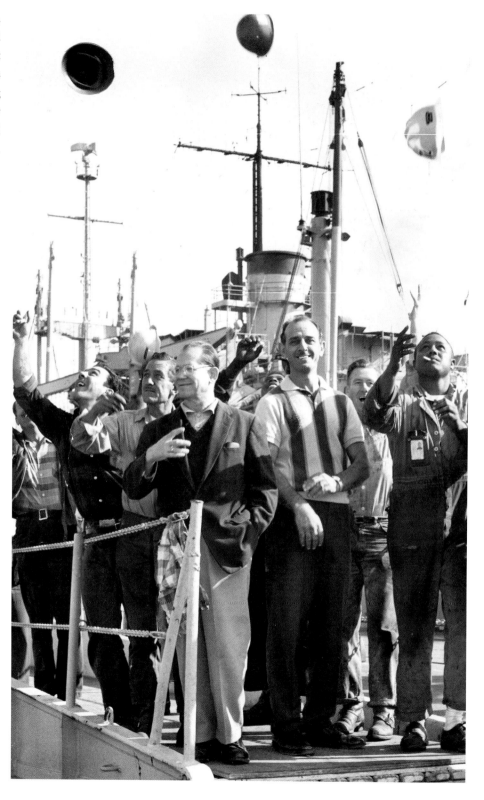

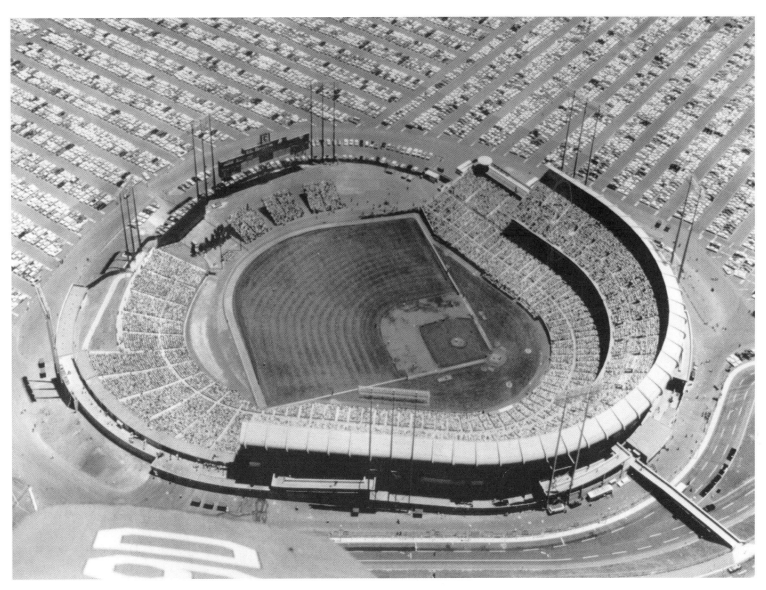

An aerial view of Candlestick Park is shown as 44,115 fans jammed into the park for the All-Star Game. Fans filled every seat, including ones installed temporarily for the game. In the bottom of the tenth inning, the National League came back on an "All-Star" rally: Hank Aaron singled, Willie Mays doubled, and Roberto Clemente singled and brought home both game winning runs. When first constructed, Candlestick Park had an open design in the outfield, which made it highly susceptible to cold high-speed winds from the bay. The outfield area was enclosed with the expansion of the upper deck in 1971 to expand seating capacity for the San Francisco 49ers, though the view of the Bay was lost and the winds became more unpredictably swirling and just as cold.

A smiling hot-dog vendor at Candlestick Park shows off the ballpark frank. During the heydays when the San Francisco Giants played at Candlestick Park, fans gorged on 300,000 pounds of hot dogs a year at the park. Concession owners, the Stevens Brothers, took great pride in their hot dogs and popcorn, boasting that their popcorn expanded to 38 times the size of the kernel and were thus major league popcorn kernels as opposed to minor league popcorn that expands to 24 times the kernel size.

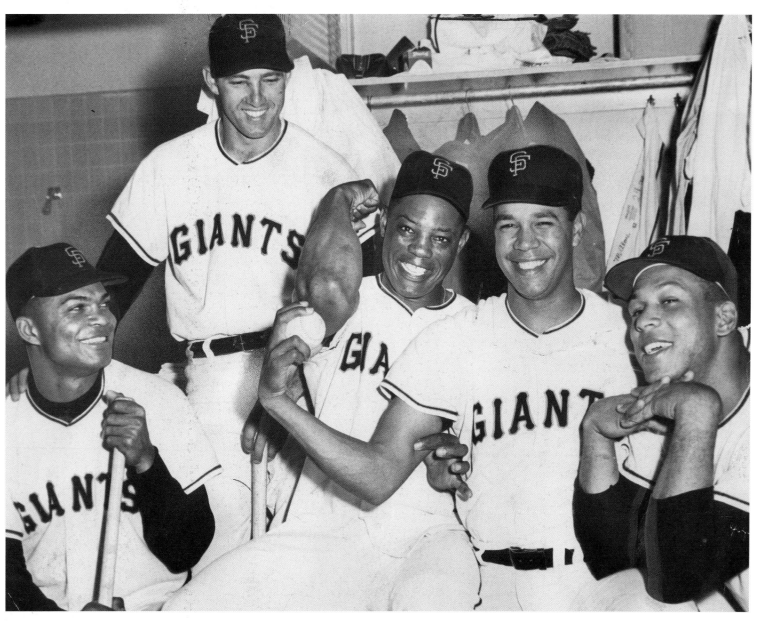

San Francisco Giants baseball heroes Felipe Alou, Jim Davenport, Willie Mays, Juan Marichal, and Orlando Cepeda, from left to right, are shown en route to the 1962 All-Star game.

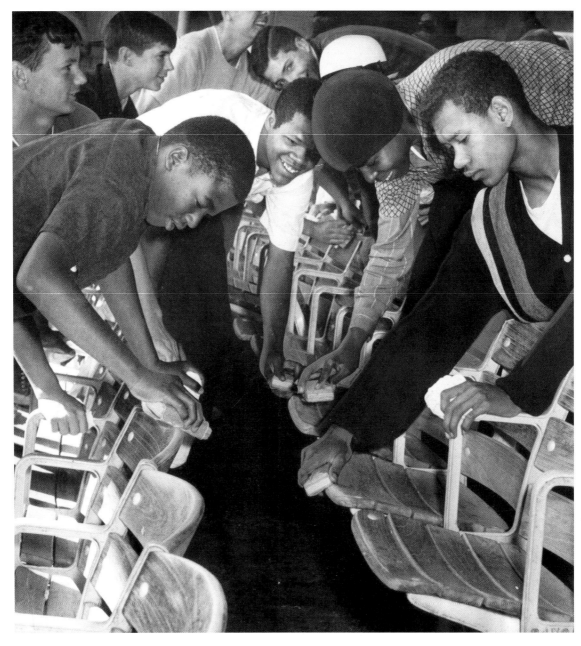

High-school students sand down wooden benches at Candlestick Park on July 21, 1964, during the SOS (Save our Stockings) project to protect ladies' stockings from snagging and tearing on the wooden seats. This project was part of the "work creation" program sponsored by the Recreation-Park Department which sent 32 teens into action against Candlestick Park's wooden seats. This five-day sanding operation provided summertime jobs to high-school students.

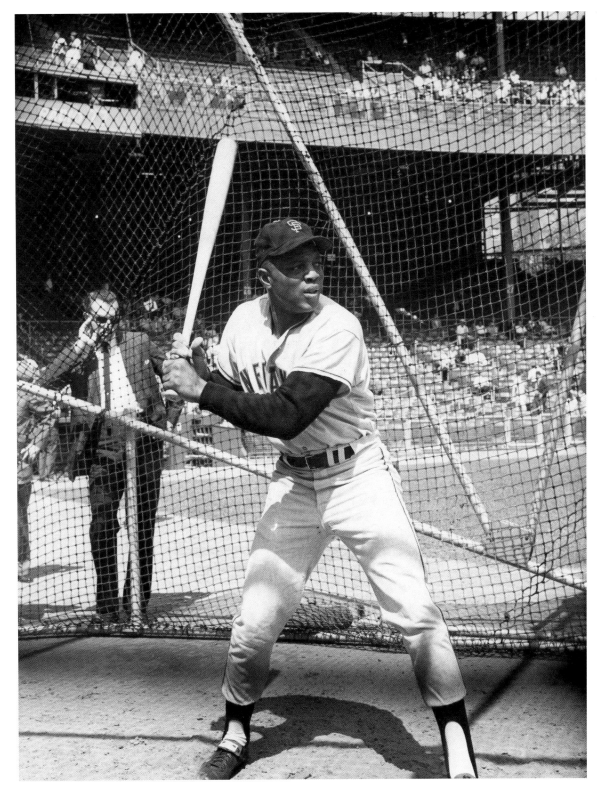

Willie Mays, the San Francisco Giant's superstar, considered by many to be the greatest baseball player of all time, is pictured here on December 24, 1964. In both the 1963 and 1964 baseball seasons, Mays had over 100 RBIs and hit 85 total home runs. Nicknamed the Say Hey Kid, he was elected to the Baseball Hall of Fame in 1979. Willie Mays, whose number 24 was retired by the Giants, is still revered by Giants fans. AT&T Park, where the San Francisco Giants have played since 2000, is located at 24 Willie Mays Plaza, where a larger-than-life statue of Mays greets Giants fans before they enter the main entrance to the ballpark.

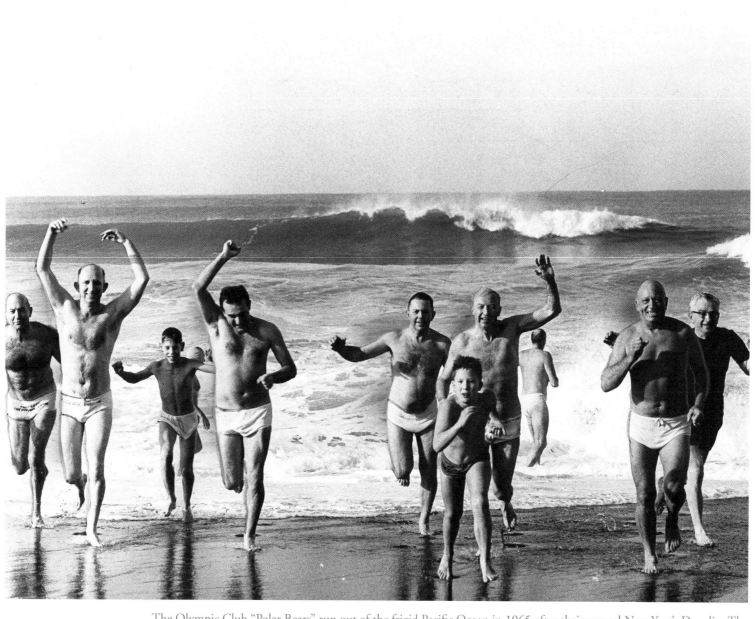

The Olympic Club "Polar Bears" run out of the frigid Pacific Ocean in 1965 after their annual New Year's Day dip. The Olympic Club is America's oldest athletic club, founded in 1860, with an active membership of over 5,000.

More than 700 demonstrators jammed the square in front of San Francisco's new Federal Building on February 13, 1965, as they hoisted a North Vietnamese flag. Federal guards, pictured here hauling down the flag, used clubs to break up the rioters. Police, FBI, and military authorities took steps to prevent an all-out invasion of the Presidio by crowds protesting America's war on North Vietnam.

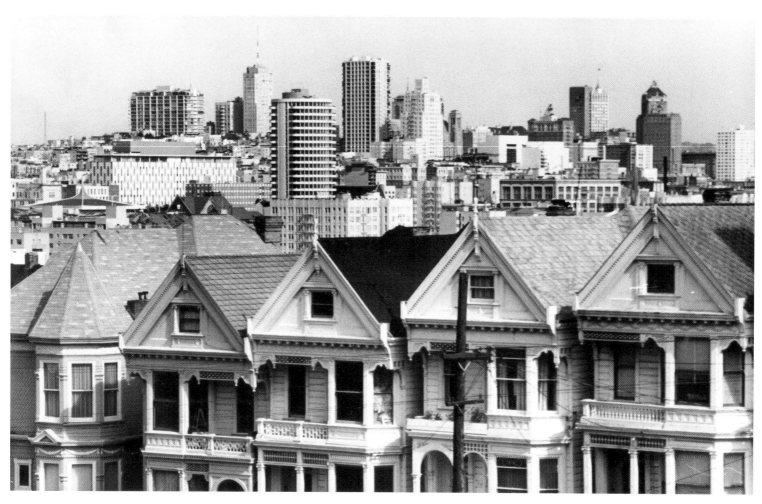

Old and new San Francisco are juxtaposed as modern skyscrapers serve as the backdrop for these beautiful turn-of-the-century Victorians on Steiner Street, pictured on February 27, 1965. This row of houses on Steiner Street, located in Alamo Square near the Western Addition, are the most famous "Painted Ladies" in San Francisco. This stretch, also known as "Postcard Row" because of how prominently they figure in images of San Francisco, was built between 1892 and 1896 by developer Matthew Kavanaugh, who lived next door at 722 Steiner. The family in the 1980s sitcom *Full House* lived in one of the painted ladies, which was shown at the beginning of each episode while the opening theme song played.

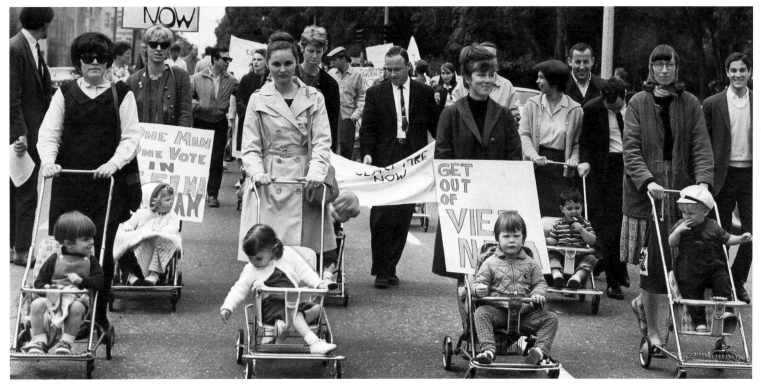

The Vietnam War was probably the least popular war in modern history. Protests in American cities and rural areas became commonplace in the mid 1960s and into the 1970s. Many citizens were opposed to the brutality and seeming senselessness of the war. In 1965, President Lyndon B. Johnson announced an escalation of the American involvement in Vietnam, and students at the University of California at Berkeley and at dozens of campuses across the country expressed strong opposition to the war through demonstrations and protests. In April 1965, a major antiwar march took place in Washington, D.C. In this photograph, taken in San Francisco on April 17, 1965, a group of women is pushing strollers down Oak Street on the way to the Federal Building in San Francisco as they lead a protest against the Vietnam War.

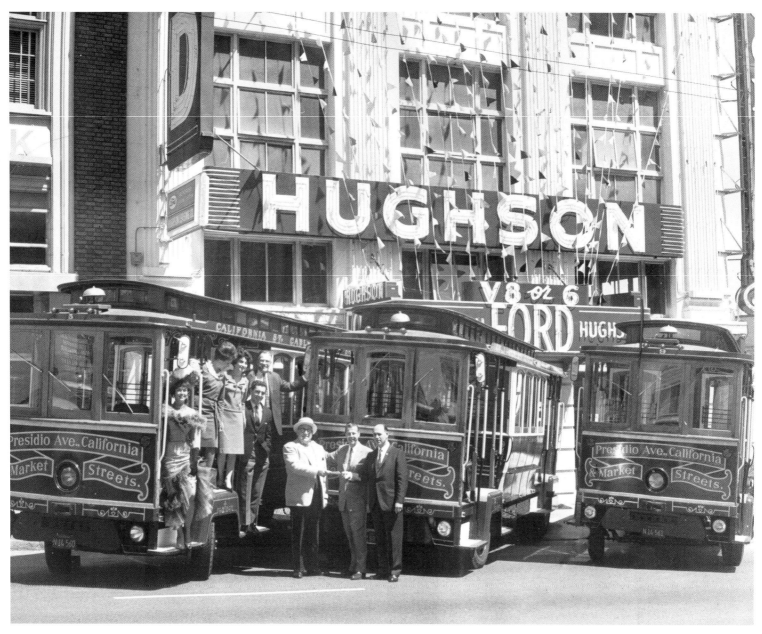

Motorized cable cars, mounted on Ford C-600 chassis purchased from Hughson Ford, are pictured on May 8, 1965, after having been used for promotional purposes by airlines and department stores. Arnold Gridley, president of Cable Car Advertisers, Inc., Bob Hellman, Vice-president and General Manager of Hughson's, and Jerry Urbach, Truck Manager of Hughson's, are standing with the cars.

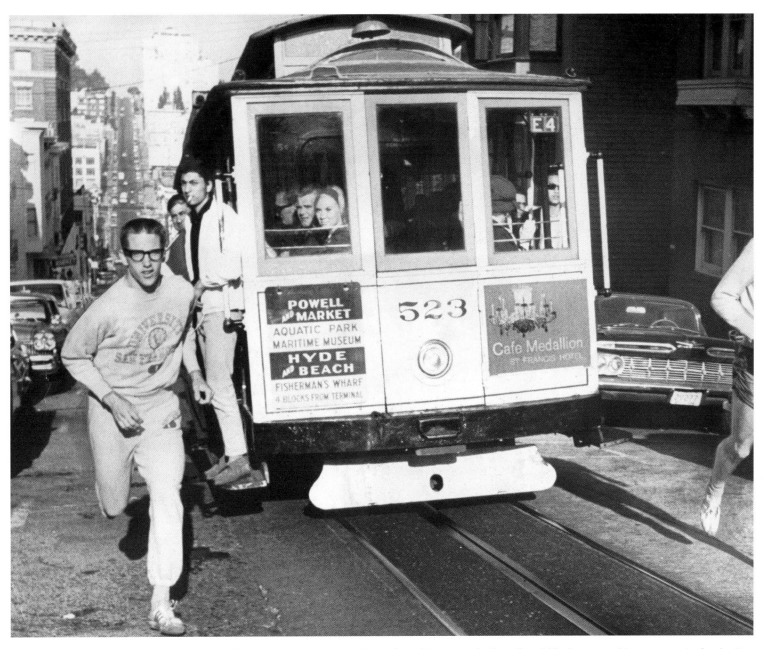

John Sweet and Rich League are running on May 14, 1965, next to the Powell and Hyde street cable cars to train for the Bay to Breakers, San Francisco's famous annual footrace. The 7.46-mile course is named for its route starting at the Bay (near the Embarcadero downtown) and ending at the "breakers" of the waves of Ocean Beach. Its founders hoped it would boost morale of the city, still rebuilding from the Great Quake of 1906. The race is one of the oldest and largest in the world. San Franciscans take the event very seriously, as it represents their city's unique character, athleticism, fun, and excesses. Serious athletes run alongside thousands of creative and outlandish costumed or sometimes naked runners. Participation has approached close to 100,000 at its highest, with an additional 100,000 spectators. Over 2.2 million people have participated since the first race was run in 1912.

Sandy Harrison and Corinne Greaves are pictured on May 19, 1965, visiting the historic sailing ship *Balclutha* at Fisherman's Wharf. The wooden beauty with whom the ladies are posing formed the prow of the old windjammer. The *Balclutha* set sail for San Francisco on January 15, 1887, arriving after 140 days at sea, and has stayed there ever since. Its complex rigging and 25 sails required a crew of 26 men. The three-masted steel-hulled square-rigged ship was built to deliver cargo around the world. It traveled around Cape Horn at the tip of South America 17 times. In the late nineteenth century, it delivered a large cargo of alcohol to the city, which at that time was in high demand. Tourists can now visit the historic ship at the Hyde Street Pier.

Sergeant Joe Galik and three dozen youngsters made a four-mile pilgrimage on July 21, 1965, from the Richmond District to the Sunset District to visit mounted policeman Edward P. Lawson, who was in a coma for three weeks after he fell from his horse in Golden Gate Park while he was chasing a bicycle thief. The youngest pilgrim was three years old, and the oldest was 13.

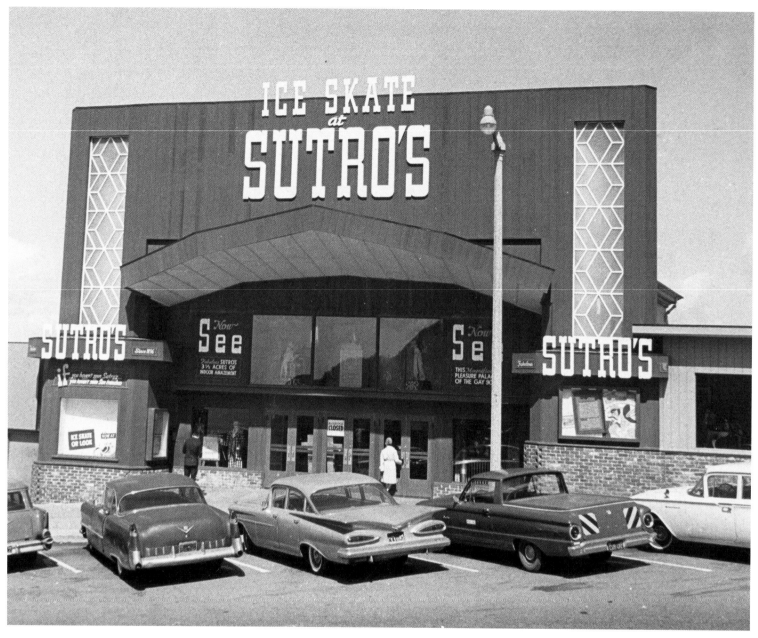

The front entrance of Sutro Baths Ice Skating Rink is pictured on March 1966. Adolph Sutro had earned a reputation as a populist, a man of the people who provided entertainment and cultural diversions for regular people at affordable rates. Despite the remote location of the Sutro Baths and Cliff House in the Outside Lands of the city, people came out in throngs. When other railroads wanted to price gauge customers to go out to Ocean Beach, Sutro simply built his own railroad, the Ferries & Cliff House Railroad, which went from Presidio Avenue and California through the sand dunes of the Outside Lands, along Land's End, to the Sutro Baths and Cliff House. At one point, the Baths reopened as "Tropic Beach," and they were converted to an ice-skating rink later. In 1952, he sold the baths for $250,000 to George Whitney, proprietor of nearby Playland at the Beach.

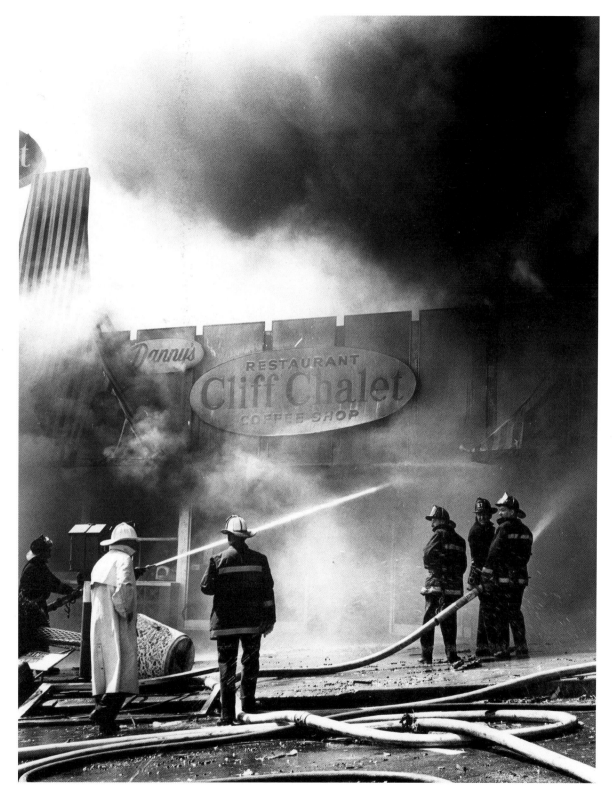

On June 26, 1966, a fire destroyed the Sutro Baths building, a fire considered by many to be "suspicious." Firemen are pictured among the smoke fighting the flames.

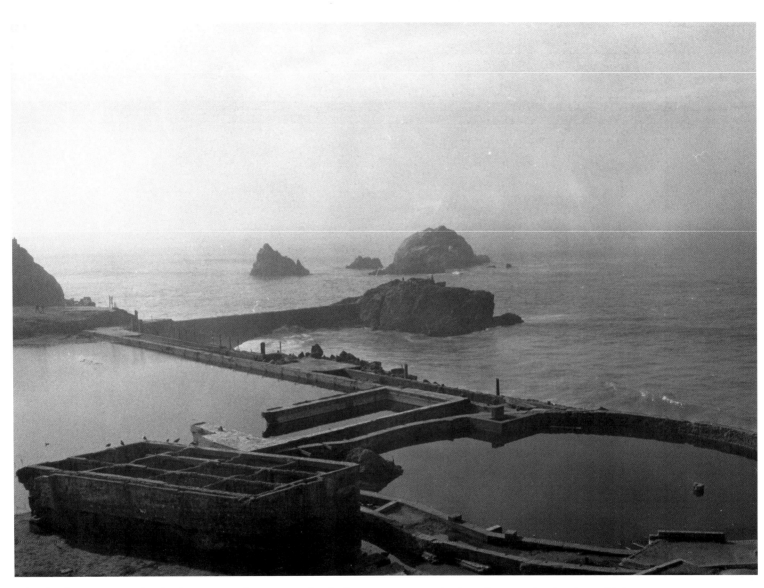

After the fire at Sutro Baths, developers wanted to convert the site into apartments and a shopping complex, but instead it became part of the Golden Gate National Recreation Area when the National Park Service bought it for $5 million in 1980. The ruins of the former Sutro Baths are pictured here long after the historic structure mysteriously burned down.

Students from Sunnyside Elementary School pose with a Muni railway operator on December 14, 1966. This public elementary school, named after its neighborhood, is located at 250 Foerster Street, not far from the Geneva Yard and Car Barn, Muni's primary site for storing historic streetcars.

On September 8, 1967, Mayor John F. Shelley accepts a statue of Juan Bautista de Anza (who led an expedition of colonists from Mexico to settle in present-day San Francisco) from Governor Luis Encinas of Sonora, Mexico. Serving from 1964 to 1968, Shelley was the first Democratic mayor elected in San Francisco in 50 years, starting an unbroken line of Democratic mayors in the city that continues to this day. His term spanned very troubled times in the city's and country's history, including many strikes over unfair hiring practices, the Bayview/Hunters Point riots of 1966, and the Summer of Love in 1967. After riots broke out in Bayview/Hunters Point on September 27, 1966, when a white officer shot and killed a black youth accused of stealing a car, the mayor called a citywide state of emergency. Shelley appointed the city's first African-American supervisor, Terry Francis.

In the 1960s, the Haight became synonymous with counterculture. Before the 1880s, sand dunes and a few farms dominated the underdeveloped area around Haight Street. In the late nineteenth century, when the Haight cable car line connected it with the Market Street line and the rest of downtown, the Haight developed into an upper-middle-class residential district of elegant Victorians. After World War II, the neighborhood fell into decline, and many buildings were abandoned. Consequently, the property values dropped, and the area became a haven for hippies. Attracted by cheap rent, many Beatniks from North Beach moved to the Haight and lived in the crumbling Victorians. Here at the apex of the neighborhood's hippie years is the store Wild Colors.

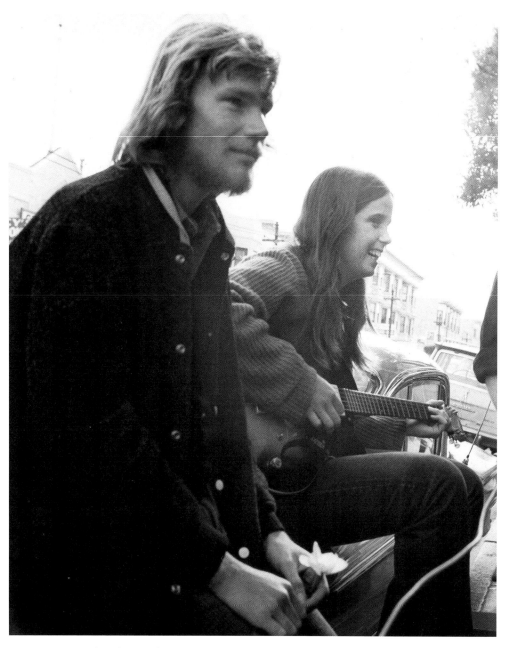

A man is pictured in the Haight in 1967, the year of the Summer of Love, also called the Long, Hot Summer. On January 14, 1967, 30,000 people gathered for the first-ever Human Be-in in Golden Gate Park, the precursor to the Summer of Love. Street artists performed for free, and drugs were cheap and plentiful. That summer, over 100,000 people converged on the Haight, bringing the hippie counterculture movement into public awareness. It was a social experiment as much as anything else, as young people gathered around a shared culture of sexual freedom, mind-altering drugs, communal living, and political ideology.

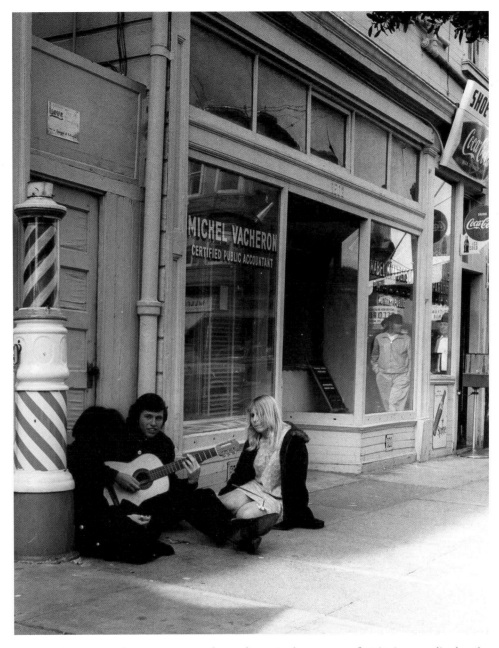

A musician plays to a two-member audience in the summer of 1967, immortalized as the Summer of Love. By 1960, a new movement was starting to develop, the San Francisco Sound. Influenced by the Beats, the Sound was an eclectic mix of folk, jazz, rock, and Eastern music with an emphasis on live performance. San Francisco became the center of the music scene, the hub of rock music. The Fillmore Auditorium, the Avalon Ballroom, and Winterland featured upcoming groups like the Grateful Dead, Jefferson Airplane, and Janis Joplin. The new music scene inspired a UC Berkeley dropout to start a new San Francisco–based music magazine, *Rolling Stone.*

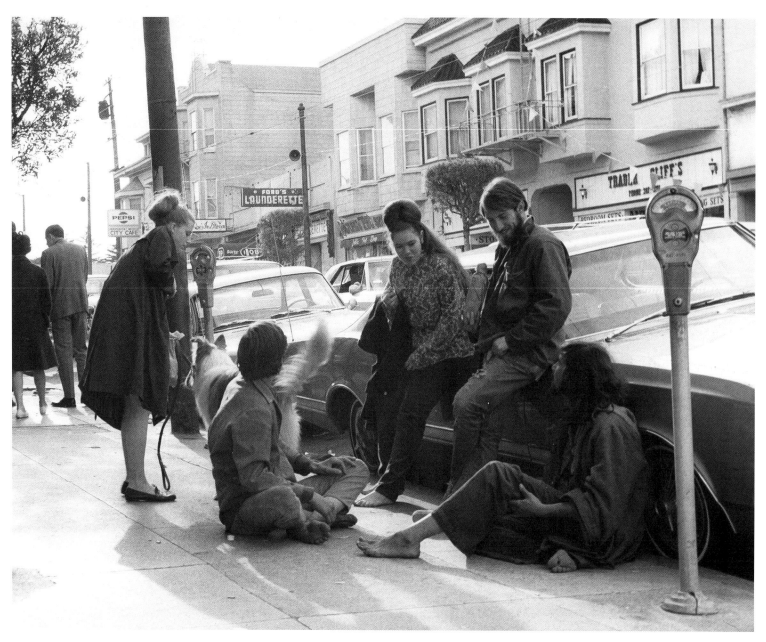

People are pictured hanging out in the Haight. In the aftermath of the Summer of Love, the neighborhood fell back into decline in the 70s and 80s. With citywide gentrification in the 1990s and an influx of new young urban professionals and people in search of the hipster lifestyle, the Haight has seen an upswing. Businesses there decided to capitalize on the neighborhood's hippie legacy, and the Haight was turned into a tourist attraction. Haight-Ashbury still evokes images of flower children, hippies, drugs, and counterculture, and it remains a center for independent business, restaurants, thrift stores, music, and bookstores.

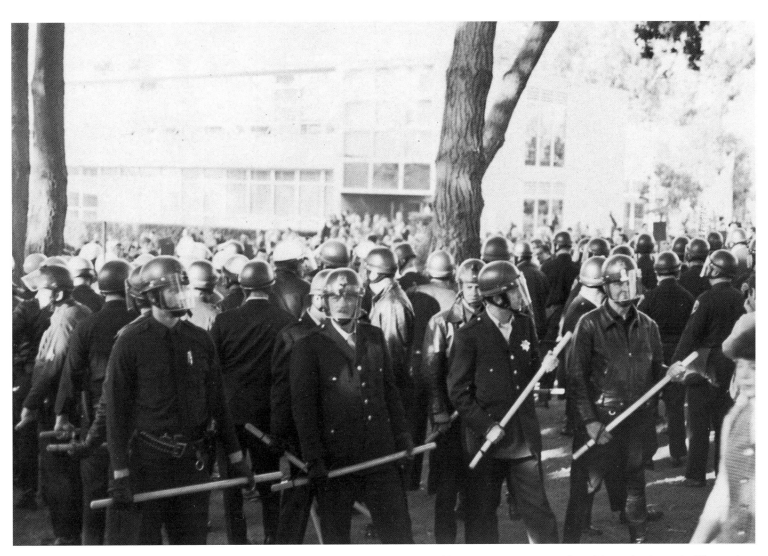

Police attempt to control the riots at San Francisco State College, now San Francisco State University, in 1968. The student strikes made global headlines. Led by the Third World Liberation Front, the strikers had the goal of creating an ethnic studies department, as well as protesting the Vietnam War. A series of protests there had been going on since 1966, including sit-ins, teach-ins, rallies, and marches—and violent confrontations with the police. The largest and longest-running strike lasted from the fall of 1968 until March 1969, when police representing multiple jurisdictions occupied the campus and arrested over 700 people. College president S. I. Hayakawa even pulled out the wires from speakers atop a van in the midst of a rally. By the following spring, the strike ended with the creation of the College of Ethnic Studies.

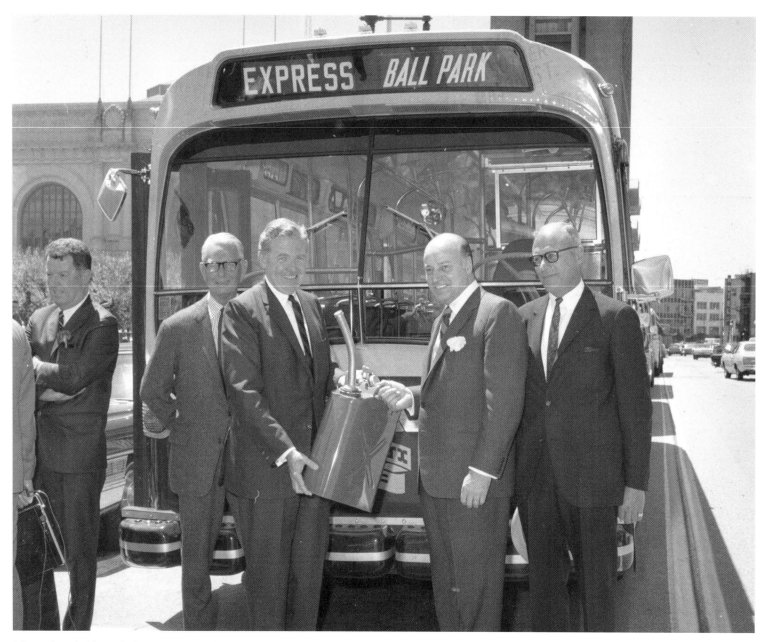

Mayor Joseph Alioto (February 12, 1916 – January 29, 1998) served as mayor of San Francisco from 1968 to 1976 during a time of major turmoil and change in San Francisco. He worked to reduce taxes and crime, was a major force behind the development of BART, the Transamerica Building, and the Embarcadero Center, and brought more minorities into city government. Alioto and others are pictured at a dedication of new Muni buses on June 24, 1969. The popular GMC "New Look" buses served as the backbone of Muni's diesel bus fleet until they were retired in the 1990s.

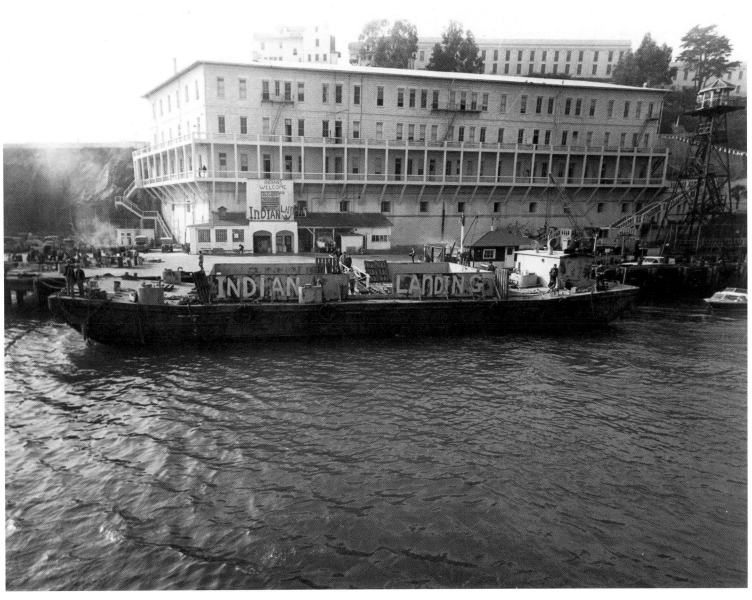

In the 1960s, Native Americans were the poorest American ethnic group, with unemployment rates ten times the national average and a life expectancy 20 years shorter than the national average due to poverty and disease. The civil rights movement inspired young Native American activists to also fight for their rights. On November 20, 1969, Richard Oakes, along with over one hundred Indians and groups of Indian students, took over Alcatraz and started a 19-month occupation of the island. The goal of this occupation was to raise awareness among the general American public to the plight of the destruction of the traditional Indian way of life, and the need to achieve self-determination among American-Indian tribes. The Indian Occupation on Alcatraz is pictured here on November 20, 1969.

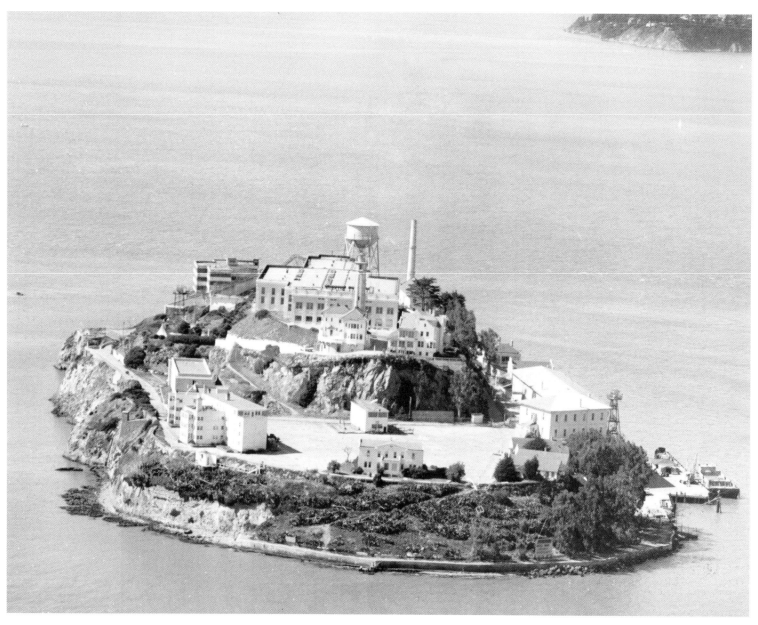

An aerial view of Alcatraz is pictured during the Indian Occupation, when several American Indians either lived on the island or helped provide food, water, and money for the occupation. The occupiers endured harsh conditions on "the Rock" for over a year and a half without adequate water, heat, and electricity. As the Alcatraz Occupation gained more international attention, thousands came to the city from across the country to show their support for the rise of "Red Power." On June 11, 1971, U.S. marshals, FBI agents, and GSA federal protective officers removed the remaining 15 Indians, consisting of six men, four women, and five children. The occupation brought a resurgence of pride for native cultures and traditions and temporary freedom from control of the federal government. It signified a major milestone of Indian activism during the 1960s and 1970s and set the stage for further demonstrations that followed in the Indian Activism Movement, including Wounded Knee II in 1973.

The 1970s:

Continued Protests, a Divided Country, and

Conclusion of the Vietnam War

As the 1970s dawned, the angst, violence, and spirit of social revolt of the 1960s carried over. President Nixon had campaigned that he had a secret plan to end the war and achieve "peace with honor," but his critics pointed to his early political successes as staunchly anti-Communist and were not optimistic.

The country was deeply divided over the issue of Vietnam, and in the early seventies, the war protests became more desperate and militant, as typified by the slaying of students at Kent State University in Ohio on May 4, 1970. In San Francisco, the tumultuous decade began with hostage attempts and shootouts in the Marin County Courthouse, and a bloody escape attempt and killing in San Quentin Prison. Between 1972 and 1974, at least 71 people died in the San Francisco Bay Area in a series of racially motivated street killings known as the Zebra Murders.

One of the most infamous and bizarre incidents of this time was the abduction of 19-year-old Patty Hearst, of the Hearst publishing dynasty, by a radical group known as the Symbionese Liberation Army. After two months of imprisonment, Hearst joined her captors in a bank robbery in San Francisco. After being captured, Hearst served two years in prison, although President Carter shortened her sentence. The attempted assassination of President Gerald Ford outside of the St. Francis Hotel in Union Square on September 22, 1975, by Sara Jane Moore marked another frightening episode in the decade. Violent gang wars plagued Chinatown throughout the 1970s, culminating in the notorious Golden Dragon Massacre at a Chinatown restaurant, killing five people, including two tourists, and injuring 11.

America's involvement in Vietnam finally ended in 1975 as American diplomats escaped from the roofs of buildings near the U.S. embassy in Saigon, televised to hundreds of millions of viewers all over the world. The United States had been so wounded in the previous decades that it seemed to be looking for spiritual healing. In turn, an explosion of alternative religious movements proliferated in San Francisco and the rest of the nation. In November 1978, cult leader Jim Jones, minister of the Peoples Temple with headquarters in San Francisco, took a thousand followers, 300 of whom were children, to "Jonestown," Guyana in South America, in search of Utopia. Instead, it became the scene of a mass-murder suicide as

909 of Jones's followers drank cyanide-laced beverages following the murder of California congressman Leo Ryan, who had traveled there to investigate the cult.

The energy and proactivity of the many mass demonstrations of the 1960s eventually extended into the domestic sphere. The most prominent causes in San Francisco in the 1970s were women's liberation and the gay rights movement. Inspired by Betty Friedan's 1963 book, *The Feminine Mystique,* and the introduction of the birth control pill in the 1960s, the women's movement took center stage in the 1970s. Women fought for equality and to end discrimination in employment, and challenged sexist power structures in America.

In the 1970s, gays also fought for acceptance and political power. In 1970, 2,000 men and women took part in the San Francisco's first Gay Pride Parade. At this time, Eureka Valley transformed into the Castro District, making it the gay capital of the world. Harvey Milk became the first openly gay San Francisco County Supervisor, the unofficial "Mayor of Castro Street," and a symbol for the gay rights movement. Milk's election sent shockwaves across the country. He became a close political ally with the new liberal mayor, San Francisco native George Moscone. They found themselves at odds with city supervisor Dan White, who was refused job reinstatement after resigning due to personal financial problems.

On November 27, 1978, White shot and murdered Mayor Moscone and Harvey Milk, but a jury convicted White of manslaughter and sentenced him to only seven years in prison. The verdict outraged San Franciscans and instigated the violent White Night Riots, when thousands marched to City Hall. White served only five years in prison and committed suicide upon returning to San Francisco. In the last years of the seventies, Feinstein became San Francisco's first (and to date, only) female mayor, and faced the problem of leading the city to healing and renewal.

By the end of the decade, people had completely lost faith in their political leaders and government due to the resignation of President Nixon over the political abuses of the Watergate scandal, the pardoning of Nixon by President Gerald Ford, an oil crisis and long gasoline lines, a weak economy, a hostage situation in Iran, and the ineffectiveness of the Carter presidency. Disco, the new sound of the final years of the decade, represented the ultimate in escapism: its lyrics were utterly devoid of any political or social significance, and San Francisco offered a plethora of clubs where people could forget their troubles and dance the night away.

As the seventies came to an end, people were ready for a new beginning. In the next decade, the country clearly would turn, taking a more conservative path as the Age of Reagan began. The economy eventually would improve, the Vietnam War was over, and many of the perceived inequities that had been the cause of protest seemed to be resolved. Many hippie men and women who grew their hair long and took part in all of the drugs, music, and protesting put on suits, joined the establishment, and began working for banks, insurance companies, and industry in the eighties. Undoubtedly, the participants remembered fondly the exciting years of San Francisco in the 50s, 60s, and 70s, when they and the world were young and the City by the Bay seemed to be the center of the universe.

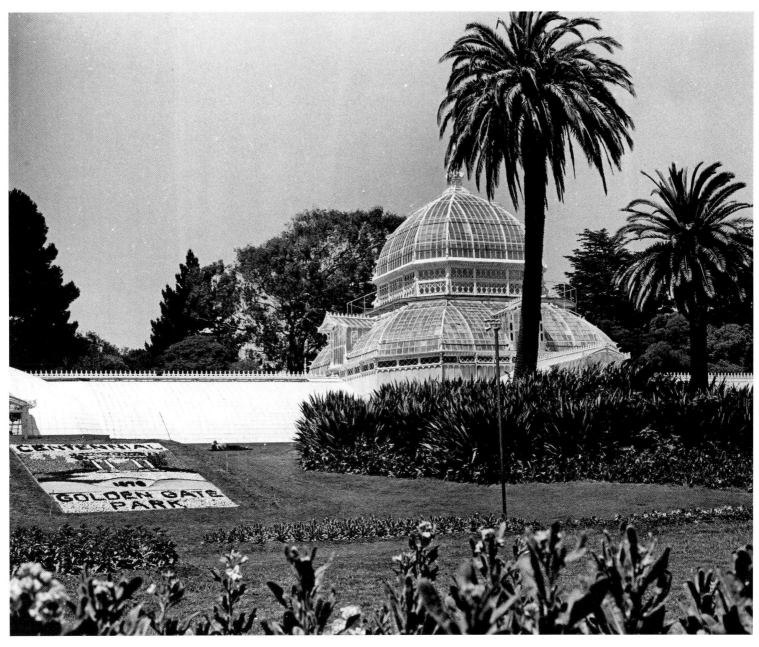

A floral display outside the Conservatory of Flowers was created for the Golden Gate Park Centennial in July 1970. The oldest wood and glass conservatory in North America, the Conservatory of Flowers opened to the public in 1879 and is a city, state, and national historic monument. James Lick, an early San Francisco pioneer who participated in the Gold Rush and was the wealthiest man in California at the time of his death, bought construction materials for the conservatory but died in 1876 before it was built. San Francisco bought the conservatory for the park as part of the city's beautification campaign to offer open spaces for the rising urban population. The beautiful Victorian botanical greenhouse is the oldest building in the park.

173

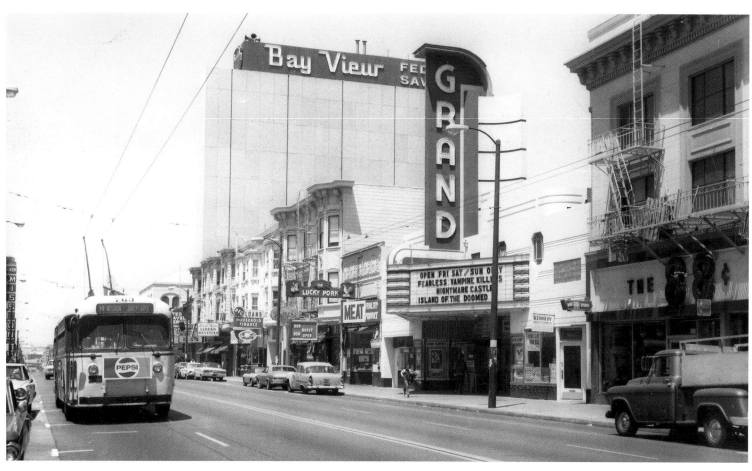

The Grand Theatre at 2665 Mission Street is pictured in 1970. By the early 1900s, Mission Street had a high concentration of movie theaters and stores and was dubbed the "Mission Miracle Mile." Historically, the Mission District has always been home to many immigrants, including the Jewish, Irish, and Germans in the nineteenth and early twentieth centuries. After the 1906 Earthquake and fires, many displaced people and businesses relocated to the Mission, and the street became a major thoroughfare. The Irish and the Italians remained in the area long after the earthquake, and later, Mexicans and then Beatniks settled there. Mission Miracle Mile is now the main working-class shopping street for the 60,000 living nearby, and at night, young people from all parts of the city flock to the area for its ethnic restaurants and trendy bars.

A collision of freighters beneath the Golden Gate Bridge caused a massive oil spill in 1971. Here, citizens at Ocean Beach are cleaning up the spill. One of the legacies of the hippie movement was the rise of environmentalism. Earth Day, which originated with peace activist John McConnell in 1969, is celebrated annually at the Spring Equinox, around March 20. America's first Earth Day Proclamation, which promoted the cleanup of streets, parks, and beaches, was given by San Francisco mayor Joseph Alioto on March 21, 1970.

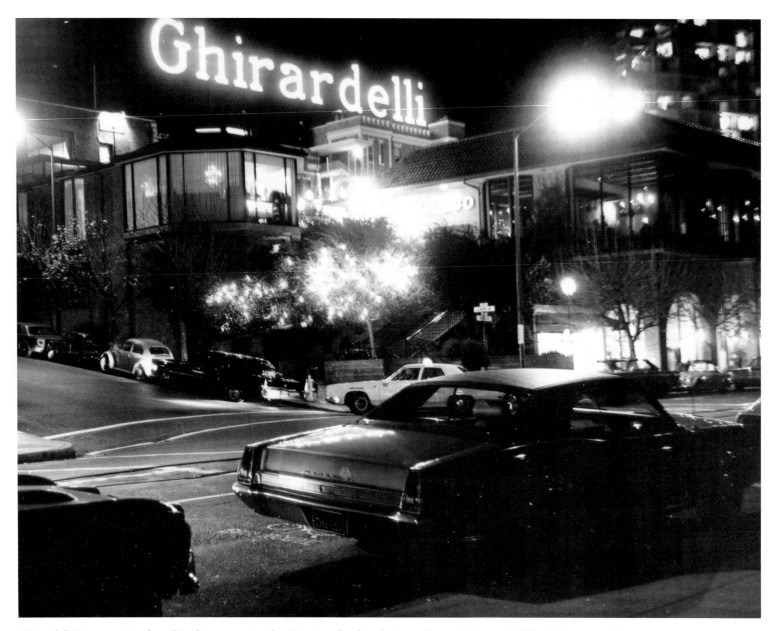

Ghirardelli Square at Beach and Larkin streets is a San Francisco landmark. Located near Fisherman's Wharf, the square features a variety of shops and restaurants, including the wildly popular Ghirardelli ice-cream shop. During the Gold Rush, Italian immigrant Domingo Ghirardelli came to California and sold his confections to miners in the gold fields. In 1852, he founded his first chocolate factory in San Francisco at the corner of Broadway and Battery. In 1893, he bought the entire block of what would become Ghirardelli Square as the headquarters for his Ghirardelli Chocolate Company. In 1967, the production of the chocolate moved to San Leandro, but San Franciscans and tourists alike can still go Ghirardelli Square in search of the best ice-cream sundaes in town. Prisoners at Alcatraz were said to have salivated over the aroma of fresh chocolate wafting over the Bay.

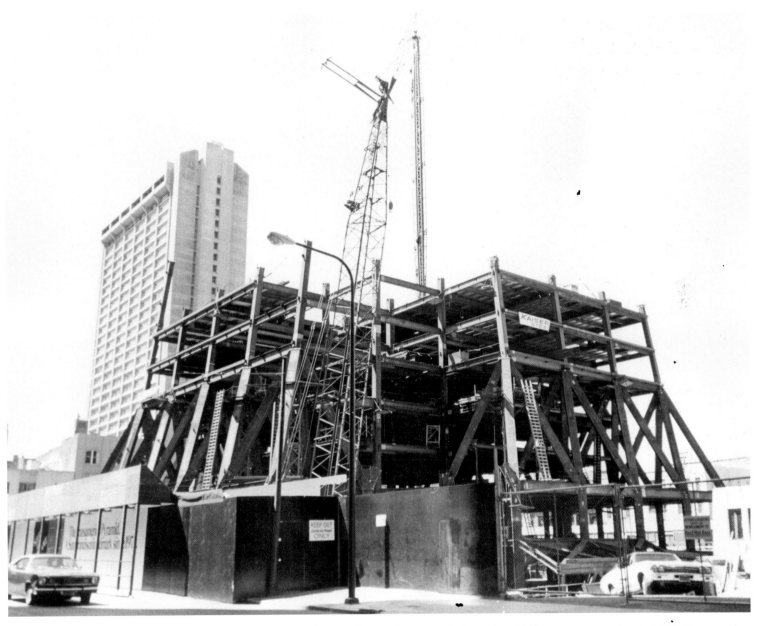

The Transamerica Pyramid, San Francisco's most famous skyscraper, is shown in middle-stage construction in 1971. Construction began in 1969 and was completed in 1972, forever changing the San Francisco skyline. The landmark was built to house the Transamerica Corporation and is still the company's logo. Architect William Pereira designed the 850-foot-tall, 48-floor building, and until 1974, it was the tallest skyscraper west of the Mississippi and remains one of the top 200 tallest buildings worldwide. The Pyramid exterior is covered in crushed quartz, giving it the white color it is known for. In 1999, it became the headquarters of the Dutch insurance company AEGON. Although the observation deck closed after September 11, 2001, the 212-foot spire houses cameras that form a virtual observation deck, controlled and viewed by visitors in the lobby.

San Francisco's Twin Peaks are two high hills in the center of the city, the second highest points in the city after Mt. Davidson. The surrounding neighborhood is also called Twin Peaks. On a clear day, the views of the city and Bay from the top of the peaks are stunning, as is evident in this November 1972 picture.

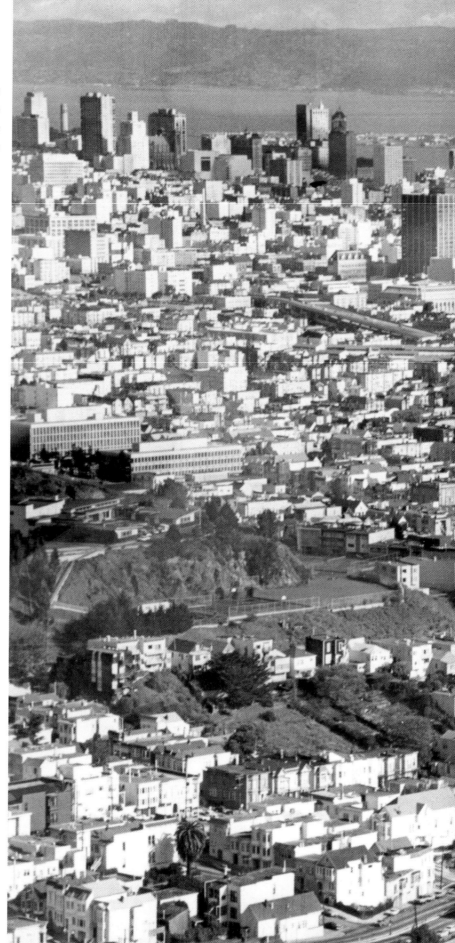

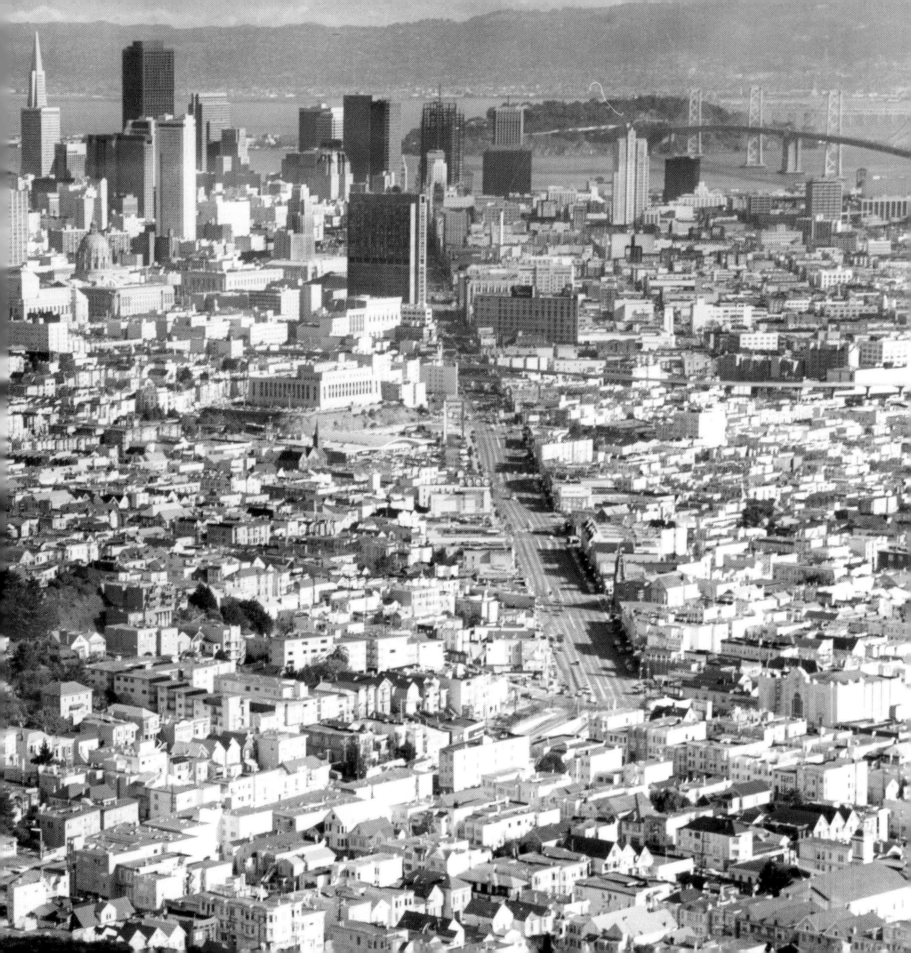

The Transamerica Pyramid dominates the San Francisco skyline as seen in this March 3, 1973, photograph that was taken from the Mark Hopkins Hotel at the top of Nob Hill.

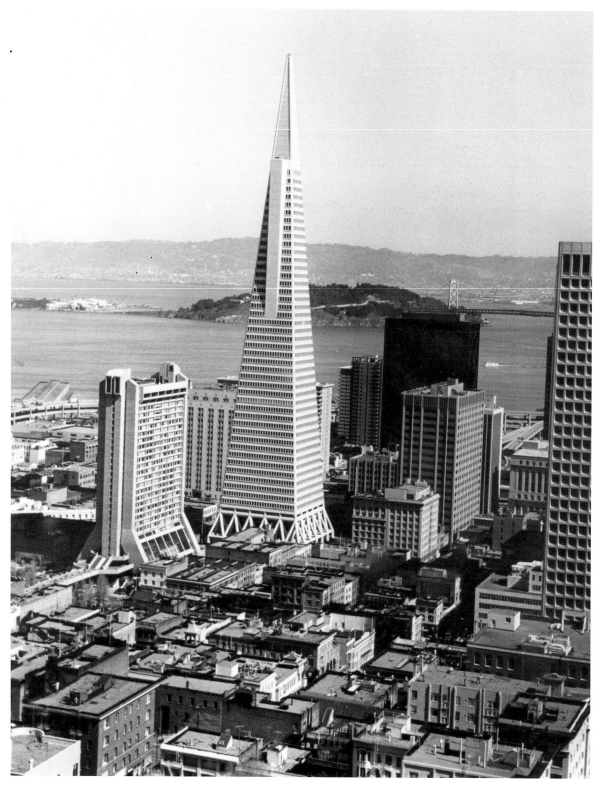

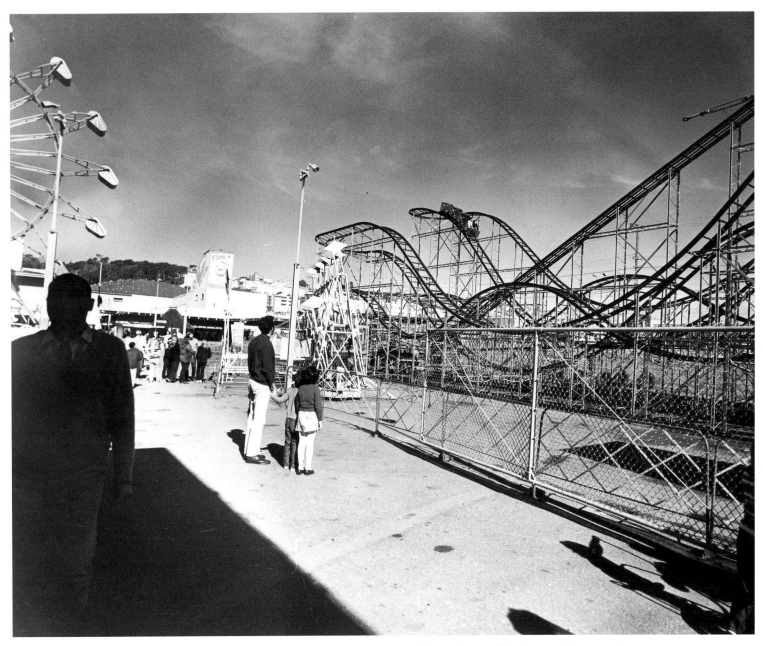

A favorite ride at Playland at the Beach was the Big Dipper roller coaster, designed by Arthur Looff and opened in 1922. At one point on the scary ride, which took one minute and seven seconds, the cars dropped over 80 feet. George Whitney purchased the Big Dipper in 1936, but the wooden roller coaster was torn down in 1955 when it failed to meet safety regulations. Although Playland began declining in popularity in the 1960s, the Big Dipper was replaced by a smaller steel roller coaster, the Alpine Racer, which met the new safety standards. The Alpine Racer had some scary hairpin turns on the flat top and made riders feel like the cars were going over the edge. However, many San Franciscans believed the Alpine Rider, shown here in 1971, was less exciting than the Big Dipper.

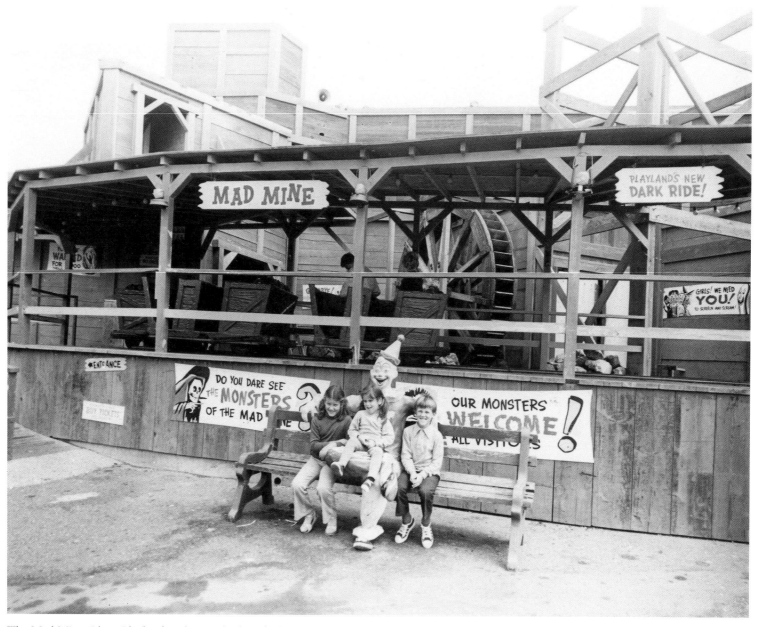

The Mad Mine ride at Playland at the Beach, described in nearby signs as a dark ride where monsters are welcome, is shown on its final day of service, September 4, 1972.

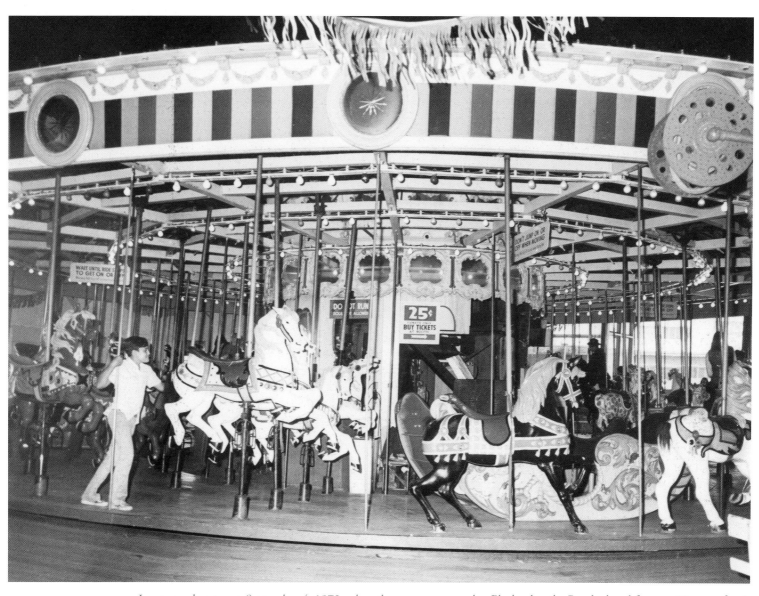

It was a sad scene on September 4, 1972, when the merry-go-round at Playland at the Beach closed forever, 58 years after it opened. In the postwar years, the amusement park's management closed down some of the most beloved attractions, such as the Big Dipper roller coaster and Chutes at the Beach, and the park was never the same. After Whitney's death in 1958, Playland's management was passed on to his son and then to Bob Frazier, and was eventually sold to developer Jeremy Ets-Hokin in 1971. The famous carousel has been refurbished and is now located at the Yerba Buena Gardens.

After Playland at the Beach was torn down in 1972, the lot remained vacant for nearly a decade before expensive, nondescript condominiums eventually replaced the beloved park. The construction site of the would-be Ocean Beach apartments is pictured here in June 1973. The lot remained vacant for a decade afterwards as punishment from the city because the contractors did not have a demolition permit. As Playland was being demolished, local neighborhood children salvaged Playland memorabilia from the dumpsters and saved many historic and antique items from the park. They are now available for public viewing at a museum 20 miles away in El Cerrito, aptly called Playland-Not-At-The-Beach.

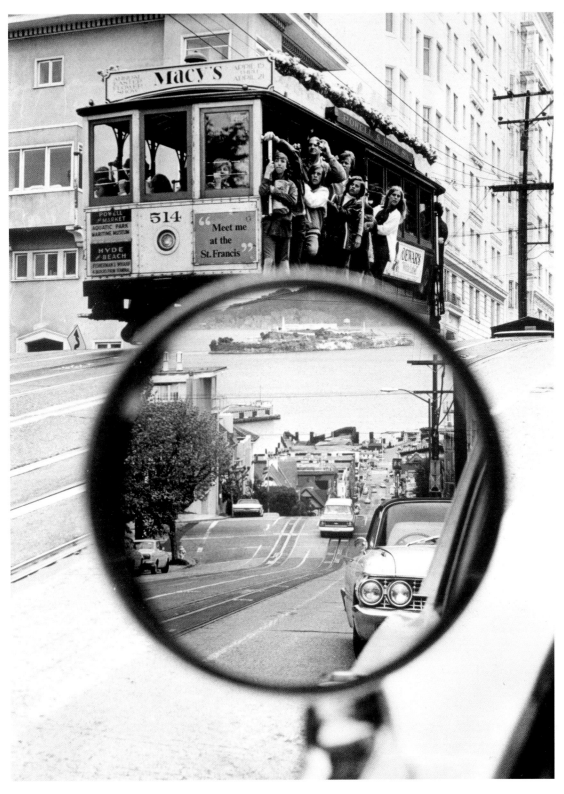

A flower-topped Hyde Street cable car heads down Russian Hill towards the San Francisco waterfront with its route reflected in the sideview mirror of a parked car. Nineteen of the city's cable cars were elaborately decorated for their Centennial Celebration in August 1973. Russian Hill is an upscale neighborhood in San Francisco known for its charming stores and restaurants as well as beautiful views of the city. It got its name after people discovered the graves of Russian fur traders atop the hill during the Gold Rush. To the north of Russian Hill is Fisherman's Wharf, to the south is Nob Hill, to the west is Pacific Heights and the Marina, and to the east is North Beach.

Diane Feinstein is pictured shaking hands with a new student officer at Sir Francis Drake Elementary School in December 1973. Today, Feinstein is a Senior U.S. Senator from California. She served as mayor of San Francisco from 1978, after Mayor Moscone was assassinated, and was elected and reelected afterwards, serving until 1988. In a decade when women fought for equality in society, Dianne Feinstein blazed the trail for the women's movement as she set many milestones—becoming the first female president of the San Francisco Board of Supervisors in 1969, and San Francisco's first (and only to date) female mayor, as well as the first woman to serve the U.S. Senate from California, and the first woman who presided at a Presidential inauguration.

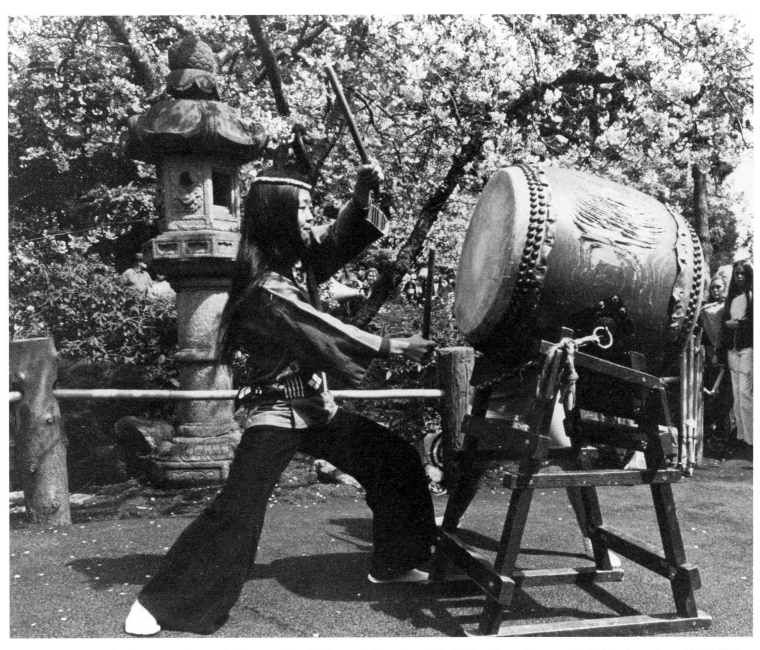

A taiko drummer plays in the Japanese Tea Garden at Golden Gate Park for the Cherry Blossom Festival in the spring of 1974. Today, the two-weekend festival is an annual celebration of Japanese culture. It features Japanese music, including taiko drums, dance, martial arts demonstrations, tea ceremonies, fashion, and food. Seiichi Tanaka, a postwar immigrant who studied taiko in Japan, brought the styles and teachings to America when he formed the first American taiko group in 1968, called San Francisco Taiko Dojo.

This panorama of San Francisco is seen in October 1974 through the windows of Henri's Room at the Top, a restaurant on the 46th floor of the San Francisco Hilton Hotel. Henri's, which today is Cityscape Bar and Restaurant, used to feature birdcages and go-go girls. The Hilton first opened in 1971, and following an expansion in 1987, is today the West Coast's largest hotel, with over 1,900 rooms.

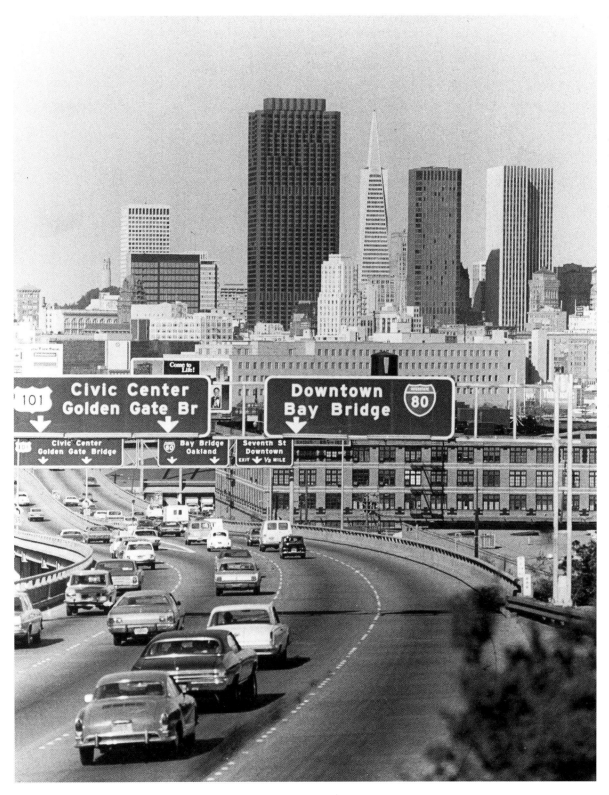

This aerial view of downtown San Francisco in February 1975 is what motorists driving northbound from the San Francisco Peninsula on the 101 Freeway see just before the fork in the highway: traffic headed along 101 to the Civic Center and the Golden Gate Bridge veering to the left, and traffic headed for downtown and the Bay Bridge staying to the right on the 80 Freeway. Visible on the San Francisco skyline are (from left) the Hartford Building, the Bank of America World Headquarters, the Transamerica Pyramid, and the Aetna and Wells Fargo buildings. Coit Tower on Telegraph Hill is seen at left.

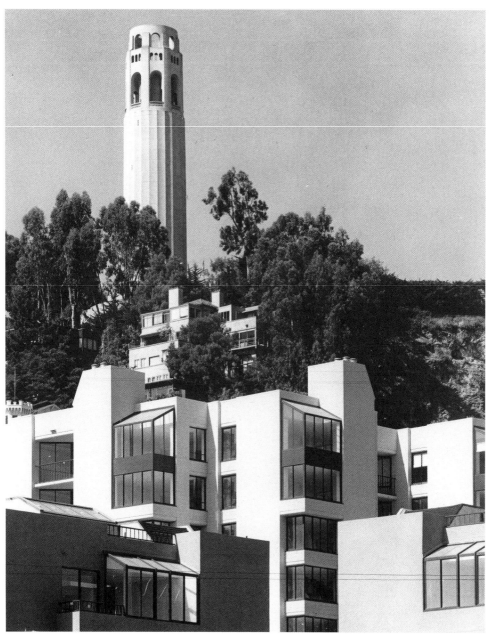

The Telegraph Landing Condominiums are seen in this 1975 photograph, with Coit Tower visible in the background. It is hard to imagine the San Francisco skyline without Coit Tower in it. San Francisco heiress Lilly Hitchcock Coit left a third of her fortune to her beloved San Francisco, as she put it, "to be expended in an appropriate manner for the purpose of adding to the beauty of the city, which I have always loved." Architects Arthur Brown, Jr., and Henry Howard designed the structure, and denied the popular urban legend that it was built to look like a firehose to honor the firemen of the 1906 Earthquake.

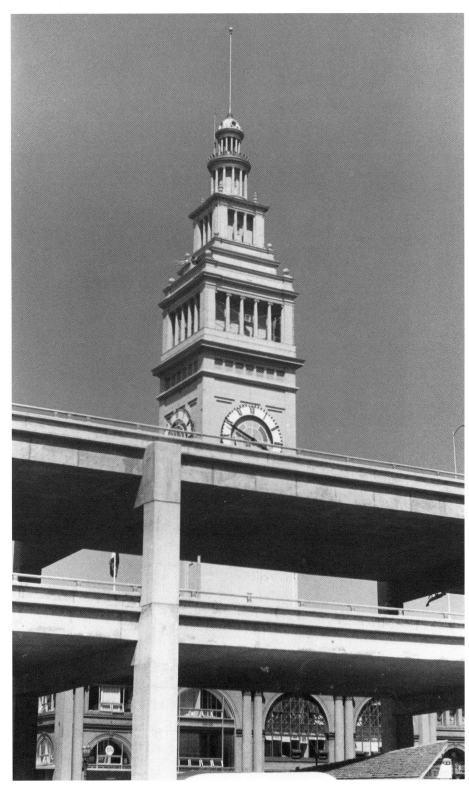

This 1970s photo shows the Ferry Building and the detested Embarcadero Freeway. The Ferry Building has always been a bustling center of activity downtown. Originally called the Union Depot and then the Ferry House, the building, with its famous 235-foot clock tower modeled after the Giralda Tower of the Seville Cathedral, was first opened in 1875 at the foot of Market Street. It was a center of transportation where horse cars and streetcars welcomed people arriving to San Francisco by ferryboat from locations across the Bay. The area in front of building is now a busy roadway and antique streetcar route, along with a lively pedestrian plaza and farmer's market. The modern Ferry Building opened in 1898 as a train and boat depot. Before the construction of the Golden Gate and Bay Bridges in the 1930s, the ferry was the sole mode of direct transportation into and out of San Francisco to the north and east, and averaged 50 million passengers yearly. The double-decker Embarcadero Freeway obstructed the front of the Ferry Building from 1957 until it was torn down after being damaged in the 1989 Earthquake.

The Peace Plaza at the Japantown Center is pictured in the seventies. San Francisco's Japantown, known as Nihonmachi in Japanese, is America's oldest Japantown. In 2006, Japantown celebrated its centennial anniversary in its present location in the Western Addition. Like the Chinese immigrants before them, the Japanese faced discrimination, immigration restrictions, segregation, and violence when they began arriving in the late 1800s and early 1900s. After the 1906 Earthquake, the Western Addition was one of the only Japanese enclaves in the city that was not destroyed. The Japanese government donated almost a quarter of a million dollars to the city to rebuild. The Peace Plaza, pictured here, was developed in the mid-1960s, and the Japantown center was completed in 1968. Today, Japantown houses most of the city's Japanese businesses.

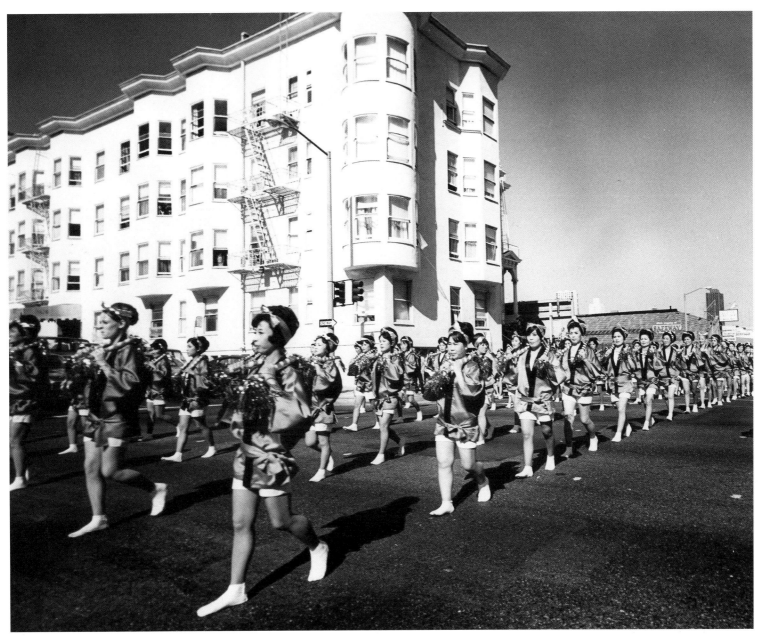

The San Francisco Cherry Blossom Festival Parade takes place in Japantown each spring as a demonstration of Japanese cultural history and pride. In 2010, the Cherry Blossom Festival celebrated its 43rd year. When it began in April of 1967, San Francisco was witnessing ongoing civil-rights and antiwar struggles and a revival of pride among ethnic groups. More than 150,000 people watch the annual festival, which celebrates Japanese culture and springtime in Japantown. San Francisco's Japantown is only one of three remaining Japantowns in the United States.

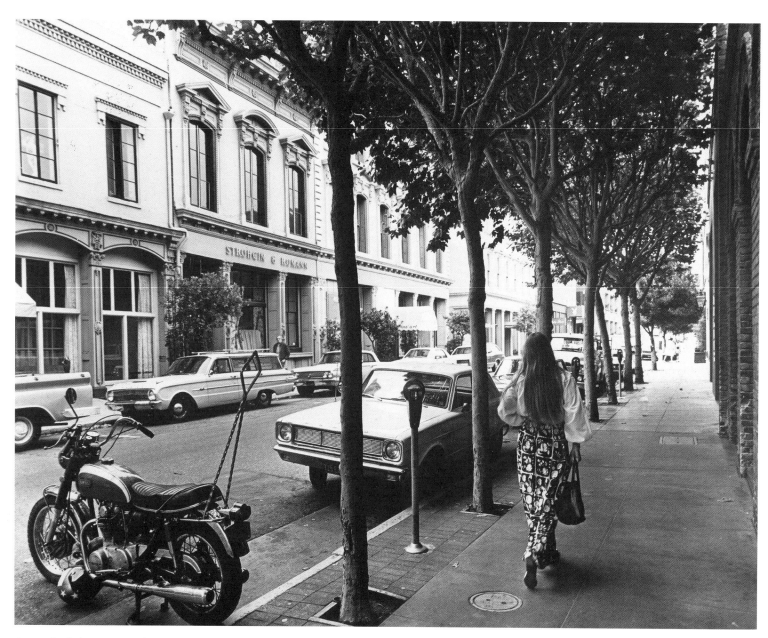

A tree-shaded street in Jackson Square, pictured in March 1975, is part of the old Barbary Coast of San Francisco. After the Gold Rush, it quickly gained a reputation as a seedy district known for its sinful pleasures, crime, saloons, prostitution, gambling halls, and opium dens. It was also an infamous spot for "Shanghaiing," the slave-labor practice in which unwary victims were beaten or drugged and kidnapped to surrender for years of service on ships headed to far-off ports, like Shanghai. The area was destroyed in the Great Earthquake and fires of 1906 and never quite reached its pre-quake debauched reputation. Many of the buildings were built of brick brought around Cape Horn, and some buildings still have "shanghai" holes in the cellar where many an unwary Barbary Coaster began an unwanted sea voyage.

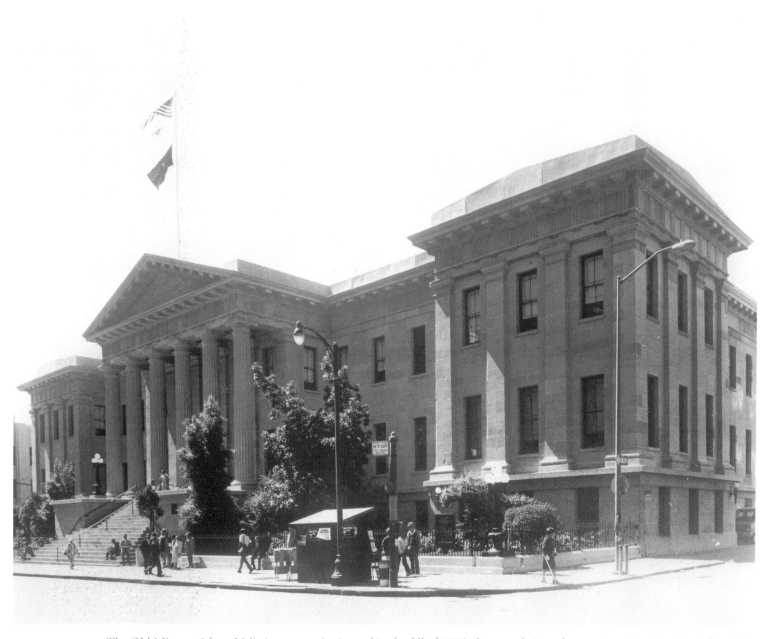

The Old Mint, at 5th and Mission streets, is pictured in the fall of 1976 after completion of restorations. San Francisco's first Mint opened in 1854 to accommodate the millions of dollars of gold flowing into San Francisco during the Gold Rush, but the Mint soon outgrew the building. Alfred B. Mullett designed the new Mint (now the Old Mint, established in 1874) in a muted Greek Revival style with a granite and concrete foundation to prevent robbers from digging underground tunnels to its vaults. In 1906, the Old Mint held a third of the country's gold reserves, nearly $300 million worth. The Old Mint is affectionately known as the "Granite Lady," though only the foundation and basement are granite. Mint operations were transferred to a new San Francisco Mint on Duboce Street in 1937, but the Old Mint still stands and became a National Historic Landmark in 1961.

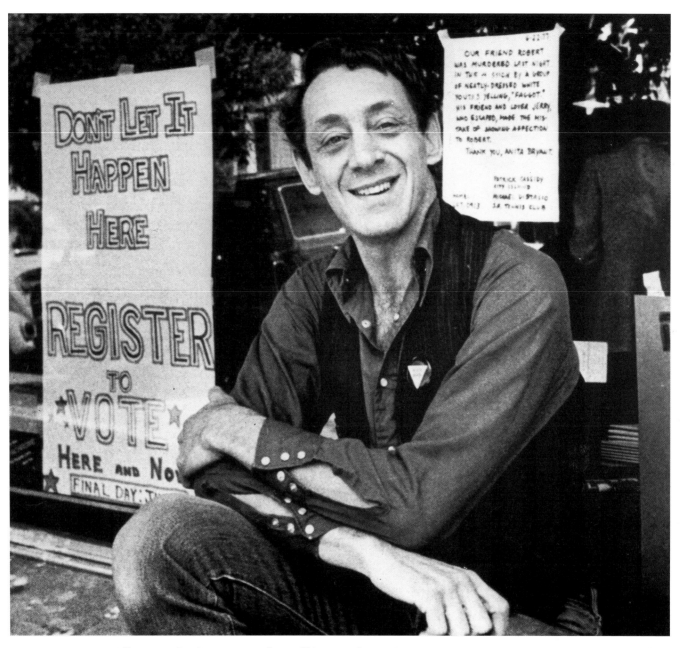

Harvey Milk, pictured in June 1977 in front of his store, Castro Camera, was a San Francisco County supervisor and the unofficial "Mayor of Castro Street." He was the first openly gay official of any big American city to be elected to office. Milk was born in Woodmere, New York, to a Jewish family on May 22, 1930. He served in the Korean War and was dishonorably discharged when his homosexuality was discovered, but he remained closeted for many years after that, working as an investment analyst on Wall Street. Milk moved to San Francisco's Castro Street in the late 1960s, at that time a neighborhood in transition from an Irish-Catholic to a gay neighborhood, and opened his camera store. After multiple tries, he was elected in 1977 to the Board of Supervisors.

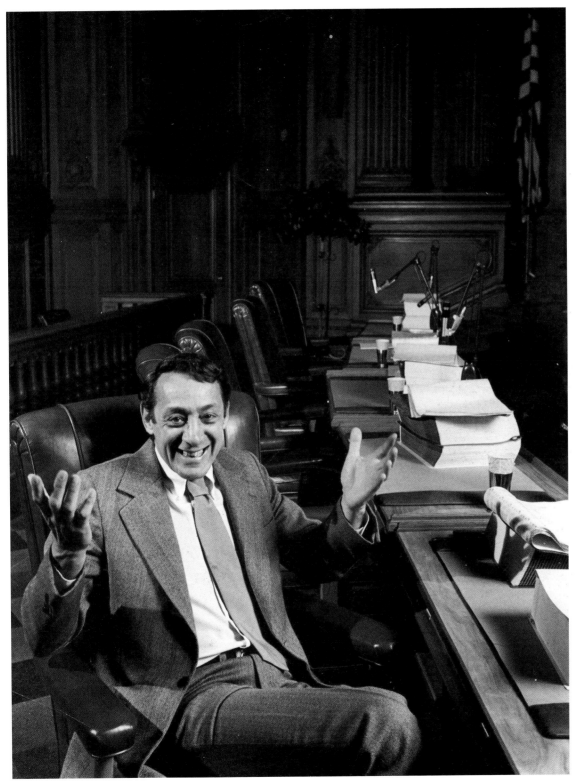

Supervisor Harvey Milk sits in the Board of Supervisors Chambers in City Hall at the Budget Hearings in 1978. In 1978, he and Mayor George Moscone were shot to death in San Francisco's City Hall by Dan White, a supervisor who had resigned and then wanted his job back. White was convicted of the lesser crime of manslaughter and not murder because of the now infamous "Twinkie defense": his lawyers claimed that he was temporarily insane due to poor diet, too much junk food, and stress. When Dan White got only a seven-year sentence, 40,000 San Franciscans came out to march in protest, and some rioted. White served only five years of his sentence before being released but ended up committing suicide after he returned to San Francisco. Milk once said that "if an assassin's bullet should go through my head, then let it destroy every closet door." He inspired other homosexuals to run for office and many thousands of gays to come out of the closet.

Harvey Milk is pictured triumphantly walking down Castro Street in front of the Castro Theatre in the late 1970s.

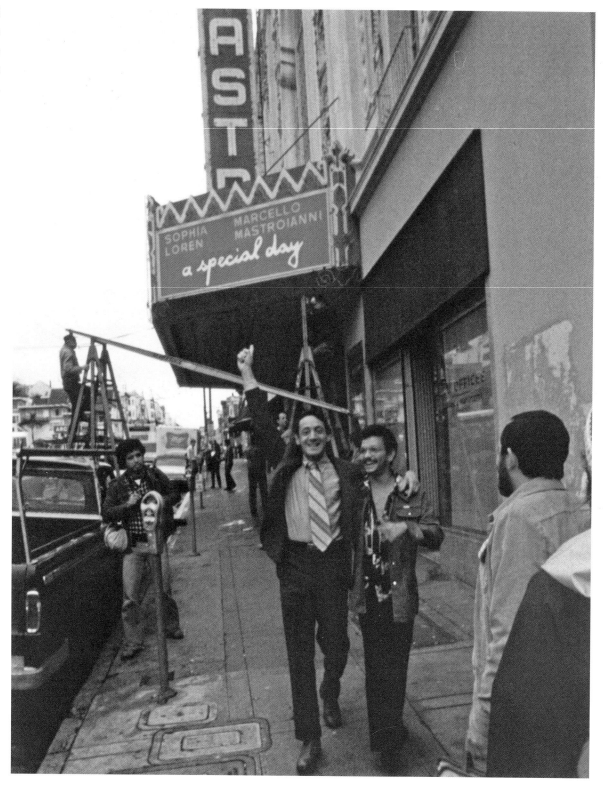

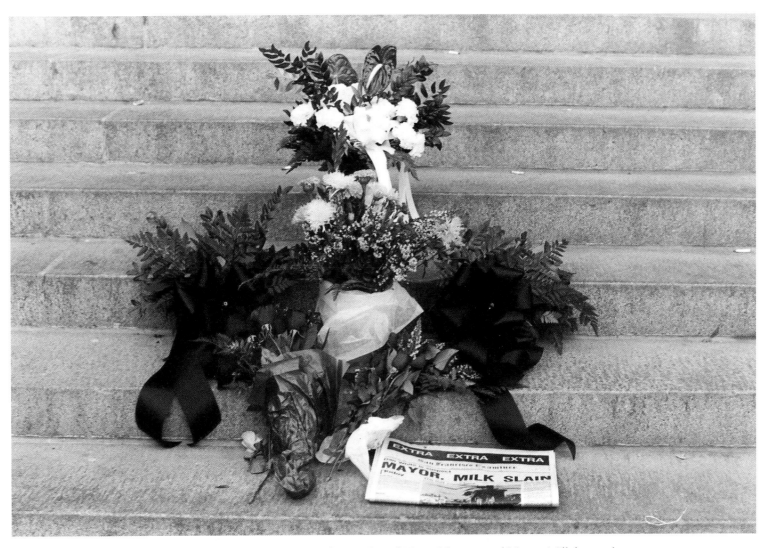

Flowers and a copy of the *San Francisco Examiner* announcing the murders of Mayor Moscone and Harvey Milk lay on the steps of City Hall on November 28, 1978, the day after the tragedy took place. It was Dianne Feinstein, President of the Board of Supervisors, who discovered Milk's lifeless body after she heard gunshots in City Hall. In a trembling voice, she announced to a stunned public that "Mayor George Moscone and Supervisor Harvey Milk have been shot . . . and killed. The suspect is Supervisor Dan White." Feinstein was sworn in as the new mayor on December 4, 1978, serving the remainder of Moscone's term, and she was elected in 1979 and again in 1983.

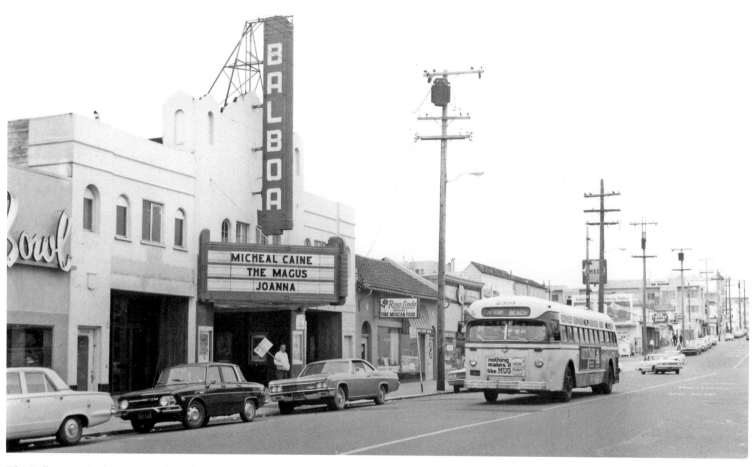

The Balboa movie theater at 38th and Balboa in the Richmond District is pictured in 1978. Samuel H. Levin opened the Balboa on February 7, 1926, as a family-oriented theatre. It remains one of the few independent theaters in San Francisco today.

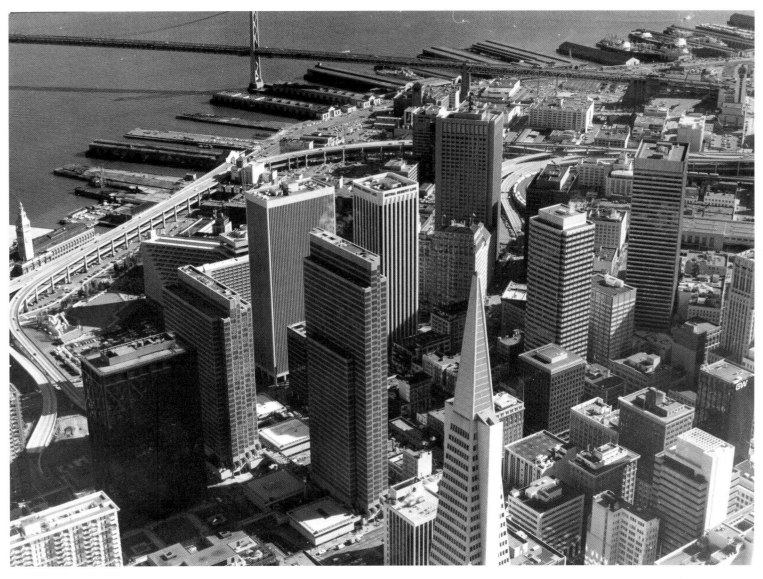

This photograph provides a stunning aerial view of downtown San Francisco. The Transamerica Pyramid in the foreground and the four Embarcadero Center buildings dominate the picture. The Bay Bridge is visible in the upper left-hand corner.

Notes on the Photographs

These notes, listed by page number, attempt to include all aspects known of the photographs. Each of the photographs is identified by the page number, photograph's title or description, photographer and collection, archive, and call or box number when applicable. Although every attempt was made to collect all data, in some cases complete data may have been unavailable due to the age and condition of some of the photographs and records.